Russell Brand

BOOKY WOOK 2

Russell Brand

BOOKY WOOK 2

This Time It's Personal

itbooks

AN IMPRINT OF HARPERCOLLINS PUBLISHERS

*it*books

A hardcover edition of this book was published in 2010 by It Books, an imprint of HarperCollins Publishers.

Additional credits and permissions appear on page 312.
All photographs are courtesy of the author with the exception of the following:
Plate sections
Brian J Ritchie/Hotsauce TV, image 2; BBC, 3; Fizz @ Lucid Pictures, 4, 5, 7, 8, 25;
Producer Paul Sheehan, 9; Getty, 12, 22; Sharon Smith, 13, 14, 15, 18, 19, 23; Justin Goff/
UK Press/Press Association Images, 16; Dan Steinberg/AP/Press Association Images,
17; Nicola Schuller, 20, 21, 28, 31, 34, 37, 47; Alfie Hitchcock, 49, 50, 51, 52, 53; Vanity
Projects, 26, 47, 48; Laura Gallacher, 32, 35; dandion.com, 46

Integrated images
page 28, © NME/IPC+ Syndication; page 67, Karen Koren, Gilded Balloon;
page 113, Nic Carter; page 117, Richard Young/Rex Features (photo), Daily Mail (article)

HarperCollins books may be purchased for educational, business, or sales promotional use.
For information please write: Special Markets Department, HarperCollins Publishers,
10 East 53rd Street, New York, NY 10022.

FIRST IT BOOKS PAPERBACK PUBLISHED 2011.

Library of Congress Cataloging-in-Publication Data has been applied for.

ISBN 978-0-06-195808-3

11 12 13 14 15 BVG/ID4 10 9 8 7 6 5 4 3 2

For Katy.

This is my past.

You are my future.

Anybody, providing he knows how to be amusing, has the right to talk about himself.

Charles Baudelaire

Have faith in Allah but always tie your camel up.

John Noel

CONTENTS

Part One

Part Two

Part Three

Part Four

Part One

Don't bend; don't water it down; don't try to make it logical; don't edit your own soul according to the fashion. Rather, follow your most intense obsessions mercilessly.

Franz Kafka

If I became a philosopher, if I have so keenly sought this fame for which I'm still waiting, it's all been to seduce women basically.

Jean-Paul Sartre

Chapter 1
LIKE A ROLLING STONE

Fame was bequeathed to me by the lips of an angel. After all my years of rancid endeavour, I was granted fame by Kate Moss's kiss.

I was born to be famous, but it took decades for me to convey this entitlement to an indifferent world and suspicious job centres – both presumed me a nitwit, possibly with good reason as I was brilliantly disguised as a scruff-bag. Being anonymous was an inconvenience to me.

My well-meaning chum John Rogers would offer kindly, useless consolations – "Do you think you'll like fame? You won't be able to go to supermarkets."

"Oh, please!" I mockingly responded. "No more supermarkets? Next you'll be telling me I'll be incessantly pestered by sex-thirsty harlots yearning to massage me out of my agony. That vainglorious sycophants will clamour to yawp odes of awe and wonder into my wealthy fizzog while fertile accolades and praise will avalanche the fields of my barren esteem, where now only bedraggled ravens hungrily drum the wretched dirt." I really wanted recognition.

The Four Horsemen of the Apocalypse signify oncom-
ing Armageddon, which must be awful for their confidence –
everywhere those dread riders canter they'll be greeted with
shrieks and condemnation. Not even the most generous spin-
ster will welcome Famine with a piece of Battenberg and a
cuppa. No rosy-faced little match girl will leap into Pestilence's
ragged arms, and Death will go to his grave (sent by whom,
we'll have to ponder) without ever tasting the kiss of a willing
debutante. Yet, like the Royals, the Horsemen continue their
grim duty as living signs, harbingers. Harbinging like there's no
tomorrow – and once they turn up there won't be.

The harbingers of my fame were far more glamorous and
perhaps yet more iconic. These were the signifiers that my life
sentence in the penitentiary of anonymity was, at last, coming
to an end. The first Horseman was Jonathan Ross, a moniker
he'll welcome as it subtly alludes to his truly equine cockleberry.
My appearance on the chat show *Friday Night with Jonathan
Ross* in 2006 flung me into the orbit of celebrity from where
I could gather momentum. It was also the commencement
of my most notorious public friendship. For just three years
later Jonathan and I were to become the Butch Cassidy and
Sundance Kid of broadcasting when, accidentally, we nearly
destroyed the greatest public service institution on Earth, the
BBC. When reflecting on monumental, life-defining events I
marvel at the ineluctable journey that led to them. From the
moment Jonathan and I met we were destined to share this
extraordinary experience, so retrospectively the preceding
events garner additional significance. Perhaps the scandal that
we inadvertently conjured wasn't predestined.

That's the thing about destiny, you can question it but you
cannot undo it once it has occurred. That's what that lunatic

Schrödinger was up to with his cat – a scientist, of all things, in analysing the nature of the known, put a cat into a sealed box with a poisoned tin of food, arguing that until the box was reopened two potential realities existed simultaneously; one where the cat was alive and another where it had eaten the food and died. What a bastard. He could've made the same point with a mouse and a Tic Tac. I think the real question is, what is this grudge that Schrödinger has against cats? What's his next experiment? Schrödinger's electric litter tray? Schrödinger's ball of wool in a shark-infested swamp? I may conduct an experiment named Russell's pointy boot in which I repeatedly kick Schrödinger in the nuts to examine whether his scrotum could be used to shine shoes. Regardless, perhaps there is an alternate reality in which Jonathan and I didn't leave Manuel from *Fawlty Towers* a message that very nearly destroyed the corporation that created that wonderful show. Later we will examine that barmy event with the cruel scrutiny of that swine-hunt Schrödinger, but first I will tell you what it's like to be plucked from a life of hard drugs and petty crime and rocketed into the snugly carcinogenic glare of celebrity.

I was nervous before going on that Jonathan Ross show. As it turned out, some people said – and they weren't entirely impartial observers, not folk stood passive on the sidelines with pads and pens peering over half-moon specs, in fact it wasn't even "people", it was a person – my dad. He said it was as significant as when Billy Connolly went on Parky, becoming in that instant a national star – as you know Connolly has never descended from that firmament. Television doesn't have the same ubiquitous potency now, which is another of the inconveniences that I've been stuck with: the availability of technology means that any prat can nick a Mac, record their voice,

broadcast it and become an internet sensation before getting their own TV and radio show. Well, in my day TV and radio shows were hard won. More than ever I understand the phrase "I'm alright, Jack, pull the ladder up" – if we can't get the ladder up simply shatter the rungs so these techno-johnny-come-latelys get splinters in their grasping palms. Now that would be ungracious – fame should be available to all who crave its dubious kiss. Let's have a fame democracy where fame is available to all. I don't think for a full Warholian fifteen minutes, that's excessive. Just a highlights package.

I often query the significance of sexuality in my pursuit of success. Is the reappropriation of biological drive the engine of ambition? Is that what's compelling me forward? What's getting me out of bed in the morning? Back into bed at night? Is that what's keeping me in bed hour after hour with strangers, exchanging the baton of my lust as they pass beneath the sheets in the relay of my needs? Olympic promiscuity. The carnal flame forever burning.

I encountered Kate Moss for the first time as a result of my appearance on Jonathan Ross. Sadie Frost, a long-time friend and a very sweet, beautiful woman, informed me of the development that even as it was issued seemed to have strayed into my mind as a fanciful refugee discarded from romantic fiction for implausibility.

"Oh, I was talking to Kate the other day and she'd like to meet you."

I was not yet the kind of person to hear the words "Kate wants to meet you" and immediately assume "Well, that must be Kate Moss." I would just think someone called Kate, like one of the thousand Kates one might bump into walking down Croydon High Street. Not canonised Kate, not the Kate who

can only be squinted at lest her radiance shreds your mortal retinas, not the Kate who'd had God present at her conception, ushering through the holy sperm to the sainted ovum, where the orgasmic cries of her parents harmonised with the salutations of the choiring cherubim.

Obviously you remember the prettiest girl in your school. Her sweeping majesty, her ethereal glow, how the playground floor did not dare besmirch her gentle feet with its lowly asphalt touch but instead protectively hummed so she might hover above you, above me, above us – for she was never meant to walk among such as we but was sent that we might know that there are higher things. Kate Moss is the prettiest girl in all our schools. Like they imposed an involuntary global pageant. Behold our queen, but don't look at her directly or all else you gaze upon till death brings down your lids will be as shadows compared to her beauty.

"Kate would like to meet you," says Sadie Frost again.

"Oh really, Kate who?"

"I was talking to Kate and Liam …" Naturally, I don't assume Liam Gallagher but, of course, it was. "I was with Kate and Liam the other day and Kate wants to meet you."

"Oh really, Kate who?" I repeated.

"Kate Moss."

There follows a sort of a silence which I vulgarly interrupt with the sound of my own swallowing, which makes more noise than it usually would. I try and stifle it and just do a normal swallow. "I'll just do a normal swallow," I think, a quiet unobtrusive swallow. But my body interprets that as "Hey let's do a ridiculous cartoon parody of a swallow that advertises your huge discomfort with this situation." A pornographically inappropriate gulp echoes through my oesophagus.

"Kate Moss? Really?"

"Yeah, yeah, she'd like to meet you, she saw you on Jonathan and thought you were fantastic." Clearly in this situation I cannot afford to do anything so brazen as be myself, I must quickly construct an edifice of studied coolness, like barely a day passes when my life isn't kicked on its arse by staggering beauty. I must say something normal and cool.

"Oh, right, well I've got a gig on Monday so perhaps she should come."

The gig was at the Hen and Chickens on Highbury Corner in Islington, a fifty-seater venue above a pub, small and drab, where Edinburgh Fringe shows go to practise, where faded stand-ups go to die. The idea of Kate Moss turning up there is like attending a church fête in Dorset to find that the raffle winners are being announced by Christ.

When the night comes, I arrive typically late and notice the place seems to have been dusted in majesty. Glamour. Whatever it is, that unknowable, unnamable quality that these people bestow upon a place or a conversation or a clothing range was present at the Hen and Chickens. As I attempt my unflustered entrance I cannot help but notice the static explosion of her perfection. A Geiger counter unhelpfully chirps within me as I see her deifying the bar with her elbow from the scorched corner of my reluctant eye.

Beyond the dreams of Pharaohs and Nazis there is an inaccessible gold that shimmers like a halo above Kate Moss. Is it her hair? Her aura? Her hair's aura? Her aura's hair? I try to drift past her nonchalantly, ignoring my own cacophonous swallows and ticks. A recalcitrant orchestra of discordant twitches. It's like meeting an angel of my own devising – and perhaps that's all angels ever are. Maybe celestial beings are only

in the heavens because that's where we look for redemption. Be normal.

"Hello Kate, nice to meet you," I burp. I can make it up with a gesture, I reason to myself. I try a gentle backhanded greeting, a slow subtle sweep such as one might make when introducing a new range of lawnmowers in an Argos commercial. She nods and smiles and seems impressed enough – kindly neither she nor Sadie remark on the gin and tonic I sent hurtling from her hand, so a partial triumph. "I go to up der stairs now Mate Koss," I suavely announce, then step on a guide dog and make my way cautiously to the tinpot theatre up the rickety staircase.

It's a warm-up show for the Edinburgh Festival and I'm obliged to do a performance. "OK," I think, "there's going to be fifty people in this room, and one of 'em's Kate Moss" – she's going to be there, a beacon of beauty, a universally accepted sign of goodness as close to truth and glory as one could ever be without uttering a word.

Towards the end of the set, which is mostly funny, if a little more self-conscious than usual due to her proximity in the tiny room – I might as well be performing on her shoe – I make a comment about coercive sex, obviously not an endorsement of the concept but some musing on the topic. At that point Kate Moss gets up and walks out and goes downstairs.

Now if Kate Moss walks out of a packed Wembley fucking Stadium you're going to notice it, because she's Kate Moss and she's wearing a constant ermine robe of beauty and a crown of charisma. So when she saunters out of the upstairs room of the Hen and Chickens in Islington our tiny world stops. I try and continue the gig for about three more seconds before I have to address the forty-nine remaining people – fifty minus Kate Moss, but if you were to take the value of their collective

presence, ninety-nine per cent of the room just walked out. There's a terrible moment of post-Kate silence. I look at the audience and they look at me and we ponder the same question together. "Do you think she walked out then because I was talking about rape?" and they laugh reassuringly. "No, no, that was very sensitively handled and comedically justified. Don't you dare reproach yourself, you brilliant man," says someone on the front row. Suddenly the forty-nine that remain are my chaperones, my indulgent aunties, my wing men.

I carry on as best I can, focusing on a job in which I've been unwittingly relegated from protagonist to extra – like Rosa Parks's bus driver, one eye forever on the door, and eventually Kate Moss blessedly returns from her inexplicable and disruptive sojourn, having missed a good bit of stand-up. Drat. I finish, bow and go backstage, like normal.

When I come off stage, regardless of its dimensions, I'm in a fragile, volatile state. The most natural thing to do, it seems to me, is to take heroin. This is no longer an option, so I generally like to have sex. Sex is usually quite captivating and distracting and, unlike the other option that people frequently suggest – a brisk jog – it ends in orgasm. The moment of climax is like pulling a rip-cord that helps me to parachute down to earth after my on-stage "Mr Fahrenheit" excursion. The Queen song to which I refer, "Don't Stop Me Now", is by all accounts Freddie Mercury's elated description of a night in Rio de Janeiro where his tour manager sweetly lined up eighty rent boys for Freddie to back-door diddle while coked up to the 'tache.

Now that is a bloody good way to relax yourself after a gig, and I for one would like to commend not only Freddie, for his commitment to promiscuity and his ability to transform the experience into a thrilling pop hit, but also the unsung hero,

the tour manager who had to source eighty lads up for a bumming so that Freddie could, in his own words, "have a ball". In the absence of Freddie's excellent entourage, however, and the decadence of Rio, a meeting with Kate Moss is a lovely way to celebrate after a show.

Kate and Sadie await in the tiny, musty, black-box theatre, black paint and atticy drapes, fag-burned seats and a lighting rig than can be adjusted by reaching upward sans ladder. My mate and Radio 2-show sidekick Matt Morgan is waiting there too with Ian the Gruff, northern promoter, the pair of 'em ransacking their limited small-talk closets for the biggest inconsequential natter of their lives. "Oh, hello Russell, that was a good one," says someone, but not Kate, who is smoking, ignoring the regulation that you mustn't smoke, along with the unwritten rule that you ought compliment people after a gig instead of driving juggernauts through their yearning hearts. If you go and see a stand-up comedian or any kind of performer, let me tell you what they want: they want specific compliments to actual bits of material you've seen, not just a generic "it was good", no. They need specific, positive criticism. "You know that bit where you talked about Freddie Mercury bumming Brazilians, that was heavenly" – that is the sort of compliment you ought offer me should we meet and discuss this book.

It becomes clear that we are not about to conduct a post-show salon, the five of us – me, Matt (highly gaff prone in a pressure situation), Ian (incredibly brusque and clumsily blunt around new people), Sadie (shy), and Kate Moss (icon of perfection) – when Kate says, "We're going to Annabel's night club to a charity auction. The top lot is a kiss. With me. Philip Green the Top Shop entrepreneur is bidding. Currently it stands at £40,000. Would you like to come?"

Obviously I want to come. At this stage I'll do anything, I don't feel I'm in a position to negotiate. I've just performed for her, her own personal jester (Depeche Mode – fancy a remix? Your own personal jester. Someone to make you smile in medieval style. Reach out and touch japes. I'm riffing), if she now wants to attend an auction where billionaires vie for the treasure of her kiss I'm not about to shake my head and suggest a kebab. I don't know why I assumed low status so swiftly, I mean *she came to see me, right?* I could've played it cool, but as an unbelievably eloquent yob once said to me before punching me in the face, "You can't play the hero if you don't know the lines." So Ian is dispensed with – he was never gonna cut it with the in crowd, even the out crowd find him a bit annoying – and we order a cab.

Every so often, in the back of the cab, she receives a call on her ever-chiming phone. "The bidding's gone up – it's fifty grand now." God. As I look into her eyes, this woman who's just come to see me in a 50-seater venue, there is literally now an auction that has gone into tens of thousands of pounds for a momentary kiss.

Utterly unfamiliar, we un-jam from the car. Me and Matt have exchanged a few glances, acknowledging the madness of our new circumstances, all the while trying to act normal. But me and Matt ain't normal, we're weird – even when doing something utterly mundane like going for a dental check-up or feeding a cat we act freaky – so when descending the stairs into Annabel's glamour palace with a Goddess there's a real possibility of meltdown.

Posh people, people you don't recognise but who you know are important, are everywhere. People who themselves know they're very important, have always known, jostle for an audience

with Kate, and soon Matt and me are just loose in this place so foreign to me it might as well have been made of edible jewels and run by an arrogant dormouse. I think Jemima Khan was there, and Philip Green, not people I recognised but that's my fault. It's certainly not their fault I don't recognise them. "You'd recognise them if you knew what to recognise, you poor suburban, arriviste twit, wandering around Annabel's not knowing who to recognise, you better act like you recognise them; you're only making it worse for yourself."

The auction has come to a climax at £70,000. Philip Green nobly decides to donate his kiss to Jemima Khan. So adorning the front cover of the London *Evening Standard* the next day is a photograph of Kate Moss kissing Jemima Khan, a kiss that I'd witnessed, and seeing it rendered on the front page the next day makes me relive the moment. It felt like the *Standard* was addressing me personally – "And do you remember last night?" the front page seemed to be saying, "Remember her?" – and of course, for once, I did.

Matt is not a recovering alcoholic and drug addict, so he disappears into chinking of glasses and glinting of sequins. I am, so I have to conduct this operation without an anaesthetic. SHE CAME TO SEE ME, I remind myself – amidst the glitz and the stink of inherent unobtainability is the inescapable fact that she must want me here. Terrifying though it is, I resolve to go and talk to her. I mean she is just a bird, right? From Croydon with its trams and Nestlé headquarters. She's a bird from south London. I have chatted up and seduced birds from south London before, and by jingo I can do it now. Denied vodka, I gulp down the intoxicating air and walk over to where she is, led by the glow.

Any chair on which she sits becomes a throne ennobled by the presence of her arse. That's why they need her on the front

of *Vogue* and next to handbags and holding lipstick, because her magic is transferable. I approach and then, against all odds and everything my life has taught me until then, an anomaly occurs. The universe tears and light bursts through and falls upon me and her gaze follows, she parts the crowd around her like Moses and indicates with an eyelash that she wants to talk to me. I follow her to an empty corner of the empty club. It is all empty now. Phantoms dance and drink, but all that's real is her. To have her attention is spellbinding. You have to go into overdrive to sustain normalcy, to be normal around her is a tremendous effort – she exists beyond her own being, photographed to endorse and beautify products. The potency of her beauty is so great that anything she touches will become beautiful, be it a wristwatch or a blouse or a fucking shampoo, if it's near her it is by association beautiful, so tonight I am beautiful, I am rendered beautiful by her company.

The tricky thing with chatting up the world's most beautiful woman is – WHAT THE FUCKING HELL DO YOU SAY TO HER THAT SHE HASN'T HEARD UMPTEEN TIMES?

INT. NIGHT.
RUSSELL
You're pretty.

KATE
Yes, it's been mentioned.

You could try something from the bible for wantaway onanists, *The Game* by Neil Strauss, but "negging" – the practice of saying something mildly negative to your "target" – seems disrespectful, and if you "ignore her", the void you leave will be filled in an instant by a dozen willing suitors.

Somehow amidst the clanging of my mind, the overtures of her beauty and the accompanying social impact, I manage to be vaguely funny. "I'll just treat her like a normal girl," I think. But before I can impose any sort of control over the situation she suggests we go back to Sadie's. Matt and, of course, given the venue, Sadie come too. The cab is pursued by paparazzi on mopeds. Maybe ten of them, an unwelcome convoy, trail the cab like a dangling haemorrhoid. That was the first time I'd been followed by photographers and it's not annoying at first but kind of exciting, it heightens the idea that what you're doing is important, that you yourself are important. After a while it becomes bloody awful, relentless and, typically, attached to a tabloid perspective of yourself with which you whole-heartedly disagree, but for now it adds to the romance.

When we arrive at Sadie's house in Belsize Park – a real-life Stella Street where David Walliams also lives as well as Bob Hoskins and Derek Jacobi – it is decided that Matt should walk Kate into the house so that there is no photo of me and her together. This gives me hope that we do have something to hide, but also makes me jealous of Matt as he gets to walk up the driveway with her. Within the beautiful house we flirt for a while, then under some mutual pretence of looking at hung photographs of Sadie's deplorably gorgeous children we wander off. We are alone.

The rest of the evening was like a beautiful road accident. I passed in and out of consciousness, scored by sirens, sporadically lit by flashing blue and red light, time bending. On a sofa in a world made only of Kate Moss's face. I cannot recall a single word of the conversation that took place; for all I know we communicated in whale song.

Drifting closer and closer together, my heart pounding, of course, but also my liver and lungs and feet. Things that don't

have pulses join the unwelcome percussion. Paul Simon thinks my vital organs may be a lost African tribe and considers recording a follow-up to *Graceland* in my colon. Eventually there is no more universe between our lips and so we kiss, and yes, on one level I'm enjoying the kiss, but my mind is screaming, screeching, body-popping, lambada-ing, every dance-craze-there's-ever-been-ing. Playground fads are revisited: yo-yos, hula hoops, pogs, the works, every exciting moment from childhood condensed into a single kiss. "Kiss properly, stop thinking about pogs, you idiot, get on with this kiss, stop thinking how this is going to sound in a book and get on with the kiss."

So I get on with the kiss, and I think it's a good kiss, but of course there's all this analysis going on simultaneously. I've got to get her out the house. Ludicrously I say to her, "Do you want to come back to mine ... Kate Moss?"

We get a minicab – from a number I had in my phone. Some bloke comes round in a beat-up car that stinks of fags, there's a blanket on the back seat. Kate Moss gets in, I get in, we sit in the back seat and drive the short journey geographically but a long journey in terms of interior design style and property value from Sadie Frost's in Belsize Park to mine in Gospel Oak – what Matt calls "not quite Hampstead". A garret, digs. Mismatched pans and a duvet that was there when I moved in.

I make her tea. There's a bit where she's in my garden, there's a bit where she's sitting with my cat and he doesn't care that she's all mysterious and wonderful. I know he's a cat but he should recognise that she has transcended the everyday. To be in her presence in my house doesn't make sense, it is a baffling fusion of the real and the imagined. It's like looking into the garden and seeing Vegas Elvis mowing the lawn, or going into the kitchen and finding Elvis in the Elvis Comeback

Special '68 suit cooking up beans, or going into the bedroom and there's golden jacket Elvis from '54 before he cut his hair, before the army cut off his balls. Elvis, lying on my bed looking into my eyes. Elvis Presley has entered the building.

Of course my mind will not shut up and let me enjoy the moment, there is an endless incessant narrative throughout it. Which is a shame because what I enjoy most about encounters with women is relief from the endless buzzing of needless thought, the neurological chaos, the Tokyo of neurons smashing into each other, the fizz, the buzz, the clatter abating, the hive of my mind quietening, but not that night.

The next day, ludicrously, I had to get up and live my normal life. Filming sketches with Matt and dopey Gareth Roy for our MTV chat show, *1 Leicester Square*, dressing up as an old Michael Winner-type man and Matt as a Nosferatu baby.

Life begins again each day anew, and when you awake you could be anybody. During the hiatus that each new day brings, I think firstly "Who am I?" and secondly "What was I doing yesterday?" My mind begins its programme and it seems more preposterous than ever – "Well, Russell, yesterday you went to bed with Kate Moss."

"That's an interesting notion, brain, and I'm going to humour you and open my eyes, but if it proves false I won't trust you again and may go back on drugs."

I open just one eye at first, because my brain's broadcast seems so unlikely, but one eye is sufficient because, brighter than the daylight flooding through the curtains that I should have replaced because they were too short, is the raging dawn of a sleeping Kate Moss, the illumination warring with the daybreak – intimidated by her radiance, the sun disappears behind a cloud. Her hair fans over the pillow like a peacock's tail.

I open the other eye. Kate Moss is indeed in the bed, and for a minute I feel like I've murdered her. "Oh my god, what have I done, don't panic, don't panic." I get up and back away like a butler on his first day with the Queen, not daring to turn from her for a moment. Like a cartoon drunk, I rub my eyes and peer at my bottle – it's only mouthwash. It is definitely Kate Moss. Not the Listerine. It's getting late. I'm going to have to leave for work, where I must do pop video reviews with Matt. What a stupid life.

I leave the house, the cat, the plants, the angel sleeping in my bed and walk out into a different London. I have been given patronage by Kate Moss and I can hear the gossip columns being typed, the photos from the previous night being processed and printed. Before I've seen a newspaper I know that I'll be in them. With a kiss she has issued what decades of hard work could not – fame. Bigger, though, than the realisation of a lifetime's ambition is the chaos she has left in my belly. I am unable to distinguish between this feeling of insane joy, this blissful disarray and love. It feels like love.

On my way home from a day of elation and delirium I chat to Nik Linnen, my partner, my manager, my outsourced rationale. I tell him what I've just told you, that I think I'm in love. With Kate Moss, or the idea of Kate Moss – which to my brain is indistinguishable from actual Kate Moss. A conveniently reductive device for dividing women who spend the night in your house is those who make the bed and those who don't. If a woman makes the bed, the insinuation is that she cares for you, that she wants to take care of you. If she doesn't, it doesn't make her a bad person, it just means she's busy and has to get out and on with her life and has no time for sweet, domestic ritual.

"If she's made the bed, Nik, I don't know what I'll do."

"Don't get yer hopes up, mate," he replies in his Manc twang. "It ain't important, you're already investing too much in it – saying you love her an' that – you don't even know her."

I open the dark blue front door of No. 7 Courthope Road. Lucky seven. I am courting hope.

"I do know her – she's Kate Moss," I argue, entering the dingy communal hall with yellow walls and obligatory gas meter cupboard where I hide the spare key.

"Yeah. That's what you're in love with, you idiot – the idea of Kate Moss – not an actual woman. You're being daft."

I open the door of the flat. Morrissey my beautiful cat weaves about my feet, still unconcerned by last night's visit.

"Look, you weren't there. We really connected. If she's made the bed it's a sign." I step into my empty flat and it has never been so empty. I make my way towards the bedroom.

"Don't be stupid," says Nik, "it don't make no difference – she probably would've left in a hurry. Don't build it up in yer head."

"I'm not building it up. I'm just curious." I close my eyes, inhale and open the bedroom door. I turn on the light and Morrissey bounds in, leaps up and lies down on the perfectly made bed. And I know that I'll never sleep again.

✝

Chapter 2
NEW MUSICAL EXPLETIVE

Being sanctioned by the Princess Diana of counterculture made an immediate impact on my career. The relationship itself went nowhere as I was ill-equipped to cope with the protocols of having a globally worshipped paramour. (To be honest, I struggled to maintain the marriage to my cat – I stoke the romance by taking him up west once a week to the Ivy, plus I keep things spicy in the bedroom by putting dead birds down my pants, so that relationship pretty much takes up all my time.)

What no one realised, not Kate nor the red-top tabloid press, was that far from viewing her as a conquest, I was absolutely smitten. When I clumsily ballsed it up by flatly telling journalists who I'd not yet learned to ignore that I was "just larking around", she wisely withdrew and I had enough sense to stop calling her. I didn't delete her number from my phone though. I left it stored under "Grimy Tyke", which is what I called her in an attempt to punctuate the endless flattery and awe. She's

probably had about five different numbers since then, but I keep it as a digital memento, just to assure myself that it did really happen, that it wasn't a dream.

I could never have anticipated the instant elevation that this liaison would afford me, it was like being awarded a celebrity Victoria Cross. The word "approved" was stamped on my forehead and I was now to appear in the *Sun* newspaper as regularly as the horoscopes and as spuriously as page 3. My mate Mark Lucey, with whom I worked on *Big Brother's Big Mouth*, remarked that in the paparazzi photos from the night I met her I looked like a shifty, greased rat as I peered out all blinking and apologetic from the back of the rain-spattered cab. "You look like you don't belong there," he said. "But here," he continued, regarding a shot several days later where I dashed from her house, "you look like a dandy lifeguard sprinting up the beach all cocky."

Due to my friendships with funny colleagues like Mark Lucey and Matt Morgan and strategists like Nik, the ol' work was going in the right direction. The Big Brother show was a cult hit, my stand-up was improving and we were deluged with further opportunities. I was even offered the chance to host the NME Awards, a notoriously difficult gig where the baddest, drunkest musicians of the year nonchalantly RSVP, then indifferently attend a debauched, yet carefully staged, indie rock and roll award show.

This was a month before I'd appeared on Jonathan Ross's show or been kissed into the mainstream, which was unfortunate because I could've used any extra status available to control a very difficult room. The NME Awards were challenging because, like all the awards ceremonies I've hosted, I was not quite famous enough to do it. If Jonathan Ross is hosting an awards show, everyone there accepts his authority, we all

respect him and sit down and shut up. But when I hosted the NME Awards, around half the people there didn't know who I was. Bob Geldof, for example, began the evening not knowing who I was and concluded it deciding I was a cunt. I know this because he said so when he collected his award.

Matt, in spite of spending much of his life skulking about like a menstrual Hell's Angel, frequently says things that are apposite and profound. Once, when we discussed negativity towards others, he said that we ought imagine that we each have an individual connection with a God or higher power through "a Doc Brown from *Back to the Future*-style metal helmet" (bear with me) that has an electric tendril that reaches up through the sky, puncturing the ozone layer, into the heavens, past the Milky Way, right into the mind of God. Like them hairdrying plastic mushroom contraptions beneath which elderly ladies sit in hairdressers, but instead of being attached to a plug socket, they are attached to God. When someone, a critic, a teacher or an enemy attacks you, it's as if they are petulantly disgruntled and dissatisfied with their own connection to the universe and like snitchy little berks, reach over and yank your tendril. We are all connected to an objective higher mind and through that to each other, so why bother jerking around with other people's connection? It's a senseless interference. We all do it, but really what's the point of sniping at our fellows? You may as well go into your garden and holler abuse at a nasturtium. In the end it's between you and God.

The NMEs were my first high-profile job and a significant breakthrough. Handled correctly these risky gigs can propel you into ever more exciting yet futile stratospheres of success. My career has certainly been expedited by three notably tricky industry galas; first the NMEs, then the Brits the following year, and more recently the MTV Video Music Awards. All three events

were just beyond my reach, so were bloody difficult and combative. Good televised award shows need an element of chaos, you need to feel that at any point they could descend into a food fight or gratuitous nudity. Think of your favourite moments from ceremonies gone by – Liam Gallagher spitting, Madonna and Britney kissing, Jarvis Cocker getting his bum out at Michael Jackson, and possibly when Bob Geldof called Russell Brand a cunt.

The NME Awards were held at the Hammersmith Palais, which was also the venue for those ridiculous "School Discos" in which grown women cavort in schoolgirl uniforms and baffled paedophiles puzzle over boundaries. "Is it all a big sexy laugh or am I a demon?" they must think.

Do we humans yet properly understand the notion of the future? It doesn't seem that we do. I'll agree to almost anything as long as it's in the way-off yonder – secretly believing the allotted time will never actually arrive.

"Russell, will you castrate this pig with your molars?"

"When?"

"In February."

"February? The existence of Februaries has never been categorically proven – I'll do it!" Of course when February comes, as February must, I regret my blithe agreement and sneak off behind my vegetarianism.

My excitement on learning that Nik and I had secured the NMEs duly ripened into horror as the day drew near – it became an ordeal. The room would be chock-a-block with alcoholics and alcohol and eccentricity and egos, and everyone would be trying so hard to be so cool that our common humanity would be as relevant to the assembly as a recipe for a damn good moussaka. On an inexplicable whim the editor of *New Musical Express* (the magazine behind the ceremony), the

boyish Conor McNicholas, decided the set should resemble the inside of Dr Who's Tardis. So at one end of this flat, dank booze hall was a sci-fi set that to me seemed non sequitous and pointless and looked like it wanted the attendees to love it. The nerdy set that would be providing my backdrop made me more nervous. Staring at it with impending dread, I reflected. Life is not a postcard of life, life is essential and about detail, minutiae and trivia. Tiny anxious pangs, heartburn and stubbed toes. "There's something in my eye. My mouth tastes funny. Have I chipped my tooth?" Titchy, Prufrock facts. Not a broad sweep of a Rothko brush, but pop art dots, like Lichtenstein's.

As was my custom at that time I was with Sharon (cockney boxer, Babs Windsor laugh, Kathy Burke warmth), my stylist, Nicola (flirty young mum, everyone's nan, lickable skin, loves indiscriminately), who does my make-up, and Matt (same twerp from Chapter 1). It was necessary then as now to ensconce myself in familiarity, estuary accents, working-class values, because after all, it's all just a bit of a fuckin' laugh, all this, innit? You don't wanna take life too seriously. If you don't laugh you'll fuckin' cry. I need that kind of attitude around me as I approach the stage, because within it's all Mozart's Requiem for Death and livid Francis Bacon pinks. I lay charred birds at Tiresias's feet as I stare down at the beast. I need ritual. Theatre was born of ritual, religion was born of ritual. If I should die think only this of me, "I thought it would be funny."

The yips, the condition that afflicts darts players and golfers, is the inability to let go of the dart or to take the final putt. Darts players before throwing the dart see a line leading from the tip of their arrow to the treble twenty or the bullseye. (As a child I always thought of the bullseye as more important, as it's got a better name. When I discovered treble twenty's superiority

I thought, "The dog out of *Oliver* is not called treble twenty, it's called Bullseye." It's a good name and an evocative image, the eye of the bull. Treble twenty is just arithmetic.) The perfect visualisation of that line sometimes makes it difficult for them to relinquish the dart and I understand that. It's acknowledging the point at which you interface with reality. Most sports are reactive, interactive, a giddy blur of controlled chaos like football or boxing, you against a swirl of oppositional energy. But the dartboard is never going to come hurtling towards you and slap you round the chops, so unless you seduce it, unless you part the thighs of the oche and make that move, nothing's going to happen. Ritual is necessary to cope with that obligation.

At the time of the NMEs I began to accumulate the people, the things and ideas that I need to succeed. Sometimes I have cause to reflect, as I walk out in front of 5,000 people or host a big event, "Fucking hell, it is still just me in a toilet," the same as it was the first time I went on to a stage at Grays Comprehensive School to chubbily inhabit Fat Sam in *Bugsy Malone*. Then as now, my bowel having loosened, my heart palpitates faster until eventually my mind moves into alignment and focus.

Now I've conducted that ceremony in thousands of toilets to ever-growing numbers of people, but ultimately it's for the same purpose of motivating myself into a position where I can legitimately ask things to go well because I'm in tune with something higher.

Often when I'm nervous before a show people will say, "Why are you worried? What's the worst that can happen?" The reason I'm nervous is that I think something unlikely, implausible but utterly awful will happen. The sort of thing that happens to me quite often. Sufficiently often for me to accept the necessity of rigorous preparation. Something, in fact, like this.

It was a good script that me and Matt knocked up, funny, with good jokes. The New York band the Strokes were there: "Oh, my nan had a stroke, I think that's what killed her – what was Julian Casablancas thinking? She was ninety years old! And she was a lesbian!" Actually my nan did have a stroke and it was that that killed her. She wasn't a lesbian though.

Jokes of that calibre kept the room entertained, and one must always remember to play to the millions of TV viewers in addition to those present. Even if the musicians are chatting among themselves and wheezing merry pepper up their hooters, the people at home are probably watching politely. I was already mates with the impeccably English and mindlessly attractive Carl Barât, formerly of the Libertines and at that time with Dirty Pretty Things, so I wasn't totally adrift socially. What's more, I had spent the previous ten years taking enough drugs to put most of those present into nappies, so I could connect on that level. I was no stranger, either, to live acts of reckless self-destruction, so was unperturbed when the lead singer of the band Cribs sharded himself up, real horrorshow, on a table full of glasses he'd Iggy Popped himself on to. I was prepared for almost anything. Including being dubbed a cunt by a saint.

When Bob Geldof calls you a cunt, speaking from experience, it is difficult because Bob Geldof comes with cultural baggage, mostly favourable. We're all aware of Bob Geldof and all the wonderful things he's done. Bob Geldof had been ever present in my own life as a benevolent, indignant narrator of the story of the possibility for positive change. So as he strolled to the pulpit, beckoned by Bono on VT, in my mind a different film played.

Cut to – 1984 Wembley Stadium, Bob Geldof louchely bounds with stern purpose on to the stage; at home in Grays,

Essex, the nine-year-old Russell Brand sits in the square-eyed danger zone staring lovingly at the hobo-knight. "When I grow up I'd like to be just like brave Sir Bob," he thinks. "Give me the fookin' money *NOW*," growls his on-screen hero. What a wonderful man. Having saved the world, Bob, by now canonised, settles down and has three beautiful daughters with names that many condemn as indulgent but that young Russell thinks are original and poetic. "You leave him be," he chides his friends. "That man saved the world." When Bob's wife Paula Yates tragically dies after the death of her new partner, Michael Hutchence, the teenage Russell notes with teary eyes that Bob took on the daughter the doomed lovers had subsequently borne. "Truly he is the lamb of God."

"And here he is," thinks contemporary Russell as wise Sir Bob mounts the stage. "At last I can meet this great man and tell him of his influence and of the hope he's given me over the years." As his hero passes, Russell scarcely dares to touch his hand but obediently gives him his deserved reward for NME's kindest, nicest man of the year.

"Russell Brand, what a cunt."

Oh. That's not very nice. Perhaps my mind is broken. I look to Matt in the wings, whose face confirms two things: yes, that actually happened, and yes, your mind is broken. But it is not a mind entirely without merits. Earlier in the day while finalising the script, by which I mean writing it, for nothing is ever written until it absolutely cannot be avoided, I said to Matt that I was worried about Bob Geldof.

"Why? What for? He'll be alright," said Matt.

"I've just got a feeling that he could be confrontational," I said. It was not entirely a male version of women's intuition – my fear was ignited by provocative elements of our script.

When me and Matt write scripts our minds depart, our better judgement takes a hike and our combined rudeness struts in with a hard-on and drizzles out what it considers to be funny but is actually offensive – usually to someone important. It did it at the NMEs (Bob Geldof), it did it at the Brits (the Queen) and it did it at the MTV VMA awards (George W. Bush). I'll tell you how we erred at these subsequent events in good time, but for now here's my forensic analysis of what may've got up Bob's nose.

1. I called him "Sir Bobby Gandalf".
2. I threw to a VT of his close friend Bono with the line, "Here's Bono, live from a satellite orbiting his own ego." Maybe that antagonised him.
3. And finally there was this link to bring him to the stage: "The winner of Best DVD is Bob Geldof. My best DVD is Big Natural Tits 10, in a welcome return to form after the lazy and derivative Big Natural Tits 8 and 9. Of course we ain't really captured the glory days of Big Natural Tits 1 and 2 – don't be ridiculous – but all this is academic because the Big Natural Tits series has been overlooked. Again. Here's Sir Bobby Gandalf!"

The moment.

At our script meeting I reasoned with Matty Morgs thusly – "That Gandalf stuff and all this rhubarb about boobs will antagonise him" (although they really are spectacular films), but Matt said, "No, he won't say nothing, he'll be flattered."

"He won't be flattered, Matt, he'll be incensed."

I presumed his response would be "There's only one big natural tit here" – then, turning to point at me, "that prick". As it transpired, Sir Bob was much more linguistically efficient.

As my gung-ho writing partner and I discussed the likelihood of a tit-for-tat reprisal from Sir Bob, an incredible thing happened. Occasionally as a comic, a line will appear as if in a dream, perfect, celestial, fully formed. The line I'm about to recite emerged from the mists of my troubled mind like Excalibur. Matt was still busily assuring me that the world's most notoriously outspoken man would tolerate my childish teasing like a big soppy ol' sheepdog when I, suddenly St Paul, all smug with epiphany, said, "If he does coat me off I shall simply reply: *No wonder Bob Geldof's such an expert on famine. He's been dining out on 'I Don't Like Mondays' for thirty years.*" Matt has never been one to dole out praise profligately; he responded to my burbled boasts about Kate Moss with the immortal "Her? She's a bit thin, ain't she?" – but now he was suitably awed.

"Fucking hell, that's brilliant."

"I know, my son," I said all holy. "Shall we put it into his intro?"

"No. That'd be overkill. But it's nice to know it's there if you need it. It's security – like Clint Eastwood's Magnum."

"Russell Brand, what a cunt." It felt like the nice man from Live Aid, the man who'd single-handedly saved Africa, had speared me through the decades. I felt like a bullied nine-year-old, hurt and defenceless. Well, you may've fed the world but you just broke my

heart, Geldof. I was eviscerated, up there. I stood at the side of the stage, white and silent with no recourse. Except I had *that line*.

But Bob Geldof is a hero, revered by millions, the perfect apotheosis of modern philanthropy, a great father, a rebel who stayed true and kept on sticking it to the man even after he made it. Who took his fame and money and power and did something truly worthwhile. There's no way I can hit back at Bob Geldof. Can I? He did just call me a cunt. On the telly. In front of my mum. What a quandary! My personal pride has been attacked, but by a great man. He has shot me down like a hangdog gunslinger riding a young pretender out of town. Except, I do have that line.

I don't know what to do. Bob's over at the pulpit giving his speech and I'm welded to the spot, still trapped in the moment where his curse pierced my flesh. I look over. I can't hear what he's saying, only my mind ticking. "Shall I say that line?" it asks. I can't see the audience, only the glare and Bob's great past and my mum at home on her sofa with her cat holding a mug, stung. Maybe she's crying. I don't know what to do. I'm up there alone, my first big gig and an international human rights campaigner has just dug me out. Do I fight back? Can I use the line?

Then I remember Matt. He's in the wings. Slowly, so slowly the audience and Bob don't notice, I turn my head. There's Matt, and like me he's motionless. He looks proper pissed off. We lock eyes. Me and Matt are mates. We've been through some capers. I've dragged him through brothels and made him score me smack. We've been in gruesome threesomes and nasty rows. Across the floor and through the silence Matt hears the wordless question.

"Shall I, mate?"

Slowly and with no trace of doubt Matt nods.

I turn. Take aim. And fire.

Now it's Sir Bob's turn to reel with stinging shame, the philanthropic Goliath felled by a wise guy slingshot. I don't get too many opportunities in life to look cool. But in this moment I was an assassin. Now the rest of the show should be a doddle. There is, however, a further challenge. Shaun Ryder, the legendary front man and doomed genius who fronted the Happy Mondays, had been up to collect an award and was a bit "the worse for wear".

He was as "worse for wear as a newt". He was "worse for weared" out of his fucking mind. I admire Shaun, he is the Queen Mother of junkies, but later in the script we had a reference to him, which was funny but, after seeing him looking a bit vulnerable, was now inappropriate and defunct. I don't get a kick from upsetting people or joking about people who are vulnerable – there have been famous occasions where I've had lapses, but they were mistakes and I urge you to stay tuned for the justification. After an emotionally exhausting night, with which I was coping, with the end just in sight I stood at the podium relieved it was almost over, when I noticed the offending joke on the teleprompter.

"NOOOoooo! Shaun Ryder is the punchline of the final joke!"

I ran over to the side of the stage.

"Matt, fucking hell! We can't write another joke. We'll have to change the name for this to work."

Jesus Christ. The joke is this: *Jo Whiley is a woman who insists on breastfeeding her children.* (That's the set-up.) *Curiously she considers all homeless people her children.* (That's the introduction of a comical idea.) *Earlier today security had to physically prevent her from putting her booby in Shaun Ryder's mouth.* (Punchline.) A bit daft, yes, but as an intro to the lovely Jo

Whiley, who's about to walk on, it works. Or did till Shaun Ryder turned up all drunk and in need of compassion. For this joke to work we have to replace his name, we have to find someone. Somewhere in this room. Who we don't mind offending. Who looks like they might be homeless ... Bob Geldof.

It was a tough night but an educational one that gave me experience that would prove invaluable in the coming years. I learned never to say anything controversial at awards ceremonies ever again.

Under any circumstances.

Unless I was absolutely certain that it was funny.

Chapter 3
BIG BROTHER'S BIG RISK

Blundersome TV producer and cohort Gareth Roy does a very good impression of my orgasm, having once overheard me dispensing with some effluvia with a couple of young people lit only by the tangerine sea of twinkling LA street lanterns, that make the Hollywood Hills so desirable a residence, and the unnecessary front room gas fire, which also drenched the contorted nude forms in naughty orange. His interpretation sounds a bit like Fred Flintstone launching into his "Yabba-dabba-doo" catchphrase then having a stroke half-way through it – "Yabaa-dadArR$%@!@*ahhhhhh- OOooh". Wilma is hysterical: "Barney, call an ambulance – made of dinosaur bones. We need a historically inaccurate solution to this comically Neanderthal problem."

Whilst Gareth may mock my rather fanciful sex celebrations, considering them no doubt to be over-blown Cristiano Ronaldo-style tricks, the women involved seem to like them. And why not? I myself like nothing more than a great big

operatic bit of showboating from my partners when it comes to a climax, so why wouldn't they be the same? I think it must be rather unrewarding for a woman if at the climax of the act some nervous nelly of an Englishman like Gareth drizzles out a teaspoon of cock-porridge without a whimper, perhaps palming over a clammy docket bearing the words "Many thanks, miss, I've just done a cum." Give me the razzamatazz of my Russell Brand, brass band orgasmo-spectaculars any day, any day, any day.

Before I ejaculate I'm a fervid, febrile mass of sexual energy. I'll do anything, I'm demonically sexy. After I cum I'm a guilty little berk in a sweaty tank top. "Good heavens, Mother, what have I done?" I wonder why the chemical change is so dramatic?

Using what I've gleaned about evolutionary psychology from Richard Dawkins and the Flintstones, the post-ejaculatory crash is to prevent Fred roaring off out of the cave the second he's spunked up, smashing that dimwit Barney in the throat and popping something messy up Betty's loincloth. God that sentence turned me on. I'm going to have to go on a course that addresses the growing problem of w-ank-imation.

I do at least give my squandered ejaculant a dignified mourning. Picture the funeral of ten million sperm, a congregation of grief-drunk mourners yelping and shrieking, sticking their fingers up their arses – a sepulchral carnival, a festival of mournography.

I am sentimentally attached to my fluids in an "Every sperm is sacred", Catholic, Pythonesque fashion (Pythons themselves loathe that adjective, so apologies, dear heroes). Perhaps it's my age, but each kinky cell seems like an opportunity for life. There are church posters that bear the hyperbolic inscription "You're one in twenty million" – each one of us is a lottery winner before we subdivide, the product of the fastest, strongest sperm. And that applies to proper little weeds like myself, not just Jesse

Owens or Michael Flatley. Whether the sperm riverdanced out of the testes or crawled out on its belly, we're all champions.

I cherish and exalt these moments of sexual bliss, because but for them my life would be an unpunctuated scroll of unremarkable sludge. I'm not given to fist-pumping displays of triumph in my daytime activities – even when they may be warranted – so these nocturnal displays are prized.

When I was informed that I'd got the job hosting *Big Brother's Big Mouth* – which changed my life and rescued me from the post-rehab routine of brittle bike rides and underpaid stand-up – I did not cleave the sky like Jimi Hendrix or Thor, I said simply, "That's good. Thanks."

The relationship between the British tabloid press and *Big Brother* is fascinating. They need yet devour each other, like Duncan's horses in *Macbeth*, which similarly is a forebear of the apocalypse. Without the tabloid interest, it wouldn't be the phenomenon it is. In America, where it is denied the tabloid fanfare, *Big Brother* is an also-ran TV show. A pertinent indication of the distinctions in national character is that in America *Survivor*, where contestants are stranded on an island and forced to do battle with the elements or be destroyed, is a must-see programme among the descendants of the pioneers. But in England we are drawn to a show where people seldom stray from stifling domesticity and the most incendiary conflagration is likely to be an altercation over the last teacake.

The concept of *Big Brother* is: twelve or so normal folk live in a camera-saturated house for several months and are voted out by the viewers according to their whims and the way the "housemates" have been edited.

It is titled in tribute to the dystopian Orwellian prediction that in the future we will be observed at all times. The fact that

Big Brother can rise to such cultural prominence without its audience acknowledging the source novel, *1984*, is one of the show's greatest achievements – similar credit must go to the programme *Room 101* for ignoring the titular implications of their show. In Orwell's novel, Room 101 is not a receptacle in which to glibly discard pop-cultural trinkets, but the setting for each individual's personal hell.

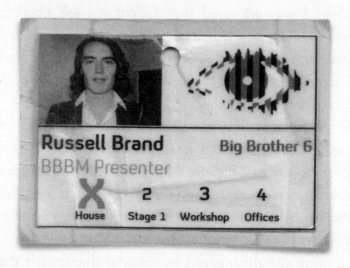

It's very exciting to work on *Big Brother* in the UK precisely because of the relationship it has with the national press. Every year there is a scandal of some kind, usually trumped up by the ravenous media but often interesting regardless, particularly if you're me in 2005 and about to embark on a career in which scandal is a key component. My time working on the show forewarned me of the appetite in the British media for salacious tales and the famed maxim that the truth will never get in the way of a good story.

The first scandal came about on the very first series I worked on, which was *Big Brother 5*. One of the genuinely intriguing aspects of the show is the social disparity between the

housemates and the conflict that can elicit. In the house that year were Victor, a south London gangsta, his chum Jason, a Scottish bouncer, a Portuguese pre-op transsexual – eventual winner Nadia – a couple of gay lads and a few women with remarkable boobs, notably Makosi, of whom more later.

I worked on the show for three years, which encompassed seven seasons. Each one had a scandal which drenched the British papers and several which went international. The debut scandal was built around a violent confrontation between Jason and one of the gays, Marco, who Jason – brilliantly – had accused of taunting him with "a dance of disrespect". The phrase has stayed with me, as Jason used it as if it were culturally loaded, like it was his own personal N-word. As if his people had been taunted by dances of disrespect from time immemorial by despised oppressors across the border. "At the battle of Culloden the hated British troops mocked their brave Celtic captives with a sickening dance of disrespect in which they camply jiggled their pert little bum-bums at the manacled Scots."

This daft provocation led to an unbroadcastable brawl that was fucking brilliant to watch – the house boiled over into a riot of slamming doors and screams, cameras couldn't keep up with the action, it was like watching CCTV footage of a 3am liquor store robbery. It was the actualisation of the unspoken incentive for watching the whole damn shebang – you wanna see 'em fight and fuck. It was primal and exciting and obviously too good to go on telly in an unedited form. I got to watch a pre-sanitised version which they sent to my flat so that I could write jokes about it. When an executive producer realised that this sensitive material had been allowed out of the Elstree studios where the show was made he rightly flipped. "What!! That new presenter, ex-junky lunatic, who had to sign a special

contract with a 'sack on sight of substance abuse' clause, is in possession of a tape that could get the whole show cancelled??!! Get it back NOW!!"

Tiptoeing around my perspective on the footage and hoping to discover what I might likely say, Shed, an exec from the channel and a lovely quirky bloke, asked me what I thought. "It was amazing," I blurted, "like when it kicks off on the terraces at football or at a protest and chaos reigns supreme and your blood surges and your gut churns. Also it calls to mind the wise words of the World War One general who said, 'You cannot rouse the animal in man then expect it to be put aside at will' – I loved it." He paused. "Could you not say anything like that on tonight's show, please?" he said firmly.

He needn't have worried – when the show began I was a tentative little worm in distressed T-shirt and pumps. I'd yet to transmute into the spiky, lacquered Jack Frost sex sprite that would soon, after a princess's kiss, a saint's curse and a chat show godfather's approving nod, adorn the tabloids like a *Big Brother* winner. I was still but a squirt sat behind a desk all neat and meek.

The show evolved in time, due to the recruitment of two very funny men, Mark Lucey (Irish blood, QPR heart, all sensitive with a sixth sense of humour, like most people I love) and Ian Coyle (giant Elvis Costello, scouse and dour yet suddenly lachrymose). They infused the show with a Reeves and Mortimer-type joy and with me created some of digital TV's most memorable catchphrases.

Distinctive and puerile idioms sprung up that assisted us in making a show that went out live and was on five nights a week. Under those conditions you need to evolve a structure and a grammar or it'd never get made. We were fortunate in

that we were in tune with an appetite to see the by now huge, phenomenal show undermined from within. We didn't view the main show with disdain but saw in the minutiae of the disputes and tiny travesties endless domestic humour.

Big Brother was always a rich source of comedy for us. Every day something ridiculous would occur and, over the period we worked together, there were events and characters that made a monumental impact: Kinga, who publicly masturbated with a wine bottle, Pete, the Tourette's sufferer and unlikely heart-throb, the romance of Preston and Chantelle ... But *Big Brother* also spawned an icon of such magnitude that she rocketed from the confines of the house and its transient, scratch-and-sniff celebrity and into true stardom – Jade Goody.

When my mum first got cancer I must've been around six years old, the age Jade's eldest son is now. Too young, in fact, to properly comprehend what was happening, but old enough to sense the tingling presence of fear, the averted looks, the stifled, thin-lipped sympathy and muddled, neighbourly compassion. My mum, thank God, did not die, and whilst her cancer returned several times, each time more frightening for me as my innocence waned, to be replaced with dread, she lives still, so I can but imagine the sad confusion of the two bereaved boys.

I knew their mother, Jade Goody, not especially well, but Jade's defining characteristic was her easy warmth that ingenuously enveloped folk, so perhaps like many people I felt more engaged by her than normal and feel more saddened by her death than I ought. I dislike the fetishisation of grief that accompanied the death of Jade's forebear, the Princess of Wales – it makes me uncomfortable, as I query its sincerity. Sentimentality is often called the unearned emotion, and intrusive carnivals of public mourning unsettle me. In the case

of Jade Goody, however, it is understandable to feel morose: she was a young mum from an awful background who got a break and shrewdly capitalised on it.

For a time she and I shared management, and we met when she came to see several shows of mine at the Edinburgh Festival about five years ago. We all hung out, me, my mum, Jade, some people from the agency and a few of my mates. She was a right laugh, she joined in with everyone and created a garrulous, giddy vibe in bars and cars that elevated the perfunctory time between shows into something which retrospectively seems more special now than it did then. Most of all, though, I was impressed with how she formed an immediate and genuinely sweet bond with my mother, chuckling and chatting with the effortless intimacy that strong yet tender women frequently conjure and which has umbrella'd me from anxiety throughout my life. She also came on a few of my dopey TV shows in later years, where she filled the room with her ebullience and wicked laugh, connecting with the audience in a way that most skilled showmen can only dream of.

One of the charges often levelled at Jade was that she was just a normal girl with no trade or practised skills. Well, people didn't care, and our heroes are not prescribed to us, we have the right to choose them and the people chose Jade. Fame has long been bequeathed by virtue of wealth and birth, and this was the first generation where it was democratically distributed by that most lowbrow of modern phenomena – reality television. She was a person who, I think due to her class, always had the propensity to irk people. When *Big Brother 3* made her famous she was vilified in the papers and bullied in the house, but through her spirit she won people back round and became a kind of Primark Princess with perfumes and fitness videos and

endless media coverage – because people were interested in her. They remain interested. Nicola, a woman in her mid twenties, is genuinely heartbroken at the death of Jade. Herself a mother from a working-class background, she obviously connects with this sad narrative in a way that she doesn't seem to with J.Lo or Jennifer Aniston or Posh Spice, most likely because of Jade's authenticity and accessibility.

I was uniquely situated when Jade returned to the house and through unschooled social clumsiness blundered into a whooped-up race row. As I said at the time, the incident where the Indian actress Shilpa Shetty was poorly treated by a group of young women was not an example of the sickening scourge of racism but simply a daft lack of education. Jade was a tough girl but utterly lacking in the malice upon which true prejudice depends. The real crime was the slick of spilled newspaper ink and the cathode-conveyed H-bomb that followed this innocuous event. Jade was made the focus of a debilitating wave of righteous loathing and condemnation, a gleefully indignant storm of trumped-up wrath that served the cause of racial harmony not one iota; but that was never its intention. The intention was sacrifice. Well, now Jade Goody is no more – claimed by cancer, a disease often brought on by extreme stress. When my mother was sick, someone unkindly informed me that her illness was my fault, induced by my bad behaviour, and for a long time I believed it.

I'm glad that Jade's death was handled with saccharine mittens by the papers. She lived and died in the glare of their interest and doubtless benefited from it hugely at times. I recall her tearstained face pegged across some rag as she endlessly sought to be forgiven by the media whom her misconstrued conduct had so incensed. It made me a little angry. She wanted

to be accepted, loved, redeemed – and now, through her early death, she is. I hope some of the lessons of this modern fairy tale are learned, that the people who aspire to be like Jade observe the price she paid. I hope her sons are OK and that, on some imperceptible level, contrition is felt by the media that gave Jade Goody everything. And I mean everything.

Jade wasn't the only contestant I became involved with. I had what I like to refer to as office romances with several housemates. These trysts were inevitable given that my waking life was spent working on that show, which meant I was forever gazing at them on screen and thinking about them or discussing them with Mark and Ian or Nicola.

I met Nicola on *Big Brother* when the regular make-up lady got pregnant and Nicola was rushed in as a replacement. I didn't get the original lady pregnant – just to be clear, she was married and in a loving relationship, it had nothing to do with me. Although, not long after starting work with me Nicola, too, was gestating a person in her belly. I adored Nicola instantly, she was incredibly maternal even before she turned her uterus into a bastard factory (literally, she's not married). Her presence immediately relaxes me. She reminds me of where I'm from and of what's real and important, she smells clean and laughs dirty. Her hair is all reflective like a shimmering chocolate lake and even when she pulls my quiff a bit or gets mascara in my eye I know she loves me. The four of us, Nicola, Mark, Ian and me, would sit in my fart-ridden dressing-room (I think it was nerves, she hardly ever does it now) and laugh about the show.

Once in a while I'd get a crush on a housemate and it would really add to the excitement of the show, knowing they'd soon be out, all pie-eyed from the flashbulbs, and I'd be there with

my hair combed and a bunch of daffodils. I didn't have affairs with that many housemates; as a percentage it'd barely register, but there were a few and it was bloody brilliant. It was like watching Indiana Jones on telly, then looking out the window on to the patio to see him out there cracking his whip, with his top off and his big, gorgeous brown boobs all jiggling about.

The most reported of my affairs was with Makosi, because I believe she spoke to the papers. Well, kiss and tells have never especially bothered me as I am lucky in my vanilla sexuality. I'm not into anything weird, I just love girls. That woman was delicious, she could've kissed and told about the darkest corners of my soul and I'd've simply raised a glass to her gold medal knockers and Venusian bum. She was lovely. All the better for having seemingly crept out of my TV set at nightfall and brought my dreams pulsating into reality.

For a fella who was a bit of a chubby nitwit at school, the status I was afforded at this new institution was like a late graduation party. Many of the *Big Brother* housemates were hapless goons, but a considerable number were bloody easy on the eyehole and now, looking back, I realise I was lucky. Really lucky to have had such a fun job with such lovely companions and such gorgeous people to flirt with. The show became increasingly successful, ratings grew, and childhood comic idols like Bob Mortimer, David Baddiel and Frank Skinner would tune in, which made me feel sanctioned. My stand-up grew from regular "circuit gigs" above pubs to extravagant cabarets with screaming girls and blokes demanding I repeat my daft catchphrases – "Ballbags, you swine! I pulled down my trousers and pants …" See? Daft. E4, the digital channel we were on, offered me new shows, as did other channels. Lesley Douglas, Controller of the world's biggest radio station BBC Radio 2 as well as its titchy,

digital sibling BBC 6 Music, offered me a show on the latter, and MTV, the station I'd been hurled out of in controversy and disgrace as a worthless junky a few years earlier, came back with the amazing offer of a sexy chat show.

Nicola I kidnapped to install in my ever-growing surrogate family. One way or another I felt kind of isolated as a kid, and consequently as an adult, or tall child or whatever it is I am, I've been team building like Brian Clough. Animals, children and the working class comprise the company in which I'll feel most at ease. I suppose then I should look for a combination of those attributes, buy a caravan and settle down. Though half an hour in bed with a pitbull puppy would be most disconcerting. As my friends grow older (whilst I curiously remain Pan-frozen) there are more children in my life. John Rogers, my invaluable moral barometer and good-humoured collaborator, has a pair of sons that I adore and with whom I can retreat for hours into lies and whimsy, lost in the boundless lunacy of their impulses and thoughts. Oliver, the oldest, is seven now and studious, and quizzes more thoroughly my assertions about unseen pixie kingdoms that thrive unseen beneath the Leytonstone streets. Joey, who is four and a half, has a bazooka mind that shells the world with scenarios and commands that would see an adult condemned to Bedlam. The last time I saw him he told me he wanted me to eat his heart, smiling as he spoke with twinkling wonder. And Nicola has since kicked out her belly squatter, Minnie, a delicate, tiny fairy charwoman.

After a recent work lunch at which most of my misfit tribe were in attendance, John Noel, the terrifying anti-hero of my first book, said as he left the table, "You've built a family for yourself there, Russell, the family you've always wanted." Then, strolling towards the restaurant door, he added in the

thick Manchester accent he has bequeathed to his eldest, Nik, "Bunch of fuckin' weirdos, but a family."

It was not only Nicola who was pregnant at work. I too was up the duff with a ghoulish tummy brood. Inside my gut hummed a chimera. A monstrous amalgamation of glam-rock icons and cartoon characters gestated in my womb. As *Big Brother*'s popularity grew, the delivery of this beast became imminent. Eventually it burst forth – devouring me whole as I bore it – this spindly liquorice man, this sex-crazed linguistic bolt of tricks and tics and kohl-eyed winks. Clad in black like a hangman or highwayman with dagger boots and hurricane hair came my creation. An organic construction sufficiently macabre to contend with the chemical warfare of modern fame, and though this monster bore my name he did not resemble the delicate schoolboy or battered addict that preceded him – no, this creature was ready.

Chapter 4
ENTER SANDMAN

I arrived on set at *1 Leicester Square*, the MTV chat show vehicle created for me, fully formed. The junky they formerly employed had died, predictably, at twenty-seven. Now, thanks to *Big Brother* and John Noel, I was employable. John, our fierce patriarch and himself no stranger to madness, had bullied me into the *Big Mouth* job, and he used his unreasonable force to get me a very good deal at MTV. I don't mean financially, though it might've been, as I tend not to ask about money, I simply trust that John, and latterly his son Nik, know what they're doing. What was more important to me on my prodigal return to MTV was control. I wanted Nicola and Sharon with me, Sharon who bejewels me, and gobs at me, and keeps me giggling. And I wanted to write the show with Matt. Matt didn't work on *Big Mouth* — he wasn't needed, the show was fast and flighty and with Mark and Ian on board it was functioning. This new show, though, on MTV, where me and Matt had met, from where I'd been fired for dressing as Osama bin Laden on 12 September and running with crack and smack as

my "dual fuels", this was the kind of "on the edge", digital stab of madness where me and Matt could flourish.

We were to be joined by a new oddball, the show's handsome series producer Gareth Roy. I've mentioned Gareth already, mostly in his capacity as a twerp – well, that is largely defining but he does have a job as well. He is a creative producer, and *1 Leicester Square* was where I met him. You'd never know at a glance that this Hull City-supporting hunk is a French hornist, and likely you wouldn't care, I mention it only because the introverted nerdiness required to master a wind instrument is in evidence every time he opens his mouth. MTV, as you know, is cool. It is cool above all else, its graphics, its shows, its attitude, its brand are all about coolness, so the fact that their cool new flagship chat show ended up being hosted by a twit, written by a berk and produced by a prat is worthy of note.

Gareth has qualities, of course, he's funny and silly and understands TV, he's sweet and thoughtful and charming and a fine writer. What he ain't is cool. None of us are. Yet, somehow, the show was. So MTV must know what they're doing. *1 Leicester Square* had a beautiful set, trash burlesque, pink chandeliers and leopard-skin chaises longues. Again, cool.

Geographically it was a nightclub space above, as the name would suggest, 1 Leicester Square in the West End of London, causing friend, comedian, quiz show smartarse and pilot episode guest Simon Amstell to memorably say, "*1 Leicester Square?* It sounds so glamorous. Number 2 Leicester Square is an Angus Steak House." We cut that from the show; the guests are not encouraged to have better lines than me. We didn't, it stayed in. It was only a pilot.

Nik Linnen, my manager, John Noel's eldest, made an early foray into the perspicacity that would soon make him my

partner and move his magical, volatile father into an "upstairs role" (where our more frequent and ultimately loving clashes of character would be curtailed) when he observed that whilst, in the UK, MTV is an obscure satellite channel, in the US it is an institution; meaning the standard of guests the show would attract would be unusually high. He also reasoned that if I met Hollywood movie stars there would be an opportunity for me to impress them – and "Who knows what that might lead to?" This was a shrewd judgement. A few years earlier making a decision that hinged upon me impressing movie stars would be evidence that you ought be offered a residency in "everyone's favourite nuthouse" – Broadmoor – but now, a few years clean, my ambition gleaming, surrounded by a good team and with a lovely new hairdo, the proposition was prudent.

1 Leicester Square was, indeed, "where the stars came out to play". Well, maybe not to "play", but to promote their movies and products and contend with some very unusual questions. With enough insanity in me to keep me amusing but not enough to get me banged up, the shows had a lovely vibe. With guests including Tom Cruise, Jamie Foxx, Christina Aguilera, Will Ferrell and Jack Black, it was an embarrassingly rich canvas upon which to jizz up some lunacy.

When Will Ferrell came on, who I think may have been the funniest guest, I asked this question, written by Matt:

"Will. You said your wife has got a big head. If you could make a pact with the devil where your wife's head would get bigger but it would make you the biggest star in the world, would you accept the pact?"

He reflected, mock-squirmed, then said, "Yes, I would accept the pact."

The next question was, "What if every time it got bigger it caused your wife pain? Would you still accept this pact?"

Will looked at me like we were in a cat-and-mouse court-room drama. "Yeah, I would. Damn you," he grimaced.

Then I called Will Ferrell a cunt whilst playing the part of a cockney mugger in an improvised sketch, and you could see his face change. Will Ferrell, reflecting instantly on the differences between UK MTV and US MTV, made a judgement on me as a comedic adversary, then, with childlike relish, he called me a cunt. It was truly an honour.

Jack Black came on with his Tenacious D partner, Kyle Gass. Jack Black, as is all too apparent, is a joy. Ebullient, wild-eyed and sweet. The commodity we buy into when watching his films is tangible when you meet him. The pair of them were a right laugh. They ambled on in Paddington Bear duffle-coats and were twinkly and polite. It was Jack's coat, however, that caught the attention of Gareth Roy. So enamoured was he of this unremarkable garment that it lodged in his peculiar mind, where it remained untroubled for two years straight, only to come gurgling out as a senseless faux pas when Jack Black once more entered our company.

Understandably I was nervous. I was backstage at the *David Letterman Show*, perhaps the most challenging talk show in the States because Letterman is so laconic a foe. If you displease him he'll lazily bring you down like a lame antelope. I was mulling over such matters in my dressing-room, surrounded by now with a good team of trusted, highly professional col-leagues – Nicola (Aunty Make-Up), Nik, Jack Bayles (Essex, sharp-dressing, quick-mind, West Ham fan), Ian Coburn (long-time promoter, harsh voice, as if sourced from a *Beverly Hills Cop* laugh) and Gareth. Ian's measured drone draws me

from my preparatory musing. "Russell, Jack Black is outside. He wants to pop in and say hello. What shall I tell him?"

Obviously Ian is being polite. If Jack Black is at the door, there is but one response: to welcome Jack and douse him in glucosey adulation. Duly Ian fetches him. Jack enters, unassuming and garrulous. I stand and greet him. One of the peculiarities of meeting famous people is the tendency to bend established protocols to accommodate them. For example under usual circumstances I'd introduce a newcomer to the group to all present with a cursory namecheck and nod. With a famous person you tend to eschew this ritual. Presuming they spend their lives encountering new people they'll never see again, you spare them the rigmarole of all that ceremony and just say, "Jack Black – these are my mates." If there were just one or two you might do names, but more than that it starts to feel tricky. Maybe Gareth felt short-changed by this slight, I don't know. All I can tell you with certainty is while Jack Black offered up all manner of heart-stopping flattery – about my performance hosting the MTV VMA awards, and my turn as Aldous Snow in the film *Forgetting Sarah Marshall* – Gareth Roy was providing a metronomic beat beneath the conversation, contrived from the Rainman-ish observation that Jack Black was wearing the same coat.

"Man, I gotta congratulate ya – you did a swell job out there …"

Tick-tocking along under the compliment I can hear Gareth, chewing his way through a thought, like a mouse gnawing electric cable. "He's wore that jacket on *1 Leicester Square*."

I try to meet Gareth's eye, but it is trained on the jacket, a jacket upon which he is so fixated that had it been heroically returning from Vietnam, his interest might still've been thought excessive.

"Jack Black's got the same jacket on. Same buttons, same hood. Same jacket."

Jack, ever the professional, ignores the tinnitus of Gareth's commentary. A DVD extra that no one had selected. "It's great to see ya man."

Gareth draws nearer. "It even smells the same. Crisps. It smells of crisps."

Eventually the autistic soundtrack becomes so intrusive that I have to say, "Is that a new jacket, Jack?" A question I wouldn't have dreamed of asking had it not been necessary to subdue Gareth's Forrest Gump-ish detail fetish. If only, three months later, when editing a pre-recorded radio show I'd made with Jonathan Ross, Gareth had employed the same fastidious obsession with procedure, perhaps the BBC might not have been facing destruction. But these are thoughts for a later chapter, for now America is a long way away. We sit in the dressing-room at *1 Leicester Square* devising risible enquiries to blurt at … well, movie stars.

The best question Matt wrote was this one: guesting on the show were a composite boy band constructed for a reality TV show from members of 'N Sync and Boyzone and a boy band called 911 (which is the number for US emergency services but also looks like the numerical date for September 11th, which is pertinent to the bad taste punchline). The question was: "So, Steve, you were in Boyzone?"

"Yeah."

"Pete, you were in 'N Sync, that must have been fun, was it?"

"Yeah, yeah, it was."

"And Chris, here it says you were involved in 9/11. What on earth were you thinking?"

He looked baffled. We weren't allowed to use that.

Tom Cruise has an awareness of how he's portrayed and constantly wants to be seen as ordinary. It's one of the things that great big movie stars do, they don't want to seem antithetical, insulated, overly-privileged and completely abstracted from their audience. They need to be accessible. We were talking about the birth of his first baby. Ours was the only interview he did in the UK, so quite a coup. The world's most famous and glamorous man, smiled his ultra-violet smile and said, "Katie and I were sitting around on the kitchen floor thinking of names when—"

I interrupted: "You sat on the kitchen floor? Oooh, you should be able to afford furniture by now, Tom, watch yer 'arris, mate, you'll get terrible piles." This was a lovely, daft little moment that went some way to deflating the sycophantic tide of pink helium balloons and baby toys that inundated the studio that day.

Amazing women turned up as guests on that show. Kelly Brook, so beautiful and comely that I'd be prepared to fight any one of her consistently burly lovers for the privilege of brushing a hair from her forehead – if it was one of my own pubic hairs. Sorry. That was childish. She is beautiful and unnerving and from Rochester in Kent, dammit – which means she's normal and could handle me. Dannii Minogue further demonstrated the hitherto absent tabloid interest in me when she dubbed me a "vile predator" – the papers enjoyed that. I think during the interview I'd politely flirted, such was my remit, and Dannii had passed her condemnatory verdict on to the press. I learned that the media are a mercurial force even when meddling only in tittle-tattle. If flirting can see you adjudged a "vile predator", what language remains for murderous paedophiles? I must be aware of these

newspapers, I thought. Pink came on, she's feisty and a giggle; Christina Aguilera is a bit too perfect; I'd feel guilty if I got an erection near her.

There were an abundance of famous, glorious women and with my hair-trigger heartbreak mechanism scarcely a show ended without me scrawling a regrettable poem on to the dressing-room mirror. I still have an unsophisticated notion that women are ministers of redemption, that one day in the arms of a perfumed saviour I'll be rendered complete. Perhaps it'll be Juliette Lewis – she came on, we got on great, I thought she might be the one – or Rihanna, I foolishly pursued one of her backing dancers; had I not I could even now be sheltering beneath the umbrella (ella, ella, ella) of her perfection. Whilst *1 Leicester Square* did not provide me with a wife, it did as Nik had hoped propel me into a new realm of artistic possibility when I was "talent spotted" by one of the biggest comedy stars in history, Adam Sandler.

He came on as a guest, bringing with him, as most performers of his magnitude do, an entourage including his legendary agent, Adam Venit, some writers, Jack Giarraputo his business partner and a bunch of Teamster-looking mates. We prepared in the usual ad hoc fashion, with me fighting tooth and nail to not go and see the movie he was promoting, *Click*. Gareth had to try and persuade me to fulfil my basic, contractual obligations. "Come on, Russ. He won't come on the show if you don't watch his film. Please?"

"Why should I? What's it about? A remote control that can alter reality? It can't be done! I will not watch a film with such an unfeasible premise."

Having my own show had reawoken the prima donna in me. "Can't you watch it and then tell me what happened?"

"No, mate. His people insist."

"Can't you fast forward to tomorrow after the screening, so I don't have to watch it?" Secretly I knew I was being a ponce, so I yielded and agreed to do my job, for which I was, presumably, well paid.

When Sandler came on I was struck by how mild, pleasant, charming and unassuming he was. This caused me to briefly feel a pang for having been such a git about the screening.

"I saw your film *Click*, Mr Sandler, and if the Academy ignore it they are fools." The interview, as usual, suffered from having no real questions in it and from being conducted by a man who rather enjoyed the sound of his own voice and considered Hollywood A-listers a senseless distraction from the improvised monologue.

There's a distinction between the American character and the English character in show business. With us it's a jaunty hobby, skylarking around: "What ho! Pip pip, tally-ho, let's get some money and knock up a picture show." The Americans make films methodically, industriously. They're not overwhelmed by the "magic of the movies", it's a job. Adam Venit, Sandler's Ming the Merciless-looking agent, who also looks after Sacha Baron Cohen and Dustin Hoffman, is exemplary of this mentality. "This ain't my first rodeo, kid," he once said to me when I complimented him on his fine work. Venit later told me that before Adam came off, Sandler's entourage discussed the interview: "I wonder what Adam will make of that mouthy English oddball?" When they asked him he said, "He's great, you should sign him, he's got a future in movies." They contacted the guest booker at MTV and asked him to tell me they were interested. I knew this was monumental. I'd always believed I could be a movie star, from the first time I spoke on

stage it was my intention, but when those things materialise it punctures long-held fantasies with actual possibility and you have to make choices.

For this to happen I would have to negotiate with Nik and John and ensure cohesion without detonating Gelignite-John Noel, Nik's dad and the man who Heimliched out my bellyful of demons. He is a man whom it is unwise to cross, especially as he'd just negotiated a fantastic deal with Lesley Douglas. I was to have my own show on BBC 6 Music, and if it went well it would transfer to Radio 2. John told me that Lesley had said they'd let me do whatever I want.

Chapter 5
DIGITAL MANIPULATION

My quest for fame was so diligent and harrowing that it makes
the Knights Templar and their millennia of endeavour in pur-
suit of the Holy Grail resemble a bunch of giggly divs scrab-
bling around a city farm for Easter eggs.

For a torturous ten stretch I hobbled through a steel and
glass Hogarthian London with bandaged hands and bare feet, a
destitute vagabond, and all the while within my ragged heart an
agonised orb of white light hummed and sought its purpose.

I don't want to worry you, but this journey has never been
about *Opportunity Knocks* or a seat on *Celebrity Squares*, no. I
have a fire in me the flames of which rage further than personal
ambition. Even through the parched impecunity of my adoles-
cence and the drivel of childhood I knew beyond the burr of
words there lay a place of wonder. I feel it still, now that I have
drawn comfort in around me, snug with wealth and chance,
praise cosy, I hear yet the call of something higher. Of course
there was no way I was about to go all quiet and Trappist, tend-
ing some garden within or without until I felt appreciated. So I

quested on with jokes and shows, then telly and magazines and now films and arenas. I enjoy it but I know there's more. I feel there is something wonderful we can do together.

Once in a while, after John Noel had dragged me from the mayhem of addiction, I'd meet someone who saw possibility in me. Lesley Douglas was one such. Lesley is a powerful woman, an old-fashioned impresario who rebuilt Radio 2 in her image as a modern, fun and relevant organisation without alienating its core listeners. Her and John appear trapped in some good-natured quarrel, like bickering siblings playing swingball with Dermot O'Leary's head.

John coerced Lesley into seeing my stand-up in small venues around London. I was pleased with the work I was doing, a blend of giddy spontaneity and well-honed yarns. After seeing me for the fourth time and with the ever-growing swell of inter-est in my TV work, Lesley offered me a pilot on cool indie music station 6 Music. Initially I was paired with Karl Pilkington, Ricky Gervais's savant-ish sidekick, who is an excellent comedic foil and hugely funny in his own right. I suppose Karl main-tains the perspective of some articulate bumpkin, straight from King's Cross, casting yokel wisdom on our urban ways. Karl, though, was already well known for his work with Ricky and Steve Merchant, Ricky's writing partner, so he had already been branded. I had my own coterie of amusing mates and was double keen to create a wireless wonderland with them.

My mate Greg, known as Mr Gee, a mysterious hard-shelled, soft-centred, confectionery-obsessed south London poet who had done gigs with me in Brixton and held me back from the precipice of unwinnable drug deals several times. Then there was Trevor Lock, Cocky-Locky, an ageless philosophy graduate, a dishy square, tiny, handsome face, a thick brush of Hugh Grant

hair and an incredibly diverse, profound knowledge of alternative, indigenous, shamanistic jungle culture. He was a wise nerd. Then there was Matt and his dry, neurotic, mischievous mind, my hoppo, the commentator minstrel of my picaresque misadventures for the six years previous. Matt is like a sulky, comedically blessed liability. We have a powerful connection and a deep, annoying friendship. Like all good double-acts we are forever on the brink of never speaking again. It was to make for good radio.

We did a couple of pilots in which I designated Matt and Trev specific roles – Matt was to run the desk (that means he was in charge of the buttons and playing in tracks), while Trevor would take care of listener competitions. In truth both these roles were arbitrary, really they were there to provide me varying surfaces to bounce off, then Gee would sum it all up with a rhyme he'd write as the show was in process.

Once I read of myself, which is a habit I ought work to dispatch, that I was Britain's first digital star. This I liked. I like being the first, primary or inaugural anything, it appeals to the pioneer in me. Thank God I'm good at showing off and telling jokes, or there'd be a real risk that I'd crop up in *The Guinness Book of Records* winking into a beard of bees or a bath of beans – anything to feel the Neil Armstrong rush of stomping on virgin moon dirt. This bit of self-obsessed reflection, however, was pertinent. The *Big Brother* show was on digital TV, the MTV show likewise, and 6 Music is a digital station. This meant that the first audience I garnered had to deliberately seek me out. I wasn't splashed all over terrestrial telly or bellowing out on commercial radio, I was sequestered off at the esoteric end of the dial, learning, developing a relationship with my audience (some have argued a little too intimately), a relationship that was fortified by the convenient advent of social networking sites

like MySpace and Facebook. The 6 Music shows we did, due to some foresight from Lesley, were available on the BBC website and through iTunes as podcasts, and this is where they really flourished. The timing was perfect, a generation were learning to consume media in a new, more direct manner, and through sheer luck we were perfectly positioned to capitalise.

This piece of good fortune, however, was not then garnished with market-driven plasticity, for the show itself in content was a rambling anarchic shambles where the three of us would harp on about our daily lives and torment each other like a bunch of dopey mates on a Sunday morning – which is what we were. It wasn't a contrivance, it was legit. The only production came in the form of a few items, like competitions and the occasional (much too occasional, the station's core listeners would argue) record. The BBC would give us grown-up producers to curtail us and to massage the mayhem into something resembling radio, but I always kicked against authority, usually our stewards would buckle like substitute teachers, and we'd continue with the chaos.

For an idyllic few months, while my fame buzzed along at a manageable level – a growing audience on *Big Brother*, a devoted MTV following – the 6 Music show was free-form fun. Perfect. We had the piratical spirit of Radio Caroline, it was naughty but in harmony with its listeners who stayed in constant email contact, sending requests and enquiries and flirting with us on MySpace. Me and Matt would bully the impossibly English Trevor about his specs and tank tops and incompetence around women, me and Trev would rile Matt about his hypochondria, and the pair of them would forever try to puncture the fast-expanding bubble of my pomposity. We thrived in the slipstream, sailing up the iTunes charts till the mainstream came a-calling when Kate Moss's brief fly-over

provided a GM boost to the natural crop. When Jonathan Ross, the king of chat, the icon of proletariat triumph in the bourgeois world of television, wanted me to be a guest on his Friday night chat show.

With that appearance and the subsequent brouhaha, the merry burble beneath the radar became a jagged siren that could not be ignored. Fame seeped in through every crack, soon the radio show was sodden with references to my new and exciting life, and we went to the top of the iTunes chart, replacing Ricky Gervais's record-breaking podcasts.

I was resolutely single and suddenly women were available and I did not sip like a connoisseur, I barged through the vineyard kicking over barrels and guzzling grapes as they grew. Chianti, Bordeaux, Champagne, Thunderbirds – it's all the same to me, frenzied and famished I chewed through glass and clenched the soil.

This is the kind of conduct that the *News of the World* and *Daily Star* relish. Soon the Sunday rags oozed with tales of my misdeeds, ghosts of the past rose from their graves, slung on a négligé and sputtered up half-truths for lazy bucks.

The machinery of celebrity grinds into life with alarming pace and clarity. I was abstracted from myself, cast as Lothario and condemned for crimes of their creation. One night after a gig an attractive girl accompanied me home. Once there I assumed there might be some canoodling, instead she snooped about the place like she'd been sent to flush out a mouse. It was agreed that we'd never be wed and she cleared off. Forty-eight hours later I was astonished to see an exclusive piece in the *Sunday Mirror* in which she recounted the experience in vulgar detail. It transpired that she was an undercover journalist, UNDERCOVER! Like I was running a sweatshop, or an illegal whelk-picking operation.

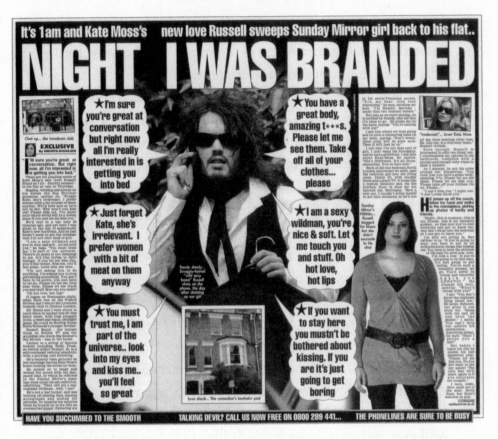

Has journalism sunk so that the practitioners of the profession of Bob Woodward and Charles Dickens are truffling out scoops by pretending to be up for bum fumble? Not to expose a terrifying circle of nonces or racists but simply to gain entry into one man's private life? Would John Pilger, to expose corruption in the developing world, turn up at the palace of some sweltering general smothered in peach lip-gloss with his quim all waxed? I should coco! He's a professional. She didn't find much of note, only observing that I had a flat-screen TV and a Jacuzzi (I had neither) and that the cat's food was in a bowl on the floor – where the hell else would it be? If you put it on the sideboard he can't reach it and if you put it on the ceiling it falls out.

A few weeks after appearing on Jonathan's chat show he invited me to his home. It was a glimpse of a possible future. His wife Jane is beautiful, doting and fun, his children are confident, polite, cheeky and balanced (that's their characters not their names, he's not that mad), and the house is a vibrant den of pets and pleasure. I saw there a chance to break the chain of dysfunction of which I was the conclusion and to which I still clung.

Could I settle with a beautiful girl who truly loved me and build something real, that would remain after the fanfare and nourish my heart like a Tuscan supper instead of surviving on instant soup and blue drinks? I could not, I was blazing through thin air, spun out on vertigo and fellatio.

At Jonathan's house, when the canine riot abates and he talks, you can see why he has become the host of a nation's Friday night. Where confidence ends some new quality is assumed that smoothes you through the evening, relaxed and entertained. Jane will once in a while roll her eyes more deftly than he'll ever roll an "R" and reminds him that he's being daft, but they both know it's thoroughly amusing. Jonathan seemingly himself selects which will be the UK's next comedy phenomenon, he did it with Vic and Bob, *Little Britain*, Ricky Gervais, *The Mighty Boosh*, and now he had chosen me. He has a fine sense of humour – not only is he funny, he also recognises it in others. He has maintained his relevance for decades and, even though he was thought of as cool and edgy when I watched him as a kid, he has now, whilst the country's most highly paid broadcaster, kept that edge and remained relevant. He is a good bloke. One night after I'd sought sanctuary at his house he gave me a lift home in some daft orange car which, had he not been driving, I'm sure he could've worn. The unfamiliar domestic

comfort I'd experienced had heightened my awareness of my teetering solitude. For a moment fame felt scary. Jonathan sensed my disease.

"How you coping with it all?"

"Yeah. It's alright. I feel bit lonely sometimes. A bit exposed."

Jonathan employed compassion. As much compassion as a millionaire entertainer in a sports car, puffing on a huge cigar, can ever be expected to show. He exhaled.

"When you get famous," he began, "they give you a lot." The millions, the car, the cigar? I wondered. "But they also take something from you." He inhaled. "And you don't ever get it back." The car then filled with smoke and Jonathan gave me a smile that suggested he'd be there for me if it ever got too tough. I didn't know just how close.

The kiss and tells ripened through the summer, and every morning paper brought a new harvest. Barely did I have a kiss that didn't entail a tell. To me though it didn't seem pejorative, it merely helped the narrative which they'd concocted, in which I was complicit, that I was a wild man Lothario. These terms were actually used – wild man, oddball, sex insect, spindle-limbed lust merchant, sex inspector; I may've invented some of them, but that was very much the tone. It suited me, though; it was a type of notoriety that I enjoyed. The more right-wing papers used me as an icon of moral decline. In the *Daily Mail* I was second only to immigrants and paedophiles as the most dangerous entity to have breached our shores. "Lock up your daughters," they bawled. If, when you encounter that kind of hysteria, you're viewing it through a lens of agonised memories of discontent and rejection, it kind of feels like approval. Bruce Dessau, a respected comedy critic, interviewed me for a proper paper and said, "You realise you're a phenomenon, don't

you?" I genuinely didn't. I'd noticed now that my lifelong self-obsession seemed to have crept into a consciousness beyond my skull. But as my life has been a devotional pursuit of success, its arrival is only noticeable piecemeal, or when an icon appeared upon the horizon.

"Noel Gallagher was here asking for you," said the ecstatic barman at the pub in the West End of London where I was doing stand-up, almost clambering over to embrace me. "He asked what time the gig was on and if you were definitely performing, then he left." Noel Gallagher, yob poet, spitting lyrics and epigrams and scoring a decade with what I'd call nonchalance – if it wasn't so French and he wasn't so English. David Walliams lives in Noel's old house in Belsize Park, Celebrity Strasse. When Oasis ruled the world "Supernova Heights" was his Camelot. My drama school was round the corner and at night I'd take penniless romps down that road, sometimes drunk, sometimes tripping, and sometimes I'd not even be high so I'd try and get a buzz off the fumes of his success. I'd look through the wrought-iron gates and imagine what marvellous excesses went on behind the frosted glass. Now Noel Gallagher had come looking for me. I quizzed the barman. "It was definitely him, was it? I mean we ain't that far from London Zoo – phone and check they've done a roll call at the monkey house."

Noel has got a brilliant sense of humour (I hope), he came that night and we hung out with his partner Sara (too good for him) and my dad (about his level), we talked about football mostly and I was touched by his awareness of the impact of his persona. People that famous can obviously be intimidating, and sometimes instead of speaking I'd just stare at him and run out of stuff to say. Noel would fill these gaping junctures

with the sort of questions a hairdresser might ask just to keep the chat going – "Been on holiday this year?" or "Do you want some mousse for that?" But I shan't forget his surprising social dexterity and compassion in what could've been an awkward situation – certainly if left to me. Because as he spoke and smiled and swigged, my mind strolled down memory lane to five years earlier, to Drama Centre in Camden. I was transported to the drunken 3am vigils I'd observe when staggering back from some crack-shack. Noel's gaff and Oasis represented hope and escape for a lot of people, that's why it's a fucking good name.

I asked him to come on *1 Leicester Square* and the 6 Music show and he came on both and was well funny. I saw a side to him that I was unaware of – I think we all know he can be a bit of a wag and can dart out a one-liner when required, but he was funny in a daft way – he did voices, VOICES. Plus he was camp and silly. He obviously enjoyed coming on the radio show and, ridiculously, became a regular feature. He'd just stroll over from his nearby home and join in. He elevated the radio show and effortlessly made it more special. He stayed involved to the very end.

From the get-go that show had a propensity for aggravation. It was oftentimes daft and gentle, with music-hall banter and light ribbing, but Lesley loved me and gave me lots of room – so I took that room. We began to wind up the newsreaders, throwing to the news in a childish fashion, goading them into including daft words in the news. I went too far and started claiming that during the news I'd be under the desk, interacting in an intimate manner with the newswoman as she racily recited massacres and football scores. She was a bit upset. Another time, my mate Ade who's in a wheelchair was refused

entry into a nightclub and I mounted an on-air campaign to condemn them – which, while good hearted, put the BBC in a difficult position legally as the club could not respond to Ade's allegations.

These skirmishes were minor – nothing was to get in the way of my inexorable rise, everyone was talking about me, I was living like a teetotal Bacchanalian. It was time for me to make a pilgrimage, for all this success was built around comedy and I am a comedian. Yes, there is an unusual degree of tacked-on glamour and pelvic thrusting, but under the hairspray and hysteria I am but a joker, and it was time for me to return to every stand-up's Jerusalem – the Edinburgh Festival, the festival at which I'd been arrested, attacked and hospitalised, where I'd fought it out at late-night bear-pit gigs and gouched on smack on stage, and once employed, Fagin-like, a tearaway gang of local children to promote my show. Where, once clean, I'd toiled to earn the respect of my peers and laboured over my craft till I could go toe to toe with anyone. Now it was time for me to take Edinburgh by storm, to stand above it like the castle, to light the sky like the Hogmanay rockets. I was returning as a star, to show them what rock'n'roll comedy is all about. I was going to tear it up, show 'em where I'm from, go crazy. I was ready for anything they could throw at me.

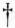

GILDED BALLOON

To Russell Brand
Pablo Diablo

22 August 2000

Dear Russell Brand

I have been made aware of several incidents involving the children you have working for you. Firstly I must point out that it is against employment law to employ minors in any capacity and that the Gilded Balloon does not allow children to work in any of its venues or areas.

There was an incident on Monday when items were taken from the Production office. You were informed of this and those involved have been barred from the administrative areas.

I have now had further complaints from Venue Managers of the same children causing a nuisance in and outside of venues. This has involved the throwing of items at people queuing for shows and abuse being given to staff and customers of the Gilded Balloon. This is unacceptable.

I must therefore insist that these children are no longer admitted to any Gilded Balloon venues or public areas and that you cease to employ them - illegally - to do flyering for you.

I am sorry to have to take this action, but they are causing a great nuisance to staff and customers alike and I would appreciate it if you could advise them to no longer come to the Gilded Balloon.

I hope that I do not have to take this matter further

Yours Sincerely

Mick Bateman
General Manager

cc. Karen Koren, Artistic Director

GILDED BALLOON LTD, 233 COWGATE, EDINBURGH EH1 1JQ, TEL.0131 226 6550, FAX 0131 226 6554
e-mail. info@gilded-balloon.co uk. web site: www.gilded-balloon.co.uk Company no. 156248 Registered in Scotland
Registered Office 16 Hill St, Edinburgh EH2 3LD. A Scottish Charity No. SCO23403 VAT No 664 0051 63

They complained about those kids. And they weren't crazy about the heroin either.

Chapter 6
NO MEANS NOooo

There's nothing more tragic than being in Edinburgh on 1 September, the day after the festival, or indeed in the first few days of August before it starts. Because of my inability to be punctual, my unmanageability and my lack of planning, I've experienced both the bookends of the month of August when Edinburgh pulls you into its cultural embrace; a cerebral carnival, not a carnival of just decadence. There is such a strong sense of unity in the city, a common manner of purpose, ad hoc venues hastily formed from dentists' waiting rooms and people performing on street corners. But "the day after", like the post-H-bomb TV movie that goes by that name, Edinburgh is bereft and eery or like Emily's shop when Bagpuss has gone back to sleep – still nice, but where's the magic? Edinburgh in its post-festival slump probably doesn't have the agonising pathos that Bagpuss had– nor does it raise so many questions, like: why was a little girl trusted to run a second-hand shop? How come Bagpuss could turn inanimate objects into dancing mice and pompous woodpeckers just

by waking up? I don't want to get all "Joseph Campbell", but that's what Jesus did with Lazarus. Where's Bagpuss's gospel? Probably never penned because, as Matt once wisely observed, the woodpecker bookend Professor Yaffel is a handicraft *doppelgänger* of that Godless stick-in-the-mud Richard Dawkins. Whenever Bagpuss was delighting the gallery with some unlikely thesis on a bottle or a ballet shoe, claiming them to be rocket ships or Minotaur mittens, Yaffel would coldly highjack these flights of fancy – "Rocket ship? Why that's nothing but an old bottle. A Minotaur's mitten? It's a dirty old shoe. Islam? It's inherently violent." Why can't Professors Yaffle and Dawkins just let us all enjoy a nice story? I expect Dawkins would say that it's because he opposes ignorance, especially where it causes war and bloodshed. Well, I happen to think people cause wars, not ideologies, and were we to be united by one, drab godless dogma we'd be murdering each other over who ate the last croissant within an hour.

The first time I went up to Edinburgh I arrived two days early, which is embarrassing, like arriving at a party early or misjudging the mood and touching a date's thigh or calling your teacher "Mummy". If I call a teacher "Mummy" now, it is a part of a cheeky little sex-game – not a kindergarten blunder – I think sometimes my sexual pursuits are like time travel: I Quantum Leap back into my past to try and unravel some perceived slight or wrong. "Hmm, those teachers didn't respect me – I'll drag a few back to my chamber, that'll remedy the wrongs of the past." I'm like Marty McFly hurtling "Back to the Future" to paint in a new present. He seemed to have an unusual interest in sex with his mother for the protagonist of a children's film – he couldn't keep his hands off her. What on earth were our young minds supposed to glean from that?

Time travel *is* possible and by the way have you noticed what a lovely arse your mum's got?

So it's a drag to arrive at the festival early, but at least there's hope. Not like the day after the festival, when it's all gone, like looking into the eyes of someone who no longer loves you, all the more empty for how full it once was. In the middle, however, it's amazing and exciting, and in *Booky Wook* – the hit autobiography (now a major motion picture in my mind) – I mentioned the excitement of the first time I went up there as part of a play with students from Webber Douglas and performed my first ever stand-up. I went there the next year with Nigel Klarfeld and it built. My first Edinburgh after becoming famous was an altogether different experience. That year Ricky Gervais literally overshadowed everything, he was performing at Edinburgh Castle for eight thousand people and caused a lot of acrimony and jealousy. But I didn't really mind it myself, I just thought, "Ricky Gervais will be up in that castle, it doesn't make that much difference, some military thing goes on there usually – the Tattoo, and I don't mind that either, just bombast and pomp, a needless display of anti-quated power." There's an easy joke to do here along the lines of "and the Tattoo's a bit pompous an all" but I admire Ricky and his success. However, the structure of that sentence does demand that I at least draw your attention to the potential for that quip.

This time I was going to Edinburgh glistening with noto-riety because of *Big Brother* and tabloid guff and being on Jonathan Ross. The previous year I'd had a cult following; girls would turn up, giggly and available, and boys would nod. There was a buzz about me, and famous people were in the audience; but this year, 2006, I was famous.

I was playing a run of one week of gigs, seven nights in a fifty-seater theatre at the Assembly Rooms and four in this thousand-seater venue and that was the biggest room I'd done – the Edinburgh International Conference Centre. The little fifty-seater room had been initially booked early in the year, then the thousand-seater had to be added. On four of the nights I'd do a gig at the small venue, then go down to the Conference Centre.

The first night as the intro music played I heard the crowd scream. This had never happened before, and Nik and I turned to each other and registered this shrill gear-change. It's very odd when you realise that you are the unknowing participant in millions of relationships and that the natural conclusion of these bizarre non-consensual marriages are teenage girls hollering or a teenage boy blandly asking you to recite a few words out of context – the catchphrase. In my case they could not be more daft. Here are some: "Ballbags, dinkle, if anything, 'citing." Out of context they aren't that funny and, in truth, there is no context that could justify them. Once you've said the catchphrase, what then? Where do you go to, my lovely? In front of fifty people you can cater to the natural appetite for repetition, but across town in the enormous Edinburgh International Conference Centre, no longer a cult comic in a cosy den but a prowling digi-god in front of screaming (what is that?) fans? Man, I love that screaming. Truly I wish I could have them all, I wish I could take that crescendo to a fluid conclusion because for a lot of my life that acceptance, that yearning, has cradled me, papering over the cracks of my maudlin, porcelain adolescence. In their howls I found the teeth to fit the wound. An audience behaves entirely differently as numbers increase, like a mob with diminished responsibility. Those shows were thrilling. Nik said that was when he knew we were getting through. People were

paying money and turning up and screaming. Luckily I am a highly disciplined man who would never exploit this crazy new resource, this oestrogen goldmine.

I was in Edinburgh with Matt Morgan and Trevor Lock as we were making the 6 Music radio show. We were staying up there in a flat that wasn't quite big enough for my rapidly expanding ego; it was above a trendy urban bar which could comfortably accommodate seventy people. After the Conference Centre gigs, Icarus-high and with Herculean hubris, I would invite the entire audience back to this bar. I'd say, "We're going to have an after-party now, it's going to take place downstairs from my house," then I'd give the address of the bar. This tiny poncey drinking den would be stuffed like a foie gras goose disgorging people pâté on to the pavement outside. Then I'd wander downstairs like a toff with a willy for a cracker and guzzle down the best bits. Of course when one starts treating the bar below as a kind of harem/wine cellar it's pretty bloody obvious that some universal adjudicator will soon step in to give your bloated "ballbags" the kicking they deserve. But this was no time to contemplate lurking karmic consequence, I had carousing to do.

Now, I find myself writing one of those passages that makes me look a bit of a bastard, and this is my book (y wook) so I'm entitled to give a good account of myself – Lord knows, once this is out there back in the clutches of the snides, I'll have no right of reply, so let me get my justification in now – while I own the page. I get accused of "banging on about sex" a lot – well, there's a few reasons for that. One is that people (journalists) are always asking me about it. They're right pervs – "How many birds? How many orgies? Gissa look at your helmet." I, being polite, especially when fame first came a-calling, would acquiesce to these requests – particularly the helmet one. Soon,

though, I realised that chatting about birds – if not done care-fully, i.e., using the word "birds" – makes me look bad. But I'm not bad, I'm analytical, self-obsessed and randy but, to para-phrase John Lennon, "I'm not the only one." I even worry about the Kate Moss chapter that opens this book – is it indiscreet? Will she mind? I hope not, because to be honest the whole affair was a tidal wave of flashbulbs and adrenalin, and I just felt like I was at Thorpe Park and had managed to get off the ghost train in the middle of a tunnel and see how the celebrity caper worked.

The other reason I harp on about the how's yer father is that it's bloody interesting and confusing and along with violence and death one of the more captivating elements of our experience on this dirty little circle. I also talk quite a lot about football and cats, but these are not topics that define our spe-cies. Of course sex is not a straightforward topic, not for me, not for any of us, and the injection of fame and availability was about to produce some diabolical consequences.

Alan Yentob, a man in his fifties, former BBC Director of Programmes and cultural commentator, came along to the final Bacchanalian late-night gig that concluded the Edinburgh run, then joined us backstage afterwards. Then, insanely, this rather demure and sophisticated gentleman was invited to our after-party. As you know, our after-parties consisted of little more than an ill-disciplined, over-excited sex-pert pied-piping strangers off a street and onto a nearby duvet. I imagine the kind of after-parties Alan Yentob must be used to include can-apés and harpists and a chap performing close-up magic; well, at our do, the canapés would've been kicked off the tray by Matt, Trevor would weep at the genius of the conjurer and I'd get the harpist pregnant.

Once out of what was surely Alan's first minibus, we romped on to the street. "Right, this is the after-show party, Alan – oozing from the bar." The audience spilled like a slick from a tanker run aground. I skidded off. "See you later, Alan," I brayed, then wandered into the bar and started chatting up girls.

One of the things I ought work on is my extreme distillation of seduction. I have created a seemingly irreversible dichotomy between love and sex, so if I'm romantically involved with someone I'll spend all sorts of time chatting them up and talking to them. But if I only want to sleep with someone I approach the affair like a harassed secretary confronting a bothersome franking machine. I don't think of it as being particularly curt or anything, I just think of it as efficient, like nature should be, like evolution is. One night we had a party upstairs, we didn't invite any men so it was me, Trevor and Matt and about twenty girls in sectarian pockets loose in our flat. Alan Yentob was nowhere to be seen, he was probably scrubbing a cormorant clean somewhere.

In the flat the atmosphere was not good. Matt must have had a girlfriend as he was "umming" and "ahhing" about "right" and "wrong" as often he does, and Trevor was dancing in the corridor. Because I don't drink I'm a lousy host. I forget that most people need a stiffener before an orgy, whereas I white-knuckle my way into the mayhem with sobriety gleaming like frost across my brain-scape. We got some gin and tonic from the bar downstairs and Trevor became a clumsy, bespectacled nit version of Tom Cruise in *Cocktail*.

Trevor Lock is an interesting cove, he's married to a Peruvian lady, and spent time in her country learning at the feet of shamans. They must've been baffled by him – he's hyper-

intelligent, analytical, sensitive, spiritual and naturally quite brilliant, funny, gentle and quick and nimble and a good performer. I really enjoyed working with Trevor Lock, a good chap and a good person to take the piss out of, a lot of fun to ridicule.

STUDIO. DAY.
>RUSSELL
>Are you alright, Cocky-Locky?
>TREVOR
>I am. I'm feeling much better, been a little bit ill this week.
>RUSSELL
>Oh, I'm sorry to hear that but not that interested.

STUDIO. DAY.
>TREVOR
>I was born in Lincoln.
>RUSSELL
>You say born, Trevor, you were more created in a Petri dish by a pervert.

He's very situated, very English and provincial, you could imagine him wearing brown brogues and having a bicycle with a basket on the front and pushing his glasses back on to the bridge of his nose, saying "Oh blimey", the sort of egg who would get a bit hot under the collar. One would be very surprised to encounter malice from him, he's a very positive person. Which made it all the more astonishing when he was accused of rape.

There are a lot of people who quite pointedly don't introduce anything negative into my experience or my life. I have some

friendships that are quite complicated and difficult, but one of my best qualities is that I'm very good at selecting people to have around, people who won't fuck me up. I'm aware of what my deficiencies are, so I surround myself with people who are fully formed and developed in the areas where I am lacking, self-assuredness perhaps sometimes, and a grounded consistency. That is not a ubiquitous verdict on all the people around me, but there are certain shared traits and one of them is a lack of negativity. I like people not to be negative or down, and Trevor was positive, positively charged energy to be around.

In Edinburgh that night, a night that we would forensically discuss and be forced to recall in excruciating detail, I had foolishly created a harem that lacked the facilities that would have been imposed by any half-decent sheikh. Surprised drunk women who moments before had been in a bar and before that were in an audience, were now in a shabby, badly run party that even Alan Yentob had swerved. Occasionally I'd sidle off with someone to a vestibule and have a canoodle and then return to the party for fifteen minutes.

I do enjoy the fifteen minutes after an orgasm, the rationality that follows, the calm, patient, reasoned man that I become, liberated momentarily from the razor-sharp biological imperative – I really hope my biological nature appreciates what I do for it because I ain't half a diligent servant. It's as if my biological nature went,

"Procreate, Russell, we must continue to procreate."

"Oh yes, sir. Yes, m'lud."

I'm the most obsequious creature, utterly enslaved by that need; I do whatever it wants, it's ludicrous, the level of servitude and the mastery over me that it has achieved.

If only one day I could find love and, like Rapunzel or some other fairy-tale twerp trapped in a phallic tower, be released from ploughing this seedy trench.

As I mooched about, snogging and seeking salvation in all the wrong places, Matt and Trev and the hostages tried their best to conjure up the atmosphere of a party in what should more realistically be considered a sexual buffet. I would have written "smorgasbord", but it's one of those words that gets used a lot in comedy situations because people obviously like it, it is a nice-sounding word but some things get tainted, "smorgasbord" being one of them, which is a shame because it's a pleasant word, but there's no going back; although, I never thought I'd use the exclamation mark again, but now I use it in texts and letters and Post-its!!! I'll tell you why, because in text communications these days there's so much lol-ing and gsoh-ing and :) and :(– wow that's literally the first time I've ever done that – and smiley faces in my day just used to mean "Aciieed!" or "Mr Happy" – that now the vulgar exclamation mark resembles a modest grammatical quirk, not the great, big, goofy, upside-down truncheon-phallus, gooning its way into a sentence, announcing its presumed humour. If the exclamation mark is now comparatively subtle, so I can use them again, perhaps "smorgasbord" too will make its way back into polite society, but until that day let's say it was a sexual buffet and people were trying to conjure up the atmosphere of a party.

I don't know if Russ Abbot's "What an Atmosphere" was playing, but in these situations my brain usually provides an appealing score.

"Oh what an atmosphere, I love a party with a happy atmosphere, what's Russell doing now?, he's just drifting from room to room like a land shark – 'Oh let me take you there, and you

and I will be dancing in the cool night air' – is he in the bath-room again? Yes, yes, I think he is."

Whilst this was going on, a girl who worked in a local bar had ambled into the tragic-comic upstairs VIP area. She was drunk, too drunk to be behind a bar. I myself was an alco-holic barman and it's the last place you should be. Or the first – there's two ways of looking at the situation and it depends what results you're trying to achieve. If it's drunkenness, get behind a bar; if it's sobriety, get out.

This girl was drunk; she was beautiful and I flirted with her for a while and enjoyed her company, she seemed sweet. I was by no means on the precipice of a great love affair, but I thought the two of us might be able to create a mutually beneficial diversion from the looming shadow of death, or to give him his proper name, Matt. No, not really, I do genuinely think of sex as a legiti-mate and fun way to avert the mind's eye from impending doom. The fact that I was chatting up this girl was by no stretch an "Excalibur" situation, where a union would signify a magically ordained bond, because I was marching around yanking cutlery out of every bit of granite in that city, there can scarcely have been a fork or spoon left un-man-handled. "Perhaps this is the sword," I'd announce, "or this, or this or this one."

"Mr Brand, you've got your foot in my fork drawer and your hand is groping the coal scuttle."

"Yeah, well, that's the way I roll, I've got four limbs for a reason, and that lady in the lake was alright, can you get me her number?"

Ghastly business really, but such is the nature of single life at a Scottish arts festival.

"Come on, shall we go and kiss each other?" I schmoozed. Luckily for me she said, "Look, I'd like to talk to you first."

I think my face must have frozen and I must have rolled my eyes, chuckled and murmured, quietly I hope, something along the lines of "OK, I'll be moving along to this person a yard away who, hopefully, won't make such outrageous demands on my time."

I like a good chat, a chinwag, a lovely conversation. When I want sex I want to be physically involved with someone, and that too is communicative, good kissing and good sex is communication beyond language. I love language, I like sexual communication with beautiful women and I don't think it's invalid. I don't think it's any lesser and I don't know how it's been tainted by morality and adjudged to be somehow lower. I know it's animal and it's primal, but there's certainly an argument that it's a purer form of communication, that there's less duplicity. I don't try and mislead someone with my sexual communication. I purely communicate, by holding on to them, by dancing my way through them, by kissing them and adoring them.

This glorious ritual could be devalued by enquiring, "Will this lead to a marriage?" The answer is no, but why ask that question? Why not ask, "Will this lead to a space mission? Will this lead to us going on a tropical quest or us setting up an accountancy firm?" No! No! No! But ought we let that undermine one of the best damn hobbies known to humankind?

That girl said, "Do you want to have a conversation?"

I said, "No, I do not want to have a conversation."

Men did not evolve over millions of years to have an inconvenient sack of chemicals dangling between our thighs that compel us to have conversations.

"Go forth and converse" is not in the Bible. I've checked it, I've double checked it, I've gummed the pages together because

I've checked it so thoroughly that I had to have a wank while reading it because of the human biological imperative to go forth and multiply.

"Take that back, Gideon, I'm going to need another one."

So I went and slept with someone else who had a bit more of a gung-ho attitude to these matters. Matt skulked off and ended up in a lap-dancing club with some interesting fella, a peripheral chancer we met, a driver; we were always meeting strange drivers around Edinburgh. Trevor ended up chatting up that girl and going to bed with her, and what happened is subject to legal dispute. Trevor says, and I believe him, that they had consensual sex. It sounded rather comical actually – until we heard her version of events FROM THE POLICE!!! (Go, exclamation mark.)

When we awoke, the previous day's shadows lay heavy upon the walls and floors. Mementoes scattered as if they contained, locked within, the memories of the nocturnal events. By this time I had acquired a PA, a personal assistant – which now, some years on seems unremarkable, which is a fair barometer of the changes in my life. A personal assistant is a barrier between you and the world – it's not the same as a secretary, their duties are mostly clerical whereas a PA will bat away, like tedious gnats ballsing up the paradise of your holiday-life, any chores that you'd rather not do. From paying the phone bill to sending flowers to collecting prescriptions, all can be swerved once a PA is recruited. Now I know that this is an alienating reality, that I now write from behind a platoon of mollycoddling adult nannies and this may put some distance between you as a reader and me as a spoiled arriviste brat. But know this: I am aware how ridiculous it all is, the money, the fawning, the girls, but what does one do? And believe me it comes at a price. Privacy and sanity are not commodities to be traded

lightly. That said, having a PA is fucking brilliant.

At that time I had a lesbian PA called Helen, perhaps unconsciously I was trying to balance some of the marauding misogyny that had inadvertently come to characterise my life – I needn't have bothered administering punitive measures to myself because the cosmos was soon to make its judicious presence felt. Helen and her bird, Shaz, awoke us from the debris of the final night and we hurtled towards Princes Street, keen to board the King's Cross train before the festival officially concluded and we were turned into pumpkins.

It was a beautiful train journey home. British train journeys can be so charming when relieved of the obligation to avoid ticket inspectors and smoke in toilets. Matt was twinkly, morning drunk and riling Trevor about the night before: the corridor dancing, the Vicar of Dibley cocktail bar he was running and his rare and, to us, amusing seduction of a woman. All in all we were enjoying the benefits of my new-found, hard-won fame.

When I got back to London I was invited to dinner with charm-monger Neil Strauss, writer of *The Dirt* – the Mötley Crüe book – and *The Game*. A further advantage of success is getting invited out to dinner by famous strangers. I was intrigued to meet Neil because *The Game* is the Koran (let's take a risk, I mentioned the Bible a page ago) of womanisers everywhere. This guide Neil penned on how to hoodwink girls into sex left me with mixed feelings – it's very well written but is it right? That is the problem with the whole womanising culture – it gets sleazier with every hour that you age and starts becoming a bit soulless. Oh, sure, it's a big, stiff hoot when you're gadding about like Bruce Wayne, but you can never forget that on the horizon, bleaching his hair and popping a

Viagra, awaits Peter Stringfellow. But these were not consider-
ations for this swish night in Claridge's – a lovely posh restau-
rant that you can only relax in if you are the Queen or Claridge
himself – God knows what he's like. Tonight I was concerned
with seeing Neil's "game", and more importantly, comparing it
to mine. Neil brought Courtney Love with him – who is a mad
enchantress, a rasping white witch, barmy and opinionated and
lion-hearted. More interesting than her lion-heart, though, is
her vagina, which has been referred to as magic, in that it has
a mythical power to bestow stardom and heavenly gifts 'pon
those who enter – a kind of Blarney-fanny. Lord alone knows
many a famous man has emerged from its confines – some
of whom surely must've been famous on the way in. Neil told
me I didn't need *The Game* as I was a natural – the best he'd
seen, which utterly charmed me, making him the winner of the
"game contest" before we'd even had soup. Which was a bloody
good job because it was one of those posh soups where you get
a bowl with some croutons and bits in it and the actual soup
comes in a jug on its own. (On one terrible occasion I phoned
room service demanding that my soup be delivered, as I just
had a bowl of breadcrumbs, and a waiter then arrived to tip
soup that was millimetres away into the dish. He couldn't have
looked more contemptuous if he were changing my nappy.)

Neil charmed anything that moved and gave me some tips on
writing. Courtney held, well, court and was marvellously indis-
creet and interesting. She gets a right drubbing in the papers but
she's brilliant. We never had sex, because we became mates, and
besides, that night I only had eyes for Neil, the manipulative
dreamboat.

I then went off to Morocco on holiday with a very lovely
girl, a gentle blonde breeze of sweetness and fun. While I was

there, there were stories about me and Courtney Love saying that we'd slept together, which often means been in spitting distance of each other – which in my view is an integral part of sex. The distance itself, though, should not be viewed as confirmation of coitus.

"There are these stories about you and Courtney Love," said Nik. The tabloids were now ever-present in my life providing salacious commentary, and wilfully misunderstanding everything I did. Initially it was a laugh, even when they said hurtful things; me, Matt and Trev would dissect it on the wireless – they'd torment me and I could defend myself. Sometimes we'd call the papers up and give them false stories, live on air. Everything could be fed into the whirring comedy buzzsaw.

I didn't care if the papers wrote that I slept with Courtney. "That's OK," I said to Nik. "She's cool, Kurt Cobain and all that – I'm not bothered."

I was less nonchalant, however, when I received a call informing me that one of the girls at the "party" on the final night in Edinburgh had said she'd been drugged and coerced into sex by one of the men present. OK. Drugged and coerced. That sounds bad. "One of the men" – why didn't I invite more men? The thing is I distinctly remember not drugging or coercing anyone into sex that night. Or ever, actually. I don't expect praise for that – I'm not saying, "Hey, I've never drugged or coerced anyone into sex – where's my effing medal? Where's my ticker-tape parade?" I'm just saying I'm opposed to drugging and raping. Except when the victim and perpetrator are both me.

The nature of such a terrible slur is that the accusation is itself a condemnation. Also I'm not impervious to the moral codes of the civilisation of which I'm part, so it's difficult not to have, if not a visceral sense of guilt, certainly an ethereal

awareness of that guilt. Occasionally you feel the ghost of that guilt passing through you. My mum is an ordinary person who's probably had three or four partners in her life, while my grandmother on one side is very Catholic and family orientated, and on the other side Protestant and quite staunch, so it's not as if I grew up in a kibbutz or some sort of commune utterly free from restrictive sexual morality. I'm subject to it, and in fact it's only my habit of defining myself as external to any culture that I'm ostensibly part of, that makes me distance myself from it. By existing in opposition to it I'm subject to its influence … it is influential.

That sense of guilt was similar to when at school in assembly they say, "Somebody here has done something terrible." I'd think, "Oh God, it's probably me." Sometimes I'd almost go, "Yeah, I did that," almost admit to it because of a sense of guilt. Enough people in my life have told me, "You are bad, you're a bad person, what you've done is bad" – in the end you start thinking, "I am a bit bad." So you are awaiting judgement, awaiting the Sword of Damocles or some guillotine swipe. Like in assembly when they said, "We'll find out who it is anyway." On the rare occasions when it hadn't been me, I would still nearly put up my hand.

We travelled back from Morocco and I saw newspapers in the airport – it was in all the daily papers. Some had been moderate, but the *Daily Star* ran on the front page "Russell Brand Rape Quiz" and I thought, well, this is going to be a tough show to pitch at Channel 4. "It's an interesting concept, Russell, but some of our female viewers might find it offensive."

Quiz is such a light word to use in conjunction with Rape. "A Rape Quiz", these two words don't belong together. Enquiry, search, quest, I don't know … there was no quiz and there was no rape. The only words that are indisputable are "Russell Brand",

and whilst I agree that is a headline, I refute the other two words, rape and quiz. If I had to choose one word to go it would be rape, making it "Russell Brand Quiz". I think that could be fun – every week Tuesday seven o'clock ask questions about me, I'll even come along and host that – but you're going to have to get rid of the rape if you want me attached.

We successfully sued the *Star* for a large amount of money as a result of that libellous headline. Then began the more important business of finding out what on earth was going on.

The Scottish police contacted the agency; and two police officers came down from Edinburgh to talk to me, Matt and Trevor. Trevor bravely admitted to having consensual sex. To be clear, I wholeheartedly believe Trevor; to accuse Trev of rape is like accusing Desmond Tutu of arson or Stephen Fry of racism. Possible but so unlikely the world would topple from its axis, spun out by the gravity of the preposterousness. Apparently at that point she was so drunk that she didn't remember, she just said "one of the men at the party" – and because of my rather unusual invitation system there were only three men at that party. Thankfully I wasn't the one the accusation was levelled at.

As with all terrifying and difficult situations, remarkably, some incredibly funny things happened. Here are some of those incredibly funny things. Trevor had to describe to the police the night's events, you have to go through it in meticulous fucking detail again and again and again, it's a police inquiry. It's tense. The word "rape" is flashing in neon throughout the pro- ceedings. John and Nik are trying to be professional, although on some level they must be thinking, "Well, it was too good to be true … we took this junky and turned him into something." The gravity of strife and mayhem had pulled me once more into its grim sphere. Perhaps I deserved it. All that showing

off and decadence. There's always a price to pay. You can't just waltz out of rehab into stardom, diddling birds wherever you go, and expect the world to tolerate it. There is no escape, the gutter is greedy and it does not like to yield its brood.

"Well, what happened on the night in question?" asked the sullen, more Taggarty of the two Taggarts that had come down to resolve this case.

I do not like authority, so in a scenario like this, self-preservation is put aside in favour of tomfoolery. "Well thankfully I've got about a dozen witnesses who can tell you where I was, officer. I've got genetic evidence, DNA all over the bedroom. If you were to shine an ultraviolet light into my room it would look like Jackson Pollock had been in there, drunk on a trampoline, which I think at one stage he was, he'd strayed in by mistake with Alan Yentob who was making an obsequious documentary about him."

Me and Matt were relatively safe now that Trevor had identified himself as the one who'd slept with the girl. Still, we had to accurately recite the events. "The girls all came upstairs and we had this gin and tonic and Trevor was nominated their barman."

Trevor added piously, innocently, on the brink of tears, "I was in the corner of the room. I was in charge of preparing the gin and tonics. I was just there in the corner of the kitchen hacking up an old lemon ..." Trevor paused, and the police looked up from their pads. Matt said, "Which is what Trevor calls a prostitute." Well, we all thought it was very amusing and lightened the horrific mood. The police on the other hand simply arrested Trevor and took him down to Kentish Town Police Station.

It was a very difficult situation, and because of a quirk in Scottish law the case is never dropped. Trevor was accused but

the case never went to court because the girl didn't want to pursue it. The case can still at any time go to court, but it's a little bit difficult because it's two or three years ago now.

Matt and I were immediately exonerated and were able to continue the radio show, whilst the investigation meant Trevor was suspended. Also he was meant to do an item on a TV show we were doing, but had to be dropped, so the incident obviously had an incredibly negative effect on Trevor's career, and it was the beginning of the end of our relationship really, because it's hard to recover from that kind of thing. So the scandal claimed Trevor, a brilliant and innocent nitwit who was loved by the radio show listeners. The first negative consequences of fame had emerged. I learned then that it is a dangerous game and like all games there will be losers – in this case, I lost a friend and the tabloids found a controversial anti-hero and quietly awaited further opportunities for annihilation.

Chapter 7
TAKE ME TO YOUR LEADER

Of course though, a career in show business isn't all tabloid scandals and seeking shelter from the clumsy fist of Scottish law; no, at some point you have to actually make some television programmes, and with the success of *Big Brother's Big Mouth*, E4 were double keen to give me enough rope. Is there some grit at my essence, some mark that I bear that prevents me escaping my tawdry origins? This I consider even as I ascend spectacularly like a spaceship above the screams and the applause and the roar, for distinctly I can hear the humdrum tick-tock terror of fate tapping his watch and reminding me that everything NASA ever flung at the moon is now a bedraggled shelter for crabs and gulls, littering the ocean like David Bowie's crashed caravan. After fifteen seconds of fame Trevor Lock, the world's least sexually threatening man, had been dragged off to Belmarsh. "This can't be the work of man," I thought. "The Furies have been sent to claim me, the gutter's henchmen. What's next – will my dear old mum be banged up

One week out of rehab, Nik holds me up. ①

I bought Jonathan that sculpture for his birthday and gave it to him on his show, although he edited it out because it was "in bad taste". Stick that in your pipe, *Daily Mail.* ②

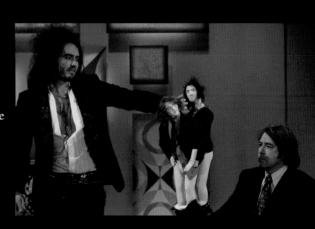

Me at my foppish best. Matt hated his hair that day as he said he looked like "an auntie". He looks better than Trevor though, who resembles a dog that'd been turned into a man five minutes before the photograph and was wearing a twee neckerchief. ③

Me and Matt in the good old days. With me as a ringmaster and him as a mermaid – perhaps the clearest actualisation of our relationship. God knows what we were filming it for. No justification could be sufficient. ④

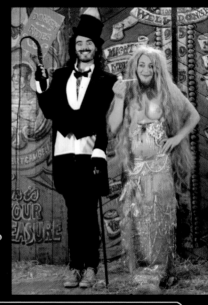

Where you see this symbol go to www.russellbrand.tv/caption for Russell's audio commentary.

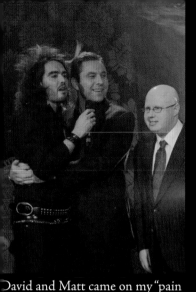

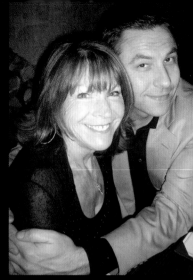

David and Matt came on my "pain in the arse" chat show and were wonderful – they bought gifts and David held my back, hand and arse throughout to comfort me. In this photo Matt has gone within himself to cope with me and David's unsettling sexual chemistry. 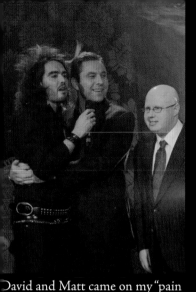 5

No man should ever be subjected to the sight of David Walliams embracing their mother. Moments after this photograph was taken they disappeared together for one month. We've never discussed it. 6

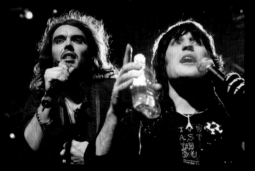

The beautiful conductor of whimsy and elf sex-appeal Noel Fielding loaned me his spectacular talent to raise money for Focus12, the drug and alcohol charity. I think, ironically, he may literally have been drinking while doing it. I mean, look at his right hand. 7

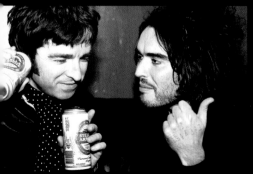

Over a century after its invention I try to explain the telephone to "prince of the north" Noel Gallagher. Actually he was raising money for Focus12 too. Interestingly, both Noels seem to have to drink to cope with working with me. 8

Where you see this symbol go to www.russellbrand.tv/caption for Russell's audio commentary

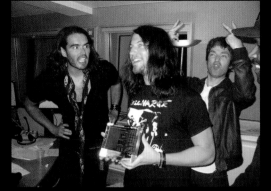

Me and Matt, Noel and Gee's nose receive the Sony Gold Award for Best Radio Show. Noel ruins the prestige employing a gesture he used to spoil the Nineties. 🔊⑨

The collective, after Radio Show Live at the Bloomsbury, in which Matt and Noel outed me as "a child who withheld faeces until toy farmyard animals were presented". Here, they proudly celebrate with a kiss. 🔊⑩

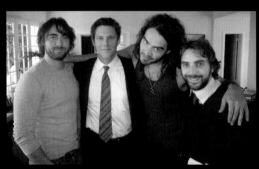

Me and Nik and our LA additions, adorable Sean Elliott (left) and my sweetheart, Dan Weiner (right). 🔊⑪

Front row at the Staples Center, watching the Lakers with my beloved, kindly Hollywood big-shot agent, Adam Venit. Here I am whispering, "Why the hell do they keep touching it with their hands?" 🔊⑫

🔊 Where you see this symbol go to www.russellbrand.tv/caption for Russell's audio commentary

ason Segel and me wear the neck pillows (Hawaiian style) that Nik buys for every flight we go on. Jason thoughtfully re-creates the expression he wore the previous evening while enjoying some "private time" with Nicola Schuller. 🔊⑬

My actual head is in that sludge being moulded for a movie. I felt like a bukkake star. 🔊⑭

Here is the costume that slime bonnet was for. A golden robot. Only the emperor remained pink. 🔊⑮

Bedtime Stories premiere. Me with Ollie and Nicola's niece Elsie, who I love. 🔊⑯

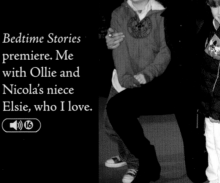

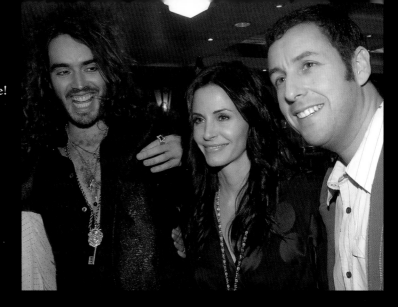

The Sand Man! Me! Courtney Cox! That was literally the only time I stood near her. 🔊⑰

Paul McKenna does the perfect "Paul McKenna" face. Imagine him saying, "Is some bitch twisting your melon?" Go on. 🔊⑱

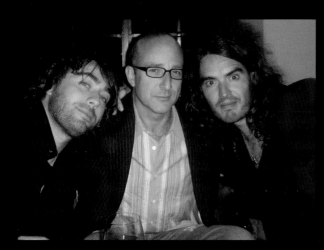

I had sex with everyone in that photo except two of the men and one of the women. At that party. Yep. It was one hell of a barbecue. 🔊⑲

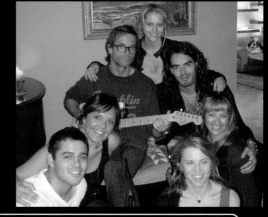

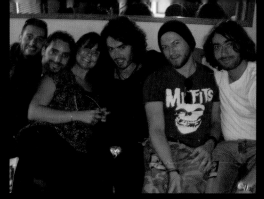

VMAs 2008. Tom, my darling assistant and modern-day gay butler, Dan Weiner, Nicola, Matt and Nik, just before we teased the triggers of a billion hillbillies. 🔊⑳

On my way to the VMAs and death threats – I'll get another one when my mum sees I used a photo of her in her dressing gown. 🔊㉑

Rusty Brown, Britney Spears and an elephant in the room. 🔊㉒

Me and Matt in our VMA backstage wigwam – Matt has the face of a man who knows he'll soon be sharing that space with bottles of his friend's urine. 🔊㉓

🔊 Where you see this symbol go to www.russellbrand.tv/caption for Russell's audio commentary

Ma'am as'n Jam not Ma'am as'n Arm. Hmmm, I'd like to lick the back of your head. 🔊24

I'm trying to force my mind into Morrissey's mind. 🔊25

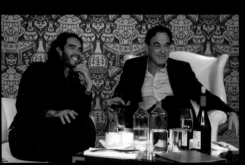

Me and Oliver Stone. Together, surely we can form some sort of revolutionary force. 🔊26

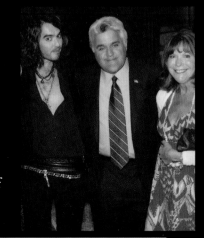

Jay Leno continues his tireless seduction of my darling mother, Babs. 🔊27

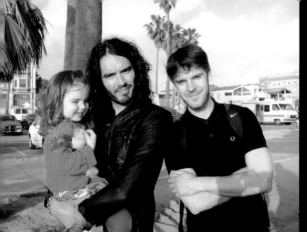

Me, little Mingo – Nicola's daughter – and Sachsgate architect, Gareth "What could go wrong?" Roy. 28

Gee writing a poem during the show. What a talent. He also failed to prevent Sachsgate. 29

I apologise and resign. Stalin looks on. I like to think he'd've been impressed. 30

An Australian radio station misjudged my persona and filled the studio with attractive girls. Me and Danny approached it like *Supermarket Sweep*. 31

Where you see this symbol go to www.russellbrand.tv/caption for Russell's audio commentary

for the Birmingham pub bombings?" Mind you, she's as guilty as them what did the stir for it.

I'd been scuttling around the foothills of fame for years. I'd done more pilots than a Virgin hostess, but this one had to be different – for a start it had to progress beyond the pilot stage and actually become a TV show, because now I was a face, a commodity, I had fans, a haircut, catchphrases – I'd bought my mum a car. There could be no more cock-ups. May I take this opportunity to say that although a lot of talented folk work on telly there's an awful lot of rhubarb goes on. I'd sit in glass-walled meetings in Shepherd's Bush (Auntie Beeb) and Horseferry Rd (C4) nodding along to doctrine from a commissioner – (no Bat-phone though), and think, "Well this all sounds very sensible – all these tips and rules and requirements – but how come whenever I turn on my TV set there's naught but winkey-water to occupy my eye-hole?"

I had two ideas to launch me from the adrenalised-spaz-grip of reality TV and into my own stratosphere. One was a Louis Theroux-style immersive documentary and the other was a studio-based audience participation show. I like to be absorbed in the subject of my work regardless of how loopy it may be. Months before, working with Damon Beesley and Iain Morris (who have now blessedly found their rightful place in the firmament with the excellent *Inbetweeners*), I'd made a film with the members of a cult known as the Jesus Christians. Now if ever there was a tautologous adjective to emphasise a noun it is this one. "Ah, but we're the *Jesus* Christians." Fucking hell! How bloody Christian do you want to be? I'd say that once you announce yourself as Christians the involvement of Jesus is pretty explicit. "It's to distinguish us from the *marzipan* Christians and the *Terry* Christians and the *'One Up the Bum No Harm Done'* Christians." Oh good. You might as well call yourself the *Christian* Christians.

Well, the problems with this bunch of doe-eyed do-gooders alas did not end with their inefficient naming strategy. There were only five of them and they travelled the world in a van like the KLF or Scooby Doo's idiot mates, trying to dole out kidneys to an unsuspecting world. Yep. They would whip out a kidney as soon as look at you and give it to someone more deserving. Now organ donation is blatantly a wonderful calling – people will always need organs – you'll never go hungry in the kidney donation game. The problem is you won't be able to process any food that you do eat as you've turned your God-given body into a vertical fridge.

Me, Damon and Iain got a crew together and tracked down the Christians at a motorway service station where they were rifling through bins in search of what they called "free dinner". They were all young, good-looking people – if a little jaundiced for some reason. Obviously I was fascinated by their sledgehammer altruism, and young people with a quest give me a stiffy because it makes me think that my oft-stated, never-realised craving for a global revolution could one day be a perfectly good system of government. They had wonderful intentions and obviously did some good, but it just made me feel a bit creepy to see their perfect bodies scarred by this cock-eyed kindness and, like a lot of people in cults, they didn't seem to be quite in their right minds – perhaps they'd scooped 'em out and borrowed 'em to a poor person in some whacky misinterpretation of Leviticus. After half an hour's tireless, Roger Cook-style investigative journalism I told the Christmas Christians that I thought they were, to quote Cypress Hill, "insane in the membrane" (Doctor, where is this mental disorder with which my poor mother is afflicted located? It's in the brain. And what's worse, the membrane), which made them go all cheesed off and refuse to film any further stuff with me.

The subject for my latest adventure was to be the Raelians – an extraterrestrial-worshipping cult who believe that ancient religious texts were written by primitive people trying to explain the advanced technology and ideologies of our alien creators. Which I'm well into. I was to make the programme with my mate and *BBBM* producer Mark Lucey. Rael was in Miami, so me, Mark and a camera operator called Craig who Mark christened "Russ-Lad" – like he was my sidekick – buggered off over there.

When making documentaries with clandestine cults, there's a lot of pressing flesh and buttering up and allaying fears, so we met several representatives of the cult in Blighty. My favourite was Glenn – the UK leader. Glenn was an actor, his previous job had been playing the part of Jesus Christ, Superstar in the musical *Jesus Christ Superstar* – I like to imagine that Glenn got so caught up in the nightly adulation of the crowny thorns and free Maltesers that when the run came to an end he thought, "Oh no you fuckin' don't – no one brings the curtain down on Jesus, I'll play this part till someone nails me to a cross." Which for three months had happened every night – that would take the sting out of it.

I've recently, for reasons I'll go into later, become sensitive to the idea of blasphemy, so let me make something clear. I am a spiritual man. If you're like me, you'll balk at someone telling you that they're spiritual as it's not a very spiritual thing to do, one can scarcely imagine St Francis of Assisi brushing a starling from his shoulder, grasping your palm then brusquely asserting that he's "well religious". He'd let you see for yourself. Well, that's not my way – and to be honest I was never gonna come off well in a spiritual dick-swinging contest with one of the most enlightened beings of all time, but to quote Morrissey for the first time in this book (y wook) – "In my own sick way, I'll always stay true to you."

I'm writing this in the Austrian Alps, for reasons that I'll go into later (yes, the same reasons as the sudden awareness of blasphemy) and from my window I can see the mountains. In fact I can see them from everywhere, they're ubiquitous, I suppose that's why it's called "the Alps". God is in the mountains. Impassive, immovable, jagged giants, separating the celestial from the terrestrial with eternal diagonal certainty. As if silently monitoring the beating heart of the creator from the universe's perfect birth. Stood in the thin air and the awe, one inhales God, involuntarily acknowledging that we are but fragments of a whole, a higher thing. The mountains remind me of my place, as a servant to truth and wonder. Yes, God is in the mountains. Perhaps the pulpit too and even in the piety of an atheist's sigh. I don't know; but I feel him in the mountains.

So, with that said and understood, let me try and earn my infidel medal. Glenn, amidst the swarm of brilliantly implausible claims that surrounded him like Jack the Ripper's fog, mentioned that when the ol' ETs return they'll bring all manner of life-changing kit. "They'll likely have cures for AIDS, tsunamis and indigestion," testified Glenn. Well, the first two seem jolly important, but indigestion? Bloody hell, we've got Rennies for that (my mate Danny calls 'em Renés, like the bloke from 'Allo 'Allo!). Brief enquiries revealed that whilst Glenn was AIDS and tsunami free, he did suffer from terrible indigestion.

Once we'd charmed the regional head of the extraterrestrial cult we were free to meet the head honcho in Miami, Rael himself. He did not disappoint. Dressed in white with a too-young wife, Rael, a Frenchman, was everything you'd want from a cult leader: eccentric, randy and smart. He was so bloody good at cult leading that when he told me he'd been up in a spaceship with Jesus, Buddha, Muhammad and Moses, I still believed him.

I refused to introduce reasonable doubt even when he said that up in that spaceship he'd had it off with futuristic, ET, prossie-sex-bots. Who could anticipate that flying saucers could be so damn saucy? Flying saucer is a bloody stupid term when you consider the minor role that piece of crockery plays in contemporary dining. Why not a flying plate? You only see saucers in Merchant Ivory films and Claridge's. It's too esoteric. It's like calling molehills dirty eggcups.

At this point I was begging Rael to let me join.

I sat in a Miami compound – a bit like sheltered accommodation it was – where Rael was holed up. He skipped around the world like a Ziggy Stardust bin Laden, avoiding indifferent authorities, so was practically homeless. His devotees would lend him a sofa. He's a slacker Jesus, bowling along with his knapsack and his child-bride, peering out the window all day long waiting for kinky Martians to turn up and put on a stag-do for prophets. There's a space in my heart for a loony with a yarn, and I'm apparently quite susceptible to cult-recruitment, because by the time the Rael interview was twenty minutes old I was pledging to help his cause in any way I could. Perhaps

by raising awareness in the British media? Given that at that time my sole contact with high-profile figures came through the dubious conduit of *Big Brother*, I don't know that I'd've been of much help. "Rael – I can get you an audience with John McCririck if you're interested. No, unfortunately Jackie Stallone passed."

Another influential factor in my sudden pie-eyed devotion was Rael's generous offer to let me have it off with one of his female followers. "What a fuckin' touch!" I thought. I was politely preparing an erection when Mark Lucey, quite rightly when all's said and done, pointed out that it might not be that professional for me to have sex with members of a cult while making an impartial documentary about them. "Oh bloody hell, Mark! How impartial does this have to be? I'm not Alan Whicker!" I reasoned that the sex could be part of the programme. "No, Russell," explained Mark patiently, "once we film you having sex we stray into a very different type of film-making. It's called porn." I was still up for it; at that time I thought "ethics" was just the place I'm from said by a bloke with a lisp. With that we made our excuses and left.

I loved them Raelians, but Channel 4 decided it was all a bit too barmy to be on the television, so we turned our attention to a studio-based show instead. Trev could no longer be in the E4 show we were hurriedly devising, as he had the looming accusation hovering above him like a tartan vulture, but I still had a good bunch of chums, an ever-expanding and fluctuating coterie with which to bake this undercooked, over-promoted TV recipe. When you're hot, people will move swiftly to cash in on the glow. This lack of guidance from the channel coupled with the tooth-melting velocity of my own ambition created a right pig's ear of a programme.

One of the things that was good about this *BBBM* rip-off was the title, *Russell Brand's Got Issues* – Matt came up with that. They say, don't they, never judge a book by its cover, but it would've been favourable if this cut'n'shut star vehicle had been judged by name alone because beyond that lay only codswallop. We'd round up a studio audience and do a Jerry Springer-type show where celebrities and the audience members would discuss an "issue" (see, good title) like crime or love or summink. It did not work, because it was inconsequential and there were too many daft ideas and not enough editorialising. Which was a shame because some talented people worked on the show. Matt, of course, who I'd kidnapped from MTV years earlier and had been writing with ever since in a fractious and hilarious partnership where we laughed like drains and bickered like sisters – he'd write the show with me and dream up disturbing and inappropriate VT ideas which we'd force on to the telly like an unwelcome nan pudding. Check YouTube, baby, because it's all there. Me and Matt above an East End pie shop dressed as Colonel Sanders and a Nosferatu toddler, eating cold beans from a fake vagina, to intro a show about pets or plants or pipe cleaners. Me and Matt dressed as medieval peasants, dragging our arses across woodland floors in an "authentic" recreation of a past life a charlatan hypnotist had told me I'd had. And my personal favourite, Matt stood in the glare on the shiny studio floor, LIVE, next to a swingometer, dressed as "Peter Zod", General Zod's fictional lipstick-wearing nephew.

Suzi Aplin, who came on with Mark to produce the show, would sneak Matt a pint of wine before we went on air to calm his jangling nerves – he thought I didn't know but I knew. I had my eye on him, that's why he was there, so I could turn and look and see old Matt pinned to the spot and terrified. In the clamour and

the chaos of a failing LIVE television show you need something to cling to, and I knew if he was there everything would be alright. The ratings told a different story of course. Everything was not alright. The show had been promoted like Coca-Cola, it was on billboards, buses and cut into students' hair, but people weren't tuning in. Thank God, because they'd've been watching a disaster. Matt told me that as the countdown wound down and the lights went up and we were "LIVE" he'd dig his fist into the pocket of his ridiculous costume and thumb his dressing-room key as a physical talisman that the show would eventually end; that the moment wasn't forever. He rubbed that key like a little tin genie and waited for the ill-deserved credits to roll down the screen like bleach down a urinal. A reminder that he'd soon be free.

No one makes me laugh like Matt Morgan. Not Bill Hicks or Peter Cook or Richard Pryor. He's all bound up in my psychosis and my humour. He could irritate and enrage me and simultaneously crack me up. Here are some of the funniest things Matt's said.

INT. NIGHT.
David Walliams's opulent house-warming party – a celeb fest, there's Dale Winton, ooooh, next to Richard and Judy and Sam Taylor-Wood, who chats to Geri Halliwell. What a night! George Michael's (not present – a lot of intrusion and stress in his life at this point – arrested in his stationary vehicle on a roundabout and found to be over the limit) long-term partner Kenny Goss is drunkenly flirting with Noel Gallagher who greets Russell Brand and Matt Morgan as they enter.

NOEL

Fookin' 'ell, I'm glad you two have turned up.
Kenny Goss has been troubling me all night.

MATT/RUSSELL

Alright mate/ How's it goin'?

Kenny is sidling over

NOEL

(nervous)

Here he comes, look …

RUSSELL

God, he looks well pissed.

Kenny is breathing all over Noel and Matt

KENNY

Wow! Who's this cutie, Noel?

NOEL

These are my mates Matt and Russell.

Kenny is clearly much more interested in Matt

KENNY

Oh I know the guy with the crazy hair, but
who's this hottie?

He means Matt, who is getting nervous

MATT

Alright mate.

Kenny moves in closer. Matt ain't happy

KENNY

I'd like to have some fun with you …

> MATT
>
> Fuckin''ell. No wonder George Michael sleeps
> in his car.

That's a gem. Look at these from the radio shows.

STUDIO. DAY.

> RUSSELL
>
> (about his boyband audition)
> And I'd been in the toilet, drinking, to cope
> with my nerves, so I was probably all red and
> blustery, and a little bit all plump and rubbish,
> all crooked and odd.
>
> MATT
>
> You drink from toilets when you're nervous?

STUDIO. DAY.

> RUSSELL
>
> (reading out an email)
> "... All the great things are simple and many can
> be expressed in a single word: freedom, justice,
> honour, duty, mercy, hope–"
>
> MATT
>
> Ghostbusters.

INT. DAY.

Trevor was at a hairdressers in Peru –

> TREVOR
>
> She [the hairdresser] indicated to me a side
> room, so I went into that with her ... and, eh ...
> she got a bucket out ...

> RUSSELL
> Trevor! This story's making me anxious.
> MATT
> What did she do? Milk you?

Plus like all truly funny people he makes you funny too. Check these set-ups, also from the radio show.

STUDIO. DAY.

> RUSSELL
> Who are you going with, your lady friend?
> MATT
> My laptop.
> RUSSELL
> Is that what you call her?

STUDIO. DAY.

> MATT
> I also used to take, when I was quite young,
> take the day off and watch *The Doors* and drink
> whisky out of the cupboard.
> RUSSELL
> You silly boy. Always drink it from a glass!
> Even Jim Morrison didn't try and drink it from
> a sideboard.

The radio show was a double act after Trev went, and the initial TV shows all bore Matt's sick stamp. Reining in the lunacy was the aforementioned television legend Suzi Aplin, who produced *Friday Night with Jonathan Ross* and also Chris Evans's masterpiece *TFI Friday*. Third time not so lucky – perhaps we should've

put Friday in the title. Even her expertise and incredible personal warmth were not sufficient to save this impatient cathode crash. Three good things came out of the show, though. Here they are –

1. I met Juliette Lewis again and from a brief flirtatious exchange glimpsed a world where I might develop a relationship that stretched beyond the pelvis and into the ticker. She was a grubby sparkle of a woman; intense and pensive, crackling and sharp. I imagined when I spoke to her what it might be like to have a lover who would also be a mate. Nothing, literally nothing happened. I was far too ensconced in what the Chinese would call "dysfunction in the affairs of the bedroom". It just made me think that maybe, one day, I might actually have a girlfriend.

2. A lad that was a researcher on the show, Jack Bayles, a kind of handsome Phil Daniels, Artful Dodger of a geezer who Suzi had brought over from Jonathan's show, stuck his bonce above the parapet and became an integral part of our ramshackle operation, our surrogate family. Jack's unusual in our group because he's cool; everyone else is a bit odd. Me – twit, Matt – freak, Sharon – warped, John R – communist, Nicola – Nan in a young woman's body. Even Nik is too good-looking to be so nice – yet is. Jack is straight up cool and professional. The first person to do the achingly necessary job of turning our Borstal board meetings into functional affairs. So on *Issues* we nabbed Jack.

3. And most importantly I learned I didn't want to wind up in the goggle box, imprisoned in living-rooms, no. After a few months of digital-diva-dom I decided that the only screens big enough to convey my ego were silver.

✝

Chapter 8
THE HAPPIEST PLACE ON EARTH

"Do you want to go to Cologne to review the Rolling Stones and meet Keith Richards for *Observer Music Monthly?*" asked Nik, excitedly. Even after his flirtation with a vaguely comical death, it is counter-intuitive to consider Richards as mortal. Bill Hicks joked that Keith lived on a ledge beyond the edge: "Look, it's Keith, he found a ledge beyond the edge," implying that Richards was beyond death and that dying would somehow be beneath him. As someone who was born after the Rolling Stones' greatest work had been achieved, my appreciation of Keith Richards is primarily as a defiant hedonist, an anti-establishment dandy and an indifferent sartorial pioneer. The music, upon reflection, is secondary.

I swung it so my Sancho Panza, Matt Morgan, could come with me. It turned a journalistic assignment into fun. We travelled with *OMM's* photographer and one of the Stones' army of public relations apparatchiks.

On the plane, Matt was pinned in at the window seat for

some reason, that it would make him less sick or more sick or something — he had some justification for needing to sit near the window. A few minutes into the flight but before the seatbelt sign was off, Matt said, "My arse is itchy, I need to go to the toilet."

"Don't be stupid," I said, "just wipe it on a napkin here."

"No, I'm not gonna do that. Come on, Russell, you've got to let me out."

"I can't be bothered to get up, look the seat belt sign's on, wipe it on a napkin here, no one will mind, no one will ever say anything."

He goes, "Alright then," and he wiped his arse on a napkin.

"Ah, Matt, that was disgusting," I said, and included that in the article that I subsequently wrote.

Interestingly I was told I would probably be in the company of Keith Richards for no more than ten minutes if that and I had to write five thousand words. A five-thousand-word piece had to be written on the basis of about seven minutes. Obviously I'd have to write about the whole journey, what I felt about the Rolling Stones, my relationship to music in general, what it was like to travel with Matt, what the hotel in Germany was like — the England football team had stayed there before us as the World Cup that had just been there. There was so much fucking padding — all filler, no killer. I liked it as a challenge, because really what is going to happen in an interview with Keith Richards? "Oh, what incredible longevity you've had as an artist, your relationship with Mick Jagger, well done not dying having taken all those drugs, you're incredibly iconic, you're a genius, why did you fall out that tree?" Anyone can ask that, but not everyone will expose that the person they went with wiped their arse on the plane — "Don't, mate, my mum will read that, it will just undermine me." I liked torturing him so much. Not every hack will

include such details, and in fact not even I included the shameful truth that there was an amazing brothel in Cologne, probably one of the best brothels I've ever been to in my life.

Surely this sweat-palmed Shangri-la had been designed by a genius, a great intellect who really understood how male sexuality works at its worst, at its most primal, the same cosmic mind that gave us Babe Station, that god-awful network where men "Call 0898 Babe Station", or Midnight Sluts or whatever, where a woman will cavort about on a bed and you can masturbate down the phone at her as she talks. Imagine that as a use for television. Some people are shocked at *Big Brother* and reality TV, but when John Logie Baird invented TV he couldn't have thought, "One day people will be able to phone up and wank into this little box." Alexander Graham Bell and John Logie Baird were fine Scottish inventors with great minds, but what ultimately drives the world forward is male onanism. Why bother to pick up a screwdriver or a pencil and paper, just put your cock in your hand and have a wank, because that's all any invention is going to lead to. I bet someone somewhere is trying to find a way of using Stephen Hawking's Wormhole Theory as a way to enhance wanking. If not they'll probably just smudge some marge on to his wormhole and use a more direct route to prickle-bliss. "Stephen, if we were to put these worms up our arses," "They're not that kind of worm," "Come on, I'm sure there must be a way."

The phenomenon of those channels is the distillation of the worst aspects of humanity; despair and the necessity of females to use their sexuality as a commodity, the need for men to have sexual release at all costs with the removal of any ritual or interaction or grace. Anyway I phoned one once. For science.

Delightfully one has the option to either be in direct interaction with the writhing dead-eyed girl on the bed and offer

her instructions to do something alluring and sexual, yes. Or you can phone up and say anything. Like "Just sit there quietly and stop worrying, you look nice, comb your hair. Why don't you leaf through a copy of *Jane Eyre*? Why don't you put on Mrs Mills and do a jitterbug? Do some sums? Stare into your terrifying future while I wank." Or, if you don't want to interact with them you can furtively eavesdrop on some other poor sod's excuse for a hobby. Now that's what I call voyeurism; you're a voyeur of someone else's voyeurism, you're watching someone else watching and masturbating. What if someone else starts watching, that's Wormhole Theory for you right there, burrowing through layer after layer of sweat-palmed reality.

After landing in Cologne, Matt and I took a cab. "Are you in a band?" enquired our driver. I've long ago learned not to be flattered by that enquiry, as it's usually pursued by a request for me to sign a photograph of Justin Hawkins from the Darkness. "No," I hastily responded, "we're here to review the Stones."

"We're journalists!" chirped Matt.

The taxi dispatched us at the door of the Hotel Crystal. I saw the backpackers queuing at the desk and the woefully cramped lobby and snootily declared I wouldn't stay.

"Don't make a fuss, you stuck-up cunt," said Matt as I asked the receptionist to book us a taxi to the Hilton. "It's only a night," he continued.

"We might pull," I reasoned. He relented.

I'd hoped the band might be staying at the Hilton and asked if so when we arrived.

"No, but the England team were here," said Melanie at the desk. England's World Cup game against Sweden had been at the RheinEnergie Stadium where the gig would take place.

"I should like Mr Beckham's suite," I requested.

"He had a standard room."

I paused. "I shall take the suite regardless."

And so to bed to rest our weary bodies and my exhausted ego. After a quick hour's sleep, the publicist and photographer arrived, sans luggage, to take us to the concert. The photographer presented us with a disposable camera to take snaps of us inside, having been informed, belatedly, that unauthorised photography is forbidden inside the venue. It seems the band's management are sensitive about their fans being photographed. As the band's age increases, so does that of their fans and the brand association is not a positive one. I must confess to being surprised by the control and neurosis present in these matters. It's the Rolling Stones, for Christ's sake. As omnipresent as the sky, worshipped across the globe for almost half a century. Surely they can afford to relax about their image? They are what they are, one would think. The objective truth, their continued brilliance, their catalogue of work, their longevity all suggest an established immovable force, above harmful critique.

As I upward sprung I saw I'd missed a bunch of nag-texts and whine-calls from the publicist and Matt. The meeting with Keith was at 6pm sharp and, obviously, you can't keep a Stone waiting. I flitted about the suite applying mascara, chainbelts and all manner of cute appurtenances until I resembled a queasy, Goth tinker en route to a marriage proposal.

It makes me feel uneasy when I am unwittingly subjugated by great fame. When preparing to meet Tom Cruise I ruefully read the litany of caveats and conditions required to assure the "un-terview" passed without incident.

The photographer wanted to arrive early to photograph me with Stones fans. What struck me first was the distinctly familial feel to the environs. This was no Altamont, it was unlikely there'd

be a stabbing here – I'd be shocked if anyone dropped litter. The stadium was ringed by stalls selling grub and the ubiquitous "Mick lip" logo, which adorned everything from T-shirts to plastic cups and gave the event the ambience of a trip to Thorpe Park or a Monster Truck rally. The publicist appeared all flustered efficiency and announced it was "quarter to Keef" and, after she'd swaddled me in wristbands and lacquered me with passes, the three of us set off, leaving Matt to merrily scoff Teutonic yob nosh. Reaching Keith, it transpires, is like attaining enlightenment: you must pass through many levels and exercise great patience and detachment.

The hospitality area had been charmingly named Voodoo Lounge or the Snake-Eyed Buffet or something, and there I met Charlie Watts's niece, Nikki, who served me banana yoghurt as the publicist went off to finalise the actual meet.

I'd become a little nervous now the meet was upon me. "He's lovely," Nikki assured me. The presence of Nikki and her pal Susie was a comfort. Both Essex girls, their bawdy humour and glottal stops gave me familiarity in this peculiar peripatetic rock mall. Noticing my pleb ticket, they said they'd arrange raised seats by the mixing desk, the gig's Camelot. As I thanked them, the publicist returned with Jane Rose, Keith's manager and a member of the Stones' entourage for thirty years. An attractive American matriarch, she initially exhibited the prerequisite austerity that all powerful women in show business seem to have – necessary, I suspect, to protect their charges and their position. Also, a dedication beyond professional loyalty was evident in her and most of those I spoke with backstage. I hope it doesn't seem grandiose to say it bordered on religious devotion, oddly discordant with the franchise feel surrounding the stadium. I was led through corridors and down stairs, like the bit in *Spinal Tap*, passing various refugees from the Sixties and exchanging a friendly nod with

Ronnie Wood till we reached a vestibule where we were to wait.

"Keith is coming," someone said. I then realised I simply had to go to the toilet. Before every exhilarating encounter, I ritually evacuate. Again, it makes me feel cleansed, light, literally unblocked; the thought, the very idea, of meeting him with full bowels seemed absurd, and someone took me, like a toddler, to the lavvy. It's not just the defecation, some faecal fetishism; I like to have a moment alone to gather my thoughts, to focus. It's the pertinent legacy from my time as a junky, when no appointment could be countenanced without a trip to a cubicle to heighten, or numb, my unreliable senses. Once solitary I began the rigmarole of unbuckling my numerous belts and peeling off my preposterously tight jeans, and then, at the least convenient juncture, came the cry, "Russell, Keith's waiting for you!" Oh God.

I hastily completed, cleansed, and buckled my belts. I think there were four and one has to be twice wrapped around your waist. It was like applying lights to a Christmas tree under the glare of an atheist with a grudge.

"Hurry up!" Oh no. I dashed out. A fidgety minion held the door ajar. I made to leave but then remembered I was about to shake the hand of Keith Richards without due hygienic procedure. "I've got to wash my hands," I said, darting to the sink. The forlorn lackey shook his head despairingly and I scrambled out the door after him while drying between my fingers with a paper towel. I still had the screwed-up towel in my wet hand as I blustered into the room where the photo that adorns the cover of that month's *OMM* was to be shot.

And there he was. Actual Keith Richards. The Keith Richards. A man called Keith Richards. Cool and chuckling, twinkling and serene, devoid of the irritation apparent among the management and flunkies provoked by my toilet trip.

"Alright mate, I'm Russell."

"Hey, man, I'm Keith."

Sometimes listening to old Hancock tapes I think, that's an old joke, before realising this was recorded in the Fifties and probably the first time anyone had commented on lumpy gravy. When Keith said "Hey, man," it seared right through three decades of cliché, a comet of authenticity, from a time when everything seemed original.

What do you say to him that he's not already heard? I resorted to pleasantries.

"You look ever so well, particularly after what happened."

"That was nothing."

I became friends once with this swami who looked at me with timeless eyes, a man uncluttered by hypocrisy, who knew that life had no meaning but to be beautiful and lived, with each breath, that ethos. This man came to mind in the company of Keith. I sense the reason he's become an icon is because of an essential quality. Rock'n'roll, it seems, is not borrowed or learned or slung about his shoulders like his guitar, but emanating from his core.

"You're a DJ?" he inquired.

"I'm a comedian, Keith."

"Hey, me too."

The photographer asked us to move closer together. Keith moved towards me, all warm.

"Can I photograph you with the guitars?" asked the photographer.

"Be easier with a camera," joked Keith, taking one guitar from a stand and handing me another. A few more flashes and clicks before we were told, "OK! That's enough!" And someone appeared to usher Keith off.

"See you later, man. Gotta go press some flesh. Enjoy the show."

"Bye, Keith. Good luck with the gig. And the flesh-pressing," I said, trying to lasso him with sycophancy as he ambled out the door.

It was dead brief, but it felt good. A hurried copulation. I felt elated. So off we went to rejoin Matt, who I knew would have spent the interim period getting drunk, and to see the Rolling Stones live in Cologne.

When they emerged with "Jumpin' Jack Flash", it was not with a roar but, rather, an echo that has perennially rung out since their birth in a crossfire hurricane. It seems churlish to chide them for not defying the passage of time. They are magnificent enough to suggest that some awful portraits must be lurking in their attics, and if they're not as good as they were in the Sixties, neither is anyone else. They have not been replaced.

The final twenty-five minutes of hits constituted the best live performance I've ever seen and called to mind Lester Bangs's famous review of Vegas Elvis when, although bloated, bejewelled and barbiturated, the King still had that voice and the power to make cocks harden and thighs tingle. Similarly, the Stones are the greatest rock'n'roll band there has ever been, and they're still without equal.

After the gig we drove around Cologne and went to a few bars and asked people where we should hang out and inevitably found a brothel. The name has long left my memory but the inspirational concept will haunt me till my dying day: on the bottom floor was a lap-dancing club. Lap-dancing is a stupid idea, because it gets you as close to sex as is possible to imagine and then denies you it at all costs, so it's actually the last thing that you should do. Women come and sit on your lap, they flirt with you, pretend the best they can that they are attracted to you, you give them some money, then they slide off and do that again with someone else, tease you to the

precipice of something wonderful, then deny you it. It's like going and watching other people taking drugs and then not using drugs yourself if you are a drug addict. Like me. Did I mention that?

Where this lap-dancing club differed was that once you'd been aroused beyond the junction at which you could legitimately hope to return, there was a brothel upstairs; the ravishing denizens of the lower floor led you up the wooden hill to Fuckfordshire like filthy Oompa-Loompas dragging away Willy Wonka's failed candidates. One moment you're being simmered to the point of ejaculation by a gorgeous transsexual, then, just when that desire is about to make you either publicly masturbate or become an avenging Whitechapel misogynist, the club's staff lead you to the promised land, one flight up – literally a stairway to heaven. As Matt procrastinated and examined a dusty Bible in his brain my unblinking Shaggy sex-force cajoled him up the steps like Scooby Doo yanked onto a kinky ghost train.

Once ascended, you peruse the Lewis Carroll corridors eyeing the treats that lurk behind the doors – an advent calendar for pervs. Three different girls visited, it was a most indulgent night. There was a period when our heterosexuality became curiously entwined without breaching the conditions of that word, escapades conducted with the nimble fingers of a bomb disposal expert, avoiding homo-combustion in the carnal hurt locker; which to me is a disconcertingly appropriate name for a gay sauna. Not that Matt and I would ever go to a gay sauna as we are not gay, our threesomes were all conducted in a manly bonding way, like a fishing trip – but a fishing trip where two pals simultaneously have sex with their catch. I believe the term is spit-roasting which is actually a good way to cook a fish al fresco. If that sounds a bit misogynistic please consider that the metaphorical fish was fully consenting and happy, and we threw it back after and she swam off all content.

Anyway, back in the German brothel. Naturally there were the ol' tragic undertones, for example the last girl was really fatigued looking, and Matt was convinced she was a post-op transsexual. "I don't think it is, Matt," I said. He kept enquiring about it like Columbo badgering a suspect. "When did you have the operation?" There was a window and you could see a train track, there's always some abject urban landscape to Nalls up my hedonism, due to the city setting. Suddenly the view from the window is pathos laden and begging for Morrissey to stick his oar in – "And when a train goes by it's such a sad sound."

The trains were going by and we were in this room. Those rooms are always lit by a single bare bulb, hanging there like a neon fissure lighting the ghastly anal cavity of a room.

I do have cause to question what it's all about, those nights where I exhaust myself with it, where I just keep excavating more and more energy – you'd think it'd be enough, you've seen the concert, you've ejaculated a few times – I go home and still there's more, it takes such a lot to lull me off to sleep.

That is again, I suppose, my unwillingness to relinquish the seamier side of life, in spite of achieving a modicum of fame, an attachment remains for the illicit and the intoxicating. I sometimes think, you've got this nice house, imagine if you had a lovely girlfriend. I don't know how to utilise things properly. Again Morrissey has a view. "When you want to live, How do you start? Where do you go? Who do you need to know?" WOohh Oooh Oh, WOoohOhho.

†

Chapter 9
HUMAN YOGHURT

At the end of 2006 we made my first stand-up DVD, *Russell Brand Live*, at the Shepherd's Bush Empire off the back of Edinburgh. My ascent from the depths was so rapid in retrospect that my memory has been bamboozled by the bends. Typically an event of that nature would be a real milestone, but actually the night of the record for me will go down as the point where my perpetually heightening hair finally reached a tipping point. It became bloody ridiculous, evidentially the extraordinary grooming of my vertical barnet had become an outlet for my addiction, as the incremental upward creep had got completely out of control like a game of "one potato, two potato" played by a pair of fiercely competitive simpletons.

Here, have a look at it. In fact look at this illustration which charts its growth over a six-month period.

I knew it was out of control, it was like when your parents show you Seventies wedding pictures – "What were you wearing – the lapels!? Look at your hair!" Except it was happening the next morning.

The Shepherd's Bush Empire is a thousand-seater room and I'd only played a venue that size for the run at Edinburgh, which was just four gigs. This would be the first time I'd headlined a big gig in London. Everything was new. As an aficionado of comedy and a social shipwreck, comedy videos were hugely significant to my childhood and adolescence – Billy Connolly, the Mary Whitehouse Experience, Lenny Henry, Eddie Izzard, Ben Elton; all were consumed and studied. David Baddiel is astonished at my ability to recall incredibly obscure bits from his set, but the reason I can is because I was a lonely little nit and those videos were my friends. So making my debut DVD was hugely significant. Not as significant as my hair, obviously, but still important. The material in *Shame*, which was the name of the tour from which the DVD was derived, was largely about humiliation and embarrassment and titled

after a catchphrase of my nan's. (Do nans have catchphrases? Of course they do.) Throughout my life she would look at me forlornly, shake her head and say, "Shame, innit?" Not to me, but about me. Although superficially this may appear to be a casual condemnation of my being, I liked it. I also dissected many of the ridiculous tabloid articles and kiss and tells that had dishonestly chronicled my adventures in the public eye.

Now that my radio days, unlike my salad days (I am vegetarian) are over, I miss what I then took for granted – weekly contact with my audience and the opportunity to parry and redress the propaganda war that the tabloids inaugurated the day I dared to dive into the mainstream. The most obvious indication of this transition was the transfer of me, Matt and Trev's rickety ol' three men on a wireless 6 Music shambles to Europe's most powerful radio leviathan, BBC Radio 2.

My Lady Macbeth-style ambition was a useful tool in slashing our way through the crusty old monarchy of red tape and, retrospectively, justifiable caution that stood in our path. As soon as we began on 6 Music I said, "Well, this is all well and good but don't you think you should get on and kill Duncan (Wogan)?" Poor bloody Macbeth. Going from "I'm not sure, I quite like him really" to "Oh no! What have I done? There's blood everywhere – here love, can you wash this out?" in a matter of days. Just to keep the fellatio flowing – I'd've stayed as a thane – whatever that is. It's a damn good argument for steering clear of marriage.

I was badgering people, mostly Radio 2's controller Lesley Douglas, beloved Lesley, a gorgeous matriarch, a warm woman

who kept me beneath her petticoats like a pasty protégé, let me hang from her apron strings from the moment she first met me. She has nurtured, nourished and indulged me as any good woman should. Short of actually breastfeeding me I can't see what more she could have done to hasten my development. Let me tell you I've been breastfed as an adult and it's better – breast milk is wasted on babies – they've got nothing to compare it to, the ungrateful little berks. I knew a woman once, married she was, who'd pop over from time to time and share her infant's creamy revenue with me, like I was a naughty jackdaw pinching creamy gold-top while it chilled on the doorstep. It was delicious – more savoury than traditional moo-cow milk – which before you condemn me is in itself a bloody odd thing to drink, and certainly the sexual element meant it was the snack you could eat between meals without ruining your sexual appetite. I felt not a flicker of guilt for this kinky act of cuckolding and tot-robbing as it were all such fun – she sprayed it everywhere – it was my own private foam party. But for one occasion of what I came to know as "dairy decadence" when the yummy mummy informed me that she'd eschewed feeding her child in order to register a surplus for this cheeky visit. Then I thought, "Is this moral? Can you ever justify stealing food from the mouth of a baby just to spice up yer sex life?" It turns out I could; after all, as I would've told the nipper had he had the facility for language – there's no point crying over spilt milk. Anyway he wouldn't have wanted to lap it up after where she'd been squirting it.

I connect well with women who are maternal, because I'm well practised at that relationship due to the intensity of the

bond with me mum. The only child of a single mum, I shall forever be contextualised by unending uteral warmth. Perhaps it is a mother's role to be taken for granted; the first face you ever see, constant source of nutrition and love. And as you grow beyond warring with their imperfection as a truculent youth you discover the truth of what they have bequeathed. I was ever a devotee to Philip Larkin's sulky ode "This Be The Verse", which begins with the lines "They fuck you up, your mum and dad. They may not mean to, but they do." Now, though, as a man I see that my more admirable traits, my compassion, gentility and warmth, are all my mother's inculcations. She who cannot pass a squirrel or a cat without imagining it a part of some Beatrix Potter world where a polite "hello" is a necessity. Often she'll make an enquiry of an animal: "Are you alright?," "What's your name?" or, more bafflingly, "Is that your baby?" Clearly my mother requires no response but she instinctively acknowledges that me, you and the furry twerps that scuttle and yip are all just making our way through life. Humble symbols of something far greater, we all may just as well have a chat.

Lesley Douglas was incredibly tolerant of my behaviour at Radio 2. If you listen to old 6 Music podcasts, you will notice that all the competition winners that came into studio while we broadcast as a prize were female. This is because there was an additional aspect to the prize which could never be explicitly stated due to the BBC's rigid policy prohibiting the misuse of the disabled lavvy. Radio 2 DJ and presumed future *News of the World* witch-hunt candidate Paul Gambaccini wrote that Lesley had a dangerous obsession with me; that I was like her pet and she was infatuated and he knew no good would

come of it. Well, I think good did come of it; it was a fantastic radio show, and yes, the BBC was destroyed in the course of it but isn't that a price worth paying for 20 or 30 relatively good podcasts and for a real hoot and a laugh?

At 6 Music, we were not "under the radar" because radar is probably a necessary part of the transmission process, but certainly we were beneath the coruscating magnifying eye of the British tabloids. The lens of their examination can combust you like a mid-August ant if you're not heat resistant. My move to Radio 2 was heralded with this headline in the *Daily Mail* above an article written by Alison Boshoff:

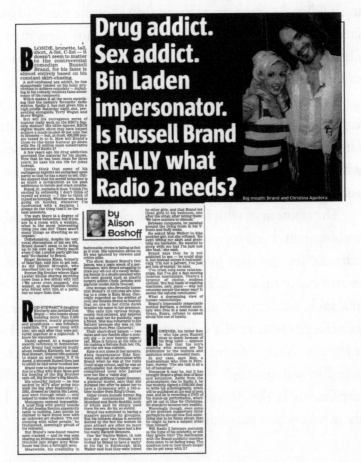

Drug addict. Sex addict. Bin Laden impersonator. Is Russell Brand REALLY what Radio 2 needs?

Big mouth: Brand and Christina Aguilera

by Alison Boshoff

My response to this was to give out Alison Boshoff's email address on-air, dubbing her "Nosh-off Bosh-off" – a suggested colloquialism for hygiene-driven inter-orifice fellatio, and to ring the *Daily Mail*. T'were a prelude to the incident that was to bring the show national notoriety; the *Mail* failed to answer the phone and we were transferred to voicemail.

"What, the *Daily Mail* not answering their phone, what are they doing, driving immigrants out of the country with a sharpened stick?" I blurted. Answering machine messages became a feature of the show.

Steve Merchant articulated Nosh-off's point more charmingly when he came on as a guest early in the run – "This is disgusting! This is Radio 2! Most listeners can't even turn off this filth when they want to – they have to hit the radio with their canes!"

We had great guests on those early Radio 2 shows. We had Courtney Love, David Walliams and Matt Lucas, and author and filmmaker Jon Ronson (who has made the shift to Hollywood with the adaptation of his book *Men Who Stare at Goats*) came on twice.

The element of which I was most proud was Noel Gallagher's involvement. He'd turn up, week in week out, like a cousin – no cabs, no fee, no shit. Just a really famous rock star shambling in and being hilarious. In spite of all the Blur vs Oasis snarling and slick, sick epigrams, he's an absolute treasure to be around, a docile sweetheart of a man who gives fine advice and has great integrity. What's more, he's a right bloody laugh and doesn't take himself seriously – and many would argue that a sense of humour is the defining quality of an Englishman. Look at these funny bits between us on the show:

STUDIO. DAY.

> RUSSELL
>
> Aw, that's a nasty, nasty perspective, especially from an atheist.
>
> NOEL
>
> I'm not an atheist!
>
> RUSSELL
>
> Hold on, you said you don't believe in God, Noel.
>
> NOEL
>
> I don't, that doesn't make me an atheist.
>
> RUSSELL
>
> Well, I think it does.
>
> NOEL
>
> Don't label me, I don't belong to any group.
>
> RUSSELL
>
> Well, you do. There's Oasis for a start.

And …

STUDIO. DAY.

> RUSSELL
>
> Alright, Noel, how's your missus?
>
> NOEL
>
> D'ya know what she done today? She fixed our boiler that had broken, she fixed it.
>
> RUSSELL
>
> Bloody hell, that's emasculating, what were you doing, needlepoint?
>
> NOEL
>
> She actually made the point that, you know

when you were doing impressions of her last night, you were making her sound like Lorraine Kelly, which did not go down well.

RUSSELL

(in Scottish accent)

"Oh it's me, Sara, I'll just fix the boiler. Noel, why don't you just sit there and wash your little vagina." That's what it's like in the Gallagher household.

NOEL

Do not refer to my son as a vagina.

He's got a natural comic mind, a quick turn of phrase. Later, when I asked if we could play "Rock and Roll Star" at the start of the MTV VMA Awards, he said, "Of course you can, then the people of America will see a bloke they've never seen before walking on to a track they've never heard of."

When things went wrong on the show, as they frequently did, we'd tell people. We were childishly honest and avoided any form of artifice, something for which the BBC was always being criticised.

We deconstructed entertainment radio. All of the items were postmodern, they were there for the sake of having an item – hence "Gay" and "Nanecdotes" (all of which originally came from emails sent in by listeners).

One week we invited linguist and radical thinker Noam Chomsky on the show and he replied saying, "Thanks for the offer but sadly life is hard and I see no place for comedy." So we went on air and launched a "Cheer up Chomsky" campaign. (Five minutes after the show Nic Philps gets a text saying that

Chomsky's wife is terminally ill, that's why he's miserable. The item was then wisely abandoned.)

We had Richard Dawkins, Ricky Gervais and Slash on the same show. We would go from an interview with Big Bird from *Sesame Street* (a bit up himself) to one with newsreader Peter Sissons (a real dreamboat). I asked Sissons if he thought the news agenda was set by the government and the forces of consumerism that control all of our minds, and whether he thought about that whilst reading the news. "Oh no," he blithely replied. "No, that isn't what courses through my brain actually, it's usually, 'Is the autocue going to work?'"

My tricky gear-shift into ubiquity was coupled with a fair amount of commentary saying, "He's come from nowhere, he's a flash in the pan." I can see why people would have been sceptical, because by the time I did become famous it was such an articulate stab; I arrived with a vocabulary, a manner of speech, a style of dress, a hairstyle, an ideology, all in alignment. Looking back a few years later, it was a perfect pantomime entry into the national consciousness.

This is where that preparation became relevant, because no longer was it just for the kids on 6 Music, there was a DVD out (and I was soon to be performing at *The Secret Policeman's Ball* at the Albert Hall). When you have to be sought out on digital media you're only going to be watched by people who actively want to see you. When you're on Radio 2 you're going to be encountered by a lot more people who don't like you. I've come to terms with the impossibility of total acceptance. Not everyone will like you if you're in a pub with twenty people in it, so when you're exposed to sixty million people obviously there'll be people who don't like you. Jonathan Ross said, "With anyone famous, there's as many people who don't like us as do, that's still enough for you

to have a career." To achieve absolute acceptance, one would have to become totally enlightened or utterly innocuous. Until then there'll always be some sort of understandable irritation.

I was very nervous about that *Secret Policeman's Ball* gig. Every gig I'm nervous about still. I can see the straight line from when I first stepped on a stage for *Bugsy Malone* to the last time I stepped on a stage, because I take performing very seriously, I'm meticulous about it, I care about it enormously, and I can't bear to be anything other than well prepared and give a good account of myself.

It was good material I did there, the Ian Huntley stuff, I always had a fascination with the tabloid demonisation of criminals. It was an indication of how far I'd come: I could do successfully at the Albert Hall material that at the Gilded Balloon just a few years earlier got me bottled off the stage and hospitalised. I'd subsequently learned how to be respectful around such subjects and where the lines are drawn, and also that once people are laughing they are a lot more tolerant of risqué material. Here is the material I performed that night, it was built around some hilarious, genuine letters from the *Sun's* "Your View" section.

I like the *Sun* a bit, I've read it all my life. I think of the *Sun* as a friend, but have you ever had a friend you fucking hate? My favourite bit is the letters page, "Dear Sun, the page where you tell Britain what you think." Not just any thought like "Move arm now, or eat breakfast this morning" – preferably a thought that might inspire hatred or antipathy towards people who are slightly different.

This is a story that concerns Ian Huntley practising witchcraft in his prison cell. When I read that I thought, what is the point of that story, because I, like most people, made my mind up about Ian Huntley when he killed those children. "What? Ian Huntley's practising witchcraft? Oh, you're joking ... I liked

him … you build them up then knock them down, don't you?"

Soham killer Ian Huntley is carrying out voodoo rituals inside jail, an ex-con revealed last night.

Let's not query that source.

"Where did you get this information?"

"This desperate criminal told me it."

"Did you give him any money?"

"Yeah, I gave him some money as an inducement to tell me the story."

"Yeah, that's alright, we'll print that, then we'll give them some fucking bingo – they'll love it."

The 30-year-old uses clay dolls made in art class, paints their faces, gives them names and sticks pins in them. He turned to the Black Magic Rituals after being befriended by 75-year-old paedophile father-figure Fred Ball.

If you're going to have a father-figure in prison, probably best to have one that isn't also a paedophile. He may abuse that position.

Here are just some of the letters elicited by that story. The first one is from Dave Franklin, who I happen to know wrote it with this expression on his face:

Would it not serve the country better if he were sent to Iraq to face the bombs and bullets our troops have been facing?

That's what the situation in the Middle East needs – heavily armed paedophiles. Have we not done enough damage in that troubled region? What we need to do is get Peter Sutcliffe in a tank and unleash him. Tell you what, let's get Rose West, take her to Basra, get her pissed, give her a jar of anthrax and let her wander round like Ophelia.

I do not think that Dave Franklin should be dabbling in international diplomacy, he lacks the aptitude. His brand of knee-jerk reaction isn't what's required.

"Dave, Dave, you're not a bright man, are you? Never speak again, you are essentially an oxygen thief."

Next letter, different tack but no less sublime. It begins thusly:

> Voodoo is very real and very dangerous, often destroying those who practise it.

Often – not talking about freak occurrences, right? On the way in tonight I saw five people practising voodoo, three of them were destroyed by it. Look at the statistics.

> With any luck Huntley will destroy himself by opening a doorway to a world beyond the knowledge of mere man.

That's a heavy thing to hope for. And then to send it to the *Sun*, which is not a metaphysical newspaper. This is a proposition that if it came from Dante would confuse you.

"Do you know what I hope happens to Ian Huntley? I hope he destroys himself."

"How?"

"This is the good bit. By opening a doorway to a world beyond the knowledge of mere man. A world so baffling and complex that

whilst Ian Huntley can perceive it – he has after all just opened a doorway to it – he can never know it, he can never integrate it into his understanding of what is, because he is a mere man. If he were a meerkat, he'd have a better vantage point."

His voodoo dolls should be taken away and burned.

Now I don't know much about voodoo … but I think that is an improper solution.

The reason I'm interested in dark subjects is that I think it's in the extremes and the margins that the interesting matters lurk. The quotidian has been dealt with on its own, it doesn't need to be explained, it's understood. Extremities of behaviour, sexuality and experience are what prickle my hackles. That's why there was that difficult transition to national fame, because my sensibilities are a little bit cult, a bit off key, but my ambition is mainstream. I don't just want to do an approximation of what already exists in the culture, I want to do things that are disturbing, unsettling and unusual, primarily funny – I want to be able to talk about anything that captures my imagination.

By the end of that year, when I did *The Big Fat Quiz of the Year* with Noel Fielding, Jonathan Ross and David Walliams, there probably weren't many people in the country who didn't know who I was. There's never a point, though, of reclining in a bath and thinking, "I've done it," and sinking down under the suds like in a Flake commercial – it always feels ongoing, it feels constant, because whenever those achievements are being made you're thinking about whatever you've got to do next. And as I've already indicated, I fancied another bash at becoming a genuine movie star – such as you might find in a cinema or a rehab clinic.

We had agreed to do *1 Leicester Square* on MTV out of what most people would think of as absurd optimism, believing that it might lead to more opportunities – perhaps in Hollywood. Remarkably, as per Nik's prediction, it did, it led to the life-changing meeting with comedy movie star and cash factory Adam Sandler. Sandler, "The Sandman" as he's known, is a compassionate fella and, far from thinking me an oik who didn't listen to the answers to questions he'd moments before posed, Sandler liked me.

Nik's foresight, my peculiar presenting style, and the astonishing approval of Adam Sandler, now meant I had an extraordinary opportunity and a difficult decision. I wanted to embrace this chance without offending my adored affiliates, as I've decided to work with them for the rest of my life, so obviously I had to consult Nik.

Nik was cool about it. "Yeah, we can pop over to America and see if we can get you in films," he said in his typical gung-ho manner. At this stage Nik had not yet metamorphosed into the swarthy man mountain-mountain man, glimmering, ultra-competitive bayonet of charisma that he is now. This was still in his scruff-bag, beach bum, wet-eyed chancer phase. And I was a volatile, sex-mad egomaniac. A trip to Hollywood at this stage could do more harm than good. We were on the next flight.

Part Two

There's gotta be a way! He who dares wins! There's a million quid's worth of gold out there — our gold. We can't just say "bonjour" to it.

Derek Trotter

If you give me the chance, I'll destroy America for you.

Johnny Rotten

Chapter 10
SERIOUSLY, DO YOU KNOW WHO I AM?

The lesson that fame is subjective is a painful one to learn. I'd
spent my entire life chasing its elusive blessing like a sunburned
tramp pursuing a butterfly made of booze, only to discover that
if you pop across the English Channel to Calais, British fame is
as much use as British currency.

"Monsieur, I should very much like to take your daughter
upstairs. And I'll have that camembert an' all."

"Alors!! You stinking English scum, my daughter will go
nowhere with you – I 'ave never seen you before and your hair-
cut is, 'ow you say ... ridiculous."

"Do you not watch *Big Brother's Big Mouth*? No? May I still
have the cheese? I'm prepared to pay ..."

Yes, anonymity was hard enough to endure the first time, but
to have it revoked by foreign travel, why, it's worse than a driv-
ing ban – it's like losing your blowjob licence. Plus I'd organised
my entire personality around fame, not to mention my physical
appearance – my haircut for heaven's sake! Without fame my

whole persona doesn't make sense. Without fame my haircut just looks like mental illness. So once me and Nik landed in LAX, I was no longer an edgy comic with a bright future, I was just another lunatic with access to strong hairspray.

Upon this trip, on these gold-paved streets, Nik and I began to forge a grown-up business partnership. He'd already shown himself to be the equal of his Darth Vadar, bare-knuckle father John Noel, our patriarch, when he'd expertly secured me the Brit Awards, which took some cunning and turned out to be a crafty move.

Me and John Noel had begun to argue; he's a force and a nat-ural dictator. I've been in meetings with him where TV shows were commissioned on the basis that the head of comedy didn't want to have his nut-bag kicked in. He was the perfect tough-guy father to get me off drugs and on to telly. Me and Nik, his son, were already mates and Nik worked at the agency, so once my career had momentum it made sense to move the emphasis and control over to Nik, a diplomat and charmer who wouldn't swagger round Hollywood pinning people to walls. So John remains for me like Don Corleone, an overlord surveying our progress, but he's not on the front line with a flick-knife.

Quarrelling between me and John was actually always very loving and manageable; I never forget what he's done for me and what I owe him. Conflict is often favourable to complicité – combined we're a terrible force when we agree, that's when problems really start. For example, John and I used our com-bined might to turn a molehill into a mountain on my radio show, giving the BBC an irritating headache that in the full-ness of scandal they would come to regard as minor. A tumult was invoked when me and John agreed that my friend Ade Adepitan, the wheelchair basketball player, tennis player, TV

presenter and *joie de vivre* beacon, had been treated badly by the Movida nightclub in London's West End.

Ade, my West Ham brethren and Stratford's finest son, told us that he'd been denied entry to Movida on account of his chair and the door staff there had used racist language, I think including the N-word, and had unforgivably called him a cripple.

Me and John were incensed, we both love a row, and John especially loves sticking up for the dispossessed – how else would I have become a client? So our combined truculence was turned upon this ghoulish boutique of vacuity and prejudice.

I decided to do no more research into the incident and invited Ade on to the 6 Music show as a guest. We urged listeners to boycott hateful, racist Movida. After the broadcast, the nightclub approached the BBC and told them their version of events. Which was essentially: "That Ade Adepitan fella's a dangerous loose cannon." They claimed he came at the door security in his wheelchair, fists blazing, firing off expletives like Gordon Ramsay in a Happy Eater; after which the BBC cut the Ade interview and Movida hate campaign from the podcast.

I was furious and John backed me. The two of us got on our high horses like angry cowboys with a cause and refused to let them release the podcast of the show without the Ade content. The Beeb stood firm, saying that their guidelines clearly stated that Movida had a "right to reply", and it would be biased to deny them that right. To which John, ingeniously, responded, "Guidelines? You don't have to listen to them. They're only there as a guide. Like a girl guide or a guide book or a guide dog. The guideline is there if you want it, but you don't have to obey it. A blind man could just kick his dog into a ditch if he

felt like it – it's only a guide." John saw the BBC's code of conduct as a mild-mannered Sherpa who he could cuff around the bonce and march past to the summit of his self-will.

I myself, in a display of hypocrisy equal to Chris Brown demanding a job at a battered women's refuge, went to Movida a couple of months later despite my demand for a global embargo. The embargo had been prematurely imposed before I learned that glamour models use it as a place to get drunk and vulnerable. This caused me to dramatically revise my policy and hurtle to the entrance in the dead of night, like Ade Adepitan, demanding entry, hammering my fists on the door – "Let me in, you fuckin' bastards, there's floosies in there," I wailed. Unfortunately, they did.

So now I work with Nik, who is a very strong character with a clear vision. You can see that he has learned at his father's knee, because he's got the purposefulness of his dad, but he's less splenetic, more considered. Nik Linnen doesn't make decisions on the basis of emotional reactions; I do, I will gamble everything on a single passing urge.

It was with Nik that I headed to LA to meet Adam Venit of the legendary Endeavor talent agency, fictitiously portrayed in the TV show *Entourage*. Arriving in LA is strange anyway, because you're tired and jet-lagged and baffled and it feels too big and you're aware of the expanse of the land. That's what I always feel when I'm in America, that I'm in a big place that's humming with difference, and being held together and pulled apart with the exact same intensity, so that it's constantly taut and vibrant, buoyant with its own suppressed explosion of diversity.

Nik and I stayed at the Chateau Marmont on Sunset Strip, on the advice of Courtney Love – I learned that Courtney Love's considerations when it comes to hotels are very different from

mine. I prioritise comfort, good food, diligence and a willingness to provide for any whim. Courtney prioritises "the vibe, man".

The Chateau Marmont is one of those hotels where you're supposed to feel grateful they've let you in. Well, that annoys me for a kick-off. I begrudge them on my groundless suspicion that if I took my mum there, she might feel uncomfortable; so, insanely, I act on the spurious and frankly "made-up" basis that they've undermined my mother in their snooty hotel. "The stuck-up bastards!"

"Sorry, what are you saying?"

"How dare you treat my mother like that!"

"Your mother?"

"Yes, my mother, who in my imagination you've just horribly derided."

"I see, sir. But she's not here."

"Yeah, because in my imagination you drove her away – you snob – you better hope that John Noel doesn't find out."

John Belushi died at the Chateau Marmont, and Marilyn Monroe stayed there. It's so beset with death and tragedy that it must be a fun place to hang out, right? For some reason a celebrity death lends cachet to a hotel which would not apply in another context. If I heard that Flipper the dolphin had had his blow-hole clogged up with dog biscuits while inexplicably staying at Battersea Dogs Home, I wouldn't be straight on the blower demanding a basket for Morrissey, but for some reason people are prepared to cough up the shekels for the chance to sleep in John Belushi's old sick.

I got the second-best suite they had, like the twerp I am, to give me something to aim for and to keep some tooth-skin attached to the fast-fading notion of humility. On the first night, I realised that because it's so cool there they don't make

an effort to please you. It's not as bad as the Chelsea Hotel, in New York, where they stop just short of punching you in the face when they give you your room key – no wonder Sid killed Nancy, he was probably bored of waiting for room service. At the Chateau Marmont the plumbing was bad. I'm not a person who's highly attuned to plumbing, I don't plumb. I'm not one to go through life noticing valves and pipes and placing my palm on radiators, but I will notice if when you turn on a tap it sounds like something from *There Will Be Blood* – a silence, then a rumble, then a gurgle ... and then Daniel Day-Lewis roars up, his face covered in oil, barking on about how he's gonna "drink my milkshake" – "You can fuckin' have it, mate, I'm lactose intolerant."

When you ask for room service, they don't sound like they're going to get it for you, it feels like a gamble; they may, they may not. Outside the window there are people carousing, you can hear the glamour clinking about in stilettos and laughing too loud at crap gags in the courtyard as you try to crawl through jet-lagged sleep on your hands and knees and you feel like there's a party down there and I should be at it but I'm too scared to go. And I can't drink. The first night I was up all night not drinking, peeping through the curtains at the tipsy glamour flirting with a pretend producer.

The next day Adam Venit and Sean Elliott inundated us with meetings. Nik was wearing a suit for the first time, he looked like he'd found it. Nik's metamorphosis over the time period from me getting *Sarah Marshall* (which is what I think the film should've been called) to now is so stark that if David Bowie had done it, people would've said, "Fucking hell, David, don't you think you're going to alienate your fans with such a dramatic transition?" He's lost two stone, dresses

impeccably and has sharpened right up.

We had meetings at Universal and Warner Brothers, Twentieth Century Fox – my favourite because every time I went into it, I sang the Twentieth Century Fox theme tune; it wasn't too many times because people wouldn't have me, they were getting annoyed.

We were having meetings with producers, which seemed to go fantastically; only when I heard the same producer who had dubbed me the "next Richard Pryor" telling a valet that he was the "Mozart of parking" did I realise they tell everyone that they're fantastic. When people say the Americans are full of bluster, I think "Hogwash!" because I enjoy people being nice to me. I don't think that when you leave the room, they go, "What a motherfucker, man!" Their frequency of communication, their social setting is more upbeat.

America in a way is the most religious country on Earth. It's not secular. They are culturally devoted to consumerism, it's a fundamentalist consumer society – "We absolutely believe that we should take your money, and we'll do it smilingly because it's polite, because you've got to hand it over anyway, if you want a doughnut."

A lot of the meetings were fruitless and pointless. Everyone was very pleased to meet us, but I quickly realised you had to have something tangible to offer, otherwise you're just going there to compare smiles with people who have better dentists than you. On the way to meetings, I'd make up ideas for films, because if they don't have a part for a sort of rookery-haired English libertarian, then you're fucked.

Fortunately, one of the people I met, Judd Apatow, did have a part for a rookery-haired English libertarian. Actually it was meant to be for a floppy-haired bespectacled English librarian,

but he changed it on the basis of my audition for the film *Forgetting Sarah Marshall*. This was a real stroke of luck.

We'd met Judd already, but Judd hadn't really made the connection that I'd be good for the part of Aldous Snow, it was an assistant at the agency Endeavor who said, "I suppose while he's here he could go read for the part of that English author in that new Judd project."

Then someone got us the script, which we didn't bother to read in the car on the way over as we were tired and kept thinking we were on holiday. (When we were early for a meeting at Universal Studios we went on the tour where Jaws jumps up and scares you. It made us late but it was also fun, I'd recommend it.) Me and Nik, all bleary eyed and baffled, made our way to some backstreet meet. I can't imagine those LA streets ever seeming familiar, like Hackney Road or Haverstock Hill or Brick Lane; just endlessly repeated grids, like those automobile play-mat carpets with roads on for little boys to push toy cars. As if the town planning was done by Fisher-Price.

We went into the designated building, where there was someone from *Desperate Housewives* auditioning in this anonymous casting director's office. It looked like the kind of place that could disappear at a moment's notice – you could turn up on Wednesday to audition for a big film, then on Thursday if you popped back to retrieve a favourite pen you'd discover that the whole operation had packed up and cleared off. "But I swear I was at an audition here, I swear I was." It was like where Joe Pesci got whacked in *Goodfellas*. Rodney Rothman, who I now know was the youngest person to be head writer on Letterman, co-wrote on loads of Judd's productions, he's a brilliant troubleshooter, he saw me and Nik in the corridor and later revealed that he overheard me asking Nik why we were

there, like a toddler at a dentist. He registered Nik's patient reply: "It's that Judd Apatow thing, mate," and I went, "Oh alright then, mate, well I'll just go to the toilet."

Rodney went back into the room and announced, "This next one should be good" – sarcastically, because we sounded like a couple of bewildered idiots in a corridor. Which we were.

Obviously I was in my full regalia, great big hair helmet, chains and crosses and quicksand jeans. On the DVD extras of *Sarah Marshall*, Nick Stoller the film's director, talking about his first impressions of the cast, said of me, "He had leather pants on and several belts." I was belted all up.

If I go to a meeting in England about telly or stand-up, people are grateful that I've come. "Have a biscuit," they say. "How's yer mum?" In LA I was on a conveyor belt of actors.

Jason Segel, the star and the writer of the film, as well as the world's most bonhomous and garrulous chap, like the Great Gatsby or some matinée idol philanthropist, and the director Nicholas Stoller were there, as was Shauna Robertson, who's Judd's trusted right-hand man, in spite of her gender, and an actress in just to read the lines for Sarah Marshall, my character's girlfriend.

They made me do it once "on script", and they laughed a bit, and then they asked if I was comfortable with improvising. The scenario they gave me was that my girlfriend doesn't want to go horse-riding, I want her to go horse-riding, and I would do whatever I could to get her to go horse-riding. That's something I'd been trained for at drama school, they teach you to use different ways of achieving an objective.

I did improvised games at Grays School and then at Italia Conti, at Drama Centre, and with my friends at the London Bridge flat when I first left home. Then Article 19, Soapbox

Cabaret, stand-up comedy with Karl Theobald, stand-up comedy on my own. Malcolm Gladwell says that success requires ten thousand hours of practice, whether it's been Bill Gates or the Beatles; he says mastery is not some sort of shamanic gift or, if it is, it's also heavily supplemented by years and years of practice and work.

So if we're in a hotel room, I'll play the view of the hotel room, I'll play the decoration of the hotel room – the sheets on the bed I'll mention. The background, reference the relationship with the girl, I'll give you something on the context of the character. At the time I arrived in that room, I was probably thirty years old, so I'd been improvising for half of my life, since I was fifteen. In a way, it was an opportunity that I'd been preparing for my whole life. All I needed to be able to do was not be so nervous and not be a dick and use what I've learned over all of those years. And thank God I was able to, because I was already way behind schedule on getting into movies.

Later that day they phoned up and said they thought I was perfect for the part, that they'd really like me to play the part of Aldous Snow, but that they'd need me to screen test with the girl that they were planning to cast as the eponymous Sarah Marshall, the beautiful Kristen Bell from *Veronica Mars* – a *Buffy*-style detective show. They wanted me to go to where that show was filmed, in San Diego, to read with her.

Instead of the advisable response, which would have been extreme gratitude and tremendous relief, I took a peculiar path, which I can only attribute to mental illness. The joyful news that I'd achieved my lifelong dream to appear in a Hollywood film was delivered by Adam Venit's clean-cut, adorably gaff-prone college boy "Robin" Sean Elliott. Sean is the impeccably spruced, Janet Jackson-headset wearing, shimmering fulfilment

of what you'd expect to find on the other end of a phone call from a talent agency in LA. I could tell from the tone in his voice that my reaction to this change in fortune was meant to be one of celebration, but I'd detected a loophole. Although Judd, Nick Stoller, Jason and everyone who had seen the audition had approved me and were keen for me to be in the film, the tape had yet to be watched by executives at Universal.

"Hmmm," I said from the shoddy, hunched bath of my hotel that I was pretending to luxuriously bathe in but was actually a painful, porcelain prison, "if Universal haven't seen it, how can I have the part?"

Sean, unfamiliar with nutcases, moved forward with his optimism-based itinerary. "Universal will approve it, they just haven't seen it."

I blew some suds off my insane hand with my crazy mouth. They didn't go far, the wall was only eighteen inches away. "Well someone should show them the tape because until I get a contract, I'm not getting out of this wonderful bath," I announced. When I look back at this senseless gamble that I was prepared to take with my cherished future dreams, it takes my breath away. I'm sure you must think as you read this, "What a pillock!" – and you're right. I can only put it down to some residual self-destructive streak left over from my junky days, masquerading as a hard-arse, off-the-wall negotiating style.

"Russell," said Sean, a little drained of the enthusiasm that had carried his previous statements, "Judd Apatow, one of the most powerful men in Hollywood, is offering you his personal assurance that the part is yours. All you have to do is get out of the bath and go to San Diego with the director, Jason, and a few other guys and read with the female lead."

I groped for the rubber duck but found a more appealing

tub toy. "It all sounds a bit fishy to me, Sean, driving to San Diego with strangers to read with a vampire detective. No. I'll take my chances here in the bath."

Sean said he'd see what he could do. Nik was at this point tied up in a meeting and unable to save me from attempted career suicide, so I determined that no matter what happened I would remain sub-aqua until my demands were met, like a one-man terrorist cell taking himself hostage – and, let me tell you, I was coming down with a bad case of Stockholm syndrome. I was identifying with my captor so strongly that I was in danger of releasing pearly ribbons into the tiny tub – never wise, as when you leave the bath you spend the rest of the day discovering crystallised sperm on your elbow.

Housekeeping and seasons came and went, but I remained in that bath. I refilled more times than Lindsay Lohan at a free bar. My hands and feet were as crinkly as my scrotum, and my scrotum itself looked like the Emperor from *Star Wars*'s neck – which turned me on so much that I had another wank. Sean sent over a back-scrubber and some bath salts, which I appreciated but also took as tacit admission that my bath-time protest was a sensible tactic. Eventually Sean called to say that Universal had seen my audition tape and approved my casting. I leaped from the bath triumphant – well, as triumphant as you can be when cocooned in your own sperm – and popped on my clobber, far dirtier than when I'd got into the bath four hours earlier but convinced I'd scored a victory.

All that remained now was for me to travel in a van to San Diego with Nick Stoller, the savant, man-child director, adorable Jason, bookish, smart alec Rodney Rothman and Shauna Robertson, a woman as mercurially fierce and sexy as she is diminutive. San Diego is bloody miles from Los Angeles, but

that is where Kristen Bell worked so I had no choice. It was a long, socially awkward journey, and had it not been for the entertainment gleaned from peeling bathtime fun from my forearms I might not have got through it. Kristen Bell is obviously a razzle-dazzle, titchy little wonk-eyed pebble of wonder, and the reading with her was a laugh. Everyone said we had chemistry and my casting was once and for all approved – I was to be the supporting lead in a big, Hollywood romantic comedy. It still astonishes me that I was prepared to jeopardise this tremendous opportunity in the blind service of my madness, but I'd gotten away with it. "If the film goes well ..." I thought on the long, LoooOOOOooooong van journey back to LA, "I could get a chance to be in my own film." But first I had to get through a three-month filming schedule in Hawaii – where I was even less famous and had no friends and no one to protect me from my sabre-toothed insanity. So much could still go wrong. It'd be a miracle if I could just get through the journey back to LA without letting the other passengers know that they were travelling with a madman.

Chapter 11
HAWAII NOT?

Nik wasn't able to accompany me to Hawaii, nor was Matt, Gareth or Jack, as they all have lives and jobs outside of me. This was at a time when the work we generated didn't justify exclusivity, so my professional friendships were polygamous. I was terrified of going there alone – whenever people remarked that working in Hawaii would be like a big three-month holiday I thought it would be more like a stint in a tropical penitentiary. Who cares about coconuts and rainbows if you're alone? Unless "coconuts and rainbows" are the names of a couple of prostitutes who work as a pair – which would not be unthinkable. Coconuts could have big, brown boobs – nice, if a little hairy – and Rainbows would be made of white light refracting through cosmic dust and give great blowjobs – for which I'd willingly pay a little extra.

In the absence of my hoppos I went with a couple of human security blankets: my assistant at the time, Marsha, who was a sweet woman, and a girl I was seeing called Jordan. I kept them either side of me as a cushion of femininity. I thought if I

took a girlfriend then I wouldn't spend my whole time hankering after women on the set, getting all daft bothering make-up women and troubling actresses.

Marsha was a diligent pepper-pot of a woman forever fussing about. It's interesting the relationship you have with assistants because, despicable though it may sound in this day and age, if I'm not careful they become like servants and I become a P.G. Wodehouse character barking giddy commands with epileptic, ever-changing needs spluttering out of my gob. And in these enlightened times one can't very well take the crop to a person just because your breakfast is a bit late – how I lament those days, though I never lived through them. I'd like to see the return of the birch for failure to bring tea on time – I once had to wait till eleven-thirties for elevenses, delirious I was by the time it arrived. Earl Grey would never have put up with that, but then he was tea's inventor.

The first duty I had to fulfil upon my frazzled arrival in Los Angeles was the Table Read. An integral part of the rehearsal process, it's often the first time the cast has got together. The table is given undue titular prominence in my view, it's a damning indictment of the standard of acting that the process gets named after the table – I'd like it to be renamed the Actor Read at very least. The fact that the table is taking all the plaudits is an indication that we need to buck up our ideas – I shall write a letter to the union.

Judd, Jason and all the cast of the film *Forgetting Sarah Marshall* were present – the brilliant Jonah Hill, Paul Rudd, Kristen Bell, Mila Kunis and myself. The four central characters (Jason, Kristen, Mila and me) sat centrally, then the other actors – such as Jack McBrayer from *30 Rock*, a brilliant comic and a fine and unusual gentleman – flanked us.

I was incredibly nervous and wanted to impress. I was also ludicrously over-dressed because I'd got the part of "myself" and thought I'd better stay in costume, even in the sweltering Los Angeles hum. I have never known whether to be flattered or insulted by the decision of those at Apatow films to alter the part of Aldous Snow from a Hugh Grant bookworm to a rock star version of me after my audition. On one hand it suggests that they were so impressed with me that they decided to rewrite the part to accommodate me, and that, through my performance, they glimpsed an unimagined world of possibility for the character. On the other it seems to imply that they thought I couldn't act. Which one is it? Will we ever know? I try not to think about it too much.

Kristen Bell and I had a bit of a flirt. I was wearing – as was the custom at the time – a belt where the excess leather swung in front of my flies.

During a break from the table read, which the table itself had demanded, claiming it had a migraine before retreating to its trailer, Kristen noticed this surplus flap of leather. That was, incidentally, why it existed: to draw the eyes of attractive women (in the case of Wonk-eye Bell, one eye is sufficient – the other one seems to have its own portfolio to wander freely, finding space, like Joe Cole). She noticed then daintily tapped it, and I thought, "Hello, the aphrodisi-belt strikes again." That flap of leather was right in front of my unmentionables (that's rich coming from me), very much the gatekeeper of my genitalia, standing there, a stout, tanned sentry guarding the door to a world of wonder. Once the sentry was accosted the treasure within stirred. As did my fragile, hungry mind. I at once conjured an on-set romance with Kristen in my mind, probably as a diversion from the angst of the situation, in addition to

her sweetness. Alas, there was an obstacle – I'd brought a girl specifically to prevent problems of this nature.

Get ready for one of those bits of the book where I demonstrate such a lack of compassion that you may be tempted to track me down and hurl your copy at my selfish face. Any normal person would, I'm sure, think, "I've brought a girl – I've made my bed – I'll lie in it." That is not how my mind functions, so instead of a reasoned response to a bit of innocuous flirting I immediately went back to my hotel and told Jordan she might as well return to London. I didn't tell her why, more likely I contrived some daft argument about a comb. *Booky Wook 1* had the huge advantage of being the tale of a man with a troubled childhood behaving badly as a result of crack and heroin addiction, this book differs because the drugs and childhood are gone but the madness remains. Well this, I'm afraid, is the way with addiction – you must know an alcoholic or a junky – we're all like it – we're nuts. Getting off drugs is just the first part, after that you've got to learn to use a brain that's previously only been employed as a filter for chemicals. Expecting good moral conduct from a junky is like expecting a clockwork mouse to cry biscuits. Stupid.

Once Jordan had packed her cases I thought I might have been a bit hasty, not to mention unbelievably brusque and cruel. I backtracked and asked her to stay. At least until I knew if Kristen fancied me.

I was socially crippled then – I'm getting better now, but on the flight over to Hawaii (or Hawaii-not? as I used to quip. Jason Segel loved that and nicked it and used it in interviews, but I think he credited me. Not to mention the fact that he did write me that lovely part – so I should probably overlook him using my not-actually-that-good Hawaii pun) with the

rest of the cast I just didn't know what to say, assumed that everyone knew each other better than I did and if we crashed in the Andes, which would've been a strange route from LA to Hawaii, I'd be the first to be eaten. In fact they probably wouldn't wait for the peanuts and tiny cans of Coke to run out before gnawing on my collarbone. I thought about eating a cellar of salt to dehydrate them on the mountain – the selfish cannibal pigs.

Interestingly Jason Segel, who's become a great friend and will be troubled to learn I was in such anguish on that isle, as he's such a shimmering comet of loveliness, has a view of me as some kind of swashbuckling womaniser. This always surprises me. I know that I've done a lot of womanising and a fair bit of swashbuckling – I mean I've hung off the edge of boats, drunk rum by the bottle and brawled with sailors – but those were all just hobbies and misdemeanours. On the inside I'm rather refined and delicate. The opposite of what Jason imagines.

Being in his movie was a big deal. Working on a movie is a big deal full stop. Millions of dollars have been spent and hundreds of people work on it. The actors, the director, the burly, surly teamsters, the camp costume folk, the nurturing but gossipy make-up people – all lazy clichés that you may as well observe as usually they'll serve you right. Perhaps entertainment has always attracted these types; even medieval bands of travelling players would, I imagine, have forged an immediate community amongst themselves as people on film sets tend to now. I had to try to bend my natural urge to isolate into a malleable rod of friendliness to survive this shoot.

We were living in a resort called Turtle Bay where the majority of the film was shot. It had the air of a joint built

in 1974 on Cosa Nostra money, like Bugsy Siegel had slung it together on a wing and a prayer. It should have been called Turtle Beige, because everything was beige: the waiters' uniforms were beige, the wallpaper was beige, the food was beige. Beige, beige, beige. When the film's set dressers decorated areas of the hotel for shooting they did such a monumentally grand job of it that if I had been the manager of that hotel I would, on seeing the unrealised possibilities that had been under my nose, have sprinted on to the shore and opened a vein with a piece of coral then offered myself to the gods of interior design. The hotel itself was festooned with tatty talismans, the odd pertinent watercolour of a turtle and a couple of actual parrots forever tethered in the lobby. I couldn't make friends with them though. I've always wanted a parrot as a result of Enid Blyton filling my head with pipe dreams as a little boy, but it is very hard to befriend a parrot, all they really want is sesame seeds and to tear your eyes out with their cruel beaks.

Hawaii, I learned, is actually a big base for American military personnel to holiday on, there were platoons of service people there. I'd see hostile aircraft darting across the sky like angry, hard confetti showering a shotgun wedding between imperial America and an unrelated distant Pacific island. The hotel didn't take advantage of the splendid view, they didn't use any of the beautiful natural artefacts, because when America marauds its way on to an island that's as near to Japan as it is to Los Angeles the indigenous culture gets ground up into beige powder.

I didn't feel employed in Hawaii, I felt marooned, shipwrecked, stranded. It took me about half an hour after arriving to turn into Robinson Crusoe. I roamed the beach looking for trinkets, any sign of civilisation, like Edward Scissorhands dressed in rags.

I racked my parched brain for cultural references to make the time pass more quickly; I remembered Tom Hanks in *Castaway* getting pally with that ball, Wilson. I thought, that's the solution, a relationship with a football. I didn't give it a name but I did build a league around kicking it through a hoop suspended from an air-vent in my room, which was rapidly becoming a madman's shack.

Due to the film's producer Shauna Robertson's relationship with Edward Norton, suddenly and without the siren that I'd've considered polite, Woody Harrelson out of *Cheers* turned up. I'd glimpse him occasionally from my one-man shanty-town, socialising with the adept members of the cast. I was of course in self-imposed exile in case my presence at gatherings revealed to the others what I was actually like.

If I'm left alone too long I regress to my childlike state, in which I'd invent games, build cultures and pass the irksome days. In Hawaii it was football that I turned to. Obviously, I played football alone, kicking the still nameless, lightweight ball through the suspended hoop in my room. I'm not very good at football and would miss most of the time, but that was actually good as it made the league I'd invented a lot more competitive – the other teams had what ought to have been the disadvantage of having no human players. They didn't have a team of animals either, I hadn't snatched a vindictive parrot from the foyer – I'm not that mad. No, I rolled a dice to ascertain their score, which I had to then beat within ten attempts. Because I was on my own I started to take it a bit too seriously and worried about upcoming games. "Wigan? Oh God, they're really on form, what are we going to do?"

I was in the middle of a tricky fixture against Spurs (I was West Ham, obviously) wearing my away strip of green under-pants when through the window I saw Woody Harrelson in

the distance walking towards my hut. I nervously watched him get nearer and nearer until he was actually at the patio door of my room. Because he's a Hollywood star he doesn't observe proper desert island protocols.

If I'm going to walk through someone's patio door I'll knock first, then once I have the inhabitants' attention I'll silently mouth, "Can I come in?" So they don't feel threatened.

Woody Harrelson just bowled in and with him came the crashing awareness that I'd been living outside society's conventions and had somehow found myself in the middle of a difficult season dressed in an unacceptable kit. I'd only been in Hawaii a day. I couldn't let Woody know I'd gone loco – I had to make the situation seem normal.

He noticed the still swinging hoop – I'd just had a shot come off the crossbar – squinted at it for a bit while I sweated, and said, "What's that hoop for, man?" I paused to see if I could think of something better than the truth to fling into the air between me and Woody; which I resented because when I invented that game I didn't think at some point I'd have to justify it to the intruding cast of *Cheers*.

I also thought, "Oh no. I'm in my green pants and there's a suspect noose-like object dangling ominously from the ceiling – he's going to think I'm into some weird Michael Hutchence-auto-erotic-asphyxiation-wank-type-thing." Here's a sex tip if you are into auto-erotic-asphyxiation: if during a wank you "start to die" – STOP WANKING, don't think, "I've started this wank, now I'm committed to it." If during a wank an ethereal, heavenly tunnel of light appears with Christ at the end of it gently beckoning you – STOP WANKING! Don't let that holy image spur the wank on to new supernatural, breathless heights. Don't think "Fucking hell there's Jesus, I'll fuck him in

the stigmata." I'll say it again: STOP WANKING. Take your penis out of your hand, loosen the belt from around your neck, apologise to Jesus and go and have a nice cup of tea.

There was an uncomfortable silence while Woody tried to work out how mentally ill I was. Until I was forced to say, "That? What, the hoop? Oh that's just where I play this football game in here on me own, day after day, hour after hour, Woody Harrelson out of *Cheers*." He looked at me. With his piercing blue, "Natural Born Killer" eyes.

It was awkward, I couldn't think of anything to say, so I went, "Would you like to play, Woody?" He studied me like David Attenborough regarding an ape that had just thrown poo at his cornet, then eventually said, "Yeah, alright."

Woody Harrelson walked over to the penalty spot, which was actually just a shower cap, put the ball down on it, looked up at the hoop, took a single breath like he were a noble Roman emperor, and said, "First time every time" – then, with hardly any back lift, took aim and struck the ball. In slow motion I watched as Douglas (I'd named him by that point – it was the panic) sailed through the air, spinning on his axis like the Earth viewed from space. Woody lowered his foot, my mouth began to gape as Douglas curved with the grace of a silken veil in the hand of a Turkish dancer and penetrated the swaying hoop like an Olympian sperm.

Then Woody smiled, strolled over to the refreshment kiosk that was being run by a cushion, picked up some Brazil nuts, didn't pay, and then meandered out the door. I watched as he marched purposefully across the green lawn and without hesitation started climbing a palm tree.

The whole sorry event totally destroyed the league, because he'd had one shot, scored one, which was an away goal – plus

he hadn't been registered as a player with FIFA – it devastated the whole system. I couldn't relax after that. I disbanded the league that afternoon in case Ted Danson burst in and start querying the offside rule. This all goes to demonstrate that no one should stay in a hotel room for three months.

What should have been happening on that island, what this chapter ought be about is me becoming a movie actor, developing friendships with the lovely people I was privileged to be working with. About how my scenes with Jonah Hill made people laugh so much that Nick Stoller wrote a film around the pair of us where I would reprise my role as Aldous Snow. And how Paul Rudd, a great character comedian, and I did a scene and how I knew as he improvised the line "You sound like you're from London" that I'd have it repeated to me all over the world – which is weird. (Sometimes people want me to say it, but, as I say to them, it was Paul Rudd's line. Then I have to say it anyway.) All these wonderful things happened in Hawaii, thanks to Jason, Nick and Judd, and now I have the chance to work as an actor in America and have my own films made.

But those are not the thoughts that occupied my mind – for example when I was doing the funny scene with Paul and Jason from which the "London" line is taken, I was in peculiar discomfort. In the set-up on the scorching beach I have to be carried from the ocean by Jason after a surfing accident, and once on the beach Jason observes that some coral is wedged in Aldous's leg. When he pulls it out, blood oozes out like a little claret mountain stream, then Jason faints and Paul arrives and delivers his line that I would have to subsequently do in cash machine queues. For me that day's shoot was defined by the prosthetic leg piece and blood pump that I had piping through my tiny swimming trunks and past my testicles. I had

to squeeze it (the pump, not my testicles) on Jason's cue so that the blood would flow at the perfect moment. When I think back to that day I think not of the performance, of Paul or the ocean, no. I recall the moment alone in the toilet of my trailer where I removed my trunks revealing my sand-caked, blood-soaked ballbags. They looked like they'd been cage fighting at the Copa Cabana. Music and fashion were always the passion … so you see for me these things are tricky. Being in movies doesn't feel the way it looks. It looks like a holiday in Hawaii, but it feels like Jack the Ripper's had a picnic on your willy.

My first day of filming was enormous. A massive, expensive scene with hundreds of extras, it was set at a celebratory barbecue or a "Luau" I believe they'd call it. There are four Hawaiian words you have to learn if you are to survive the constant goodwill, and the other three are "Mahalo", "Olu'olu" and "Aloha". They all sound pretty much the same to me – like a deaf person asking for a Polo – but I am assured they have different meanings. In the scene my character had to serenade Sarah Marshall and enact what the script referred to as simply "sexy dancing".

This is a situation where I would have definitely got drunk in the old days. I was petrified of singing in front of all those extras, cast and crew. It was a hot day, tropical. The pretty, natural coastal glade had a bizarre set superimposed on it – wooden chairs and tables, a stage with grass-skirted Hawaiian women and a fella with a little Hawaiian guitar. Actually that's not bizarre, they could've been there anyway. But also there were cables and cameras and craft services, big trucks and lights. And me, scared stiff. "I'm famous in England," I thought. "Why don't I go home and be famous there and pretend there is no America?" But you cannot pretend there isn't an America, they won't let us, they're everywhere with their golden arches

and swooshes on trainers and Coke cans and latterly, yes, their step in the right direction with Barack Obama, but a true revolutionary would argue that it's still a step in a Nike jackboot.

In a way it was a blessing, because I was flung in at the deep end. I got up on the pretend wooden stage in front of all those pretend people and sang "Inside of You", an innuendo-laden song which is explicitly about being "inside of you" emotionally, but the treble entendre of the piece is, "inside of you" vaginally, and indeed, possibly anally. Jason wrote it – and we can never truly be sure of his intentions. Given however that he has subsequently, whilst on a college tour supporting Maroon 5, performed a hilarious song called "Would it be wrong of me to use my celebrity status to have sex with a college girl tonight?" I think we can reasonably assume his intentions were cheeky. I sang Segel's filthy lyrics and "sexy danced" like it was nineteen ninety-nine. It went well. Judd was on set that day and I've since seen footage shot for the DVD of everyone laughing and enjoying my antics, which goes some way to making up for the descent into madness and reminds me why I pursue this path, to make people laugh.

From then on in I tried to focus on the fact that I was on the island to work, it wasn't about my neurosis. I struggle in these situations not to let my madness govern me, and to let the positive aspects of my character define my life.

It became clear that there was to be no on-set romance with Kristen when Jason revealed that she had a boyfriend right when I was in the middle of doing some world-class flirting, which I'm sure was about to send her knickers pinging off into the sea. There I was, joking and winking and possibly jigging by the catering lorry, when Segel sidled over like a handsome oak tree and said, "How's your boyfriend, Kristen?" I packed up my

sideshow sharpish, like a snake oil salesman when the towns-
people realise their teeth have gone yellow, and pitched up by
Mila Kunis. I was running some pretty good gear – stuff that
would have thighs being flung open from Truro to Aberdeen
– when Mila casually revealed she too had a boyfriend. Then
in a needlessly vindictive twist of the knife she added that her
sweetheart was the little boy out of *Home Alone*. Initially I was
disgusted, thinking her some kind of sexy, female nonce, then
I remembered that fifteen years had passed since then and he
would probably be an adult by now. He turned up at some
point and was very cool and nice as it happens. At least he
didn't stroll into my shack, because after the twin co-star rejec-
tion I'd restarted the Russell Brand football league. Well, I had
to do something or I'd've gone blind.

If my farcical romantic narrative had ended badly, it was
as nothing compared to the slapstick extracurricular lessons
I had to undertake to prepare me for the series of technically
demanding stunts I had to do, like horse-riding. I thought,
horse-riding, that'll be a laugh. Well it wasn't. It's really hard,
mostly because it rapidly becomes apparent that the horse
doesn't want you riding it. I don't think my horse was even
that happy being a horse. I don't think he'd accepted it; he
looked a bit embarrassed. Like he'd gone to bed as a French
stockbroker with a future and woken up with a big, long head
stinking of horse shit. He was a big, muscly coward. But in
fairness to him, it looks like it'd be inconvenient to be a horse,
walking around on those spindly chopstick legs. He'd look at
me from the side of his narrow face, all bashful. "Oh, I'm sorry,
I seem to have been reborn a horse," he whinnied through his
gritted bridle.

The equine woman in charge, who had one of those

delightful bottoms horse-women have, tried telling me that riding a horse is just like driving a car. Well, obviously, I can't drive a fucking car. All those buttons and switches and levers. A lever would make things easier – I don't like trying to control a wild and savage beast with merely a bit of rope around its neck – it's all limp and useless. I'd prefer an iron rod screwed into the base of its skull – that would give you some authority over its direction. And, for your information, big bum, it isn't like driving a car. A car won't, of its own volition, suddenly without forethought canter off into a garage and fill itself up with petrol. Sometimes, a horse just gets hungry and goes and gets dinner at the side of the road – grass they like.

Neither did I relish being aggressive to the horse – the lady told me to kick him in the ribs with my heel and "show it you're the boss". How am I the boss? He goes horse-riding every day – I've only been once. Worse was to come when I had to actually film a scene while perched on the hairy maniac's back. By this time we hated each other. I told him it wasn't my idea to kick him and that I wasn't crazy about sitting on him, but relations had broken down. On the morning of the shoot we were like divorced parents making brittle small talk on sports day. In the scene we – me and the horse – had to gallop from our mark about 100 metres, at the end of which there were literal wranglers, actual wranglers, to prevent the horse running beyond the parameters required. And I think they were wearing Wranglers, so that was good. Nick called "Action" and we galloped along for a bit while they filmed. I sat on the horse pretending that everything was OK, and for a few seconds it was. "Perhaps we've finally bonded!" I thought. This is a film within a film, where a boy and his horse, despite their differences, become friends. Yes, I've overcome this beast, I thought – "I'm a horse

whisperer!" I shouted. Then I whispered it, as I thought that would be more appropriate. Finally after seven seconds or so the hundred yards had been covered and we reached the wranglers. "STOP! STOP!" they bawled, but they could've bawled anything because the horse doesn't have language – he certainly didn't understand my whispering. Them wranglers may as well have recited a quick verse of Rimbaud. At least I'd have enjoyed that. The horse kept on galloping along past the wranglers, I noticed in passing they were wearing Levi's – the hypocrites – and through the glade. I was under no illusion about who was in control then. I couldn't negotiate with the horse. Do not negotiate with terrorists or horses. They don't like it. They don't listen anyway. He'd noticed the dynamic had been reversed and he was really happy about it. He kept up his merciless galloping till we got back to his stable. I thought, "Surely he's not taking me in there," but he was and he did. He proudly trotted in with me, his raggy-doll hostage emasculated on his back, like a Jar Jar Binks rucksack. It was so quiet in there. I was embarrassed. My horse was acting like everything was normal but the others stopped what they were doing and stared at me. "What are you doing in here?" they haughtily intoned. "We do our shits in here." I clambered down off my high horse, descended my ivory tower and tried not to puke up all the humble pie I'd been force fed. If you've seen *Sarah Marshall* you may now be thinking, "Hmmm, I don't remember the horse-riding scene." That is because my horse-riding was so unrealistic it was deemed "unusable". Even as a DVD extra.

I was also taught surfing, which was difficult. I'm not against it as a notion, but it's one of those words that elicit an image which is incongruous with the actuality, like happy-slapping. Surfing should be called "foam-choking" or "sea stabbing". If

you're a bit of a clever clogs perhaps you'll think of a theory and later learn that Heidegger or Nietzsche came up with it first, but you'll still feel quite proud of your intellectual ability. I do that sometimes, but I never would've come up with the idea of surfing. I have never looked at the ocean in all its timeless might and thought, "I shall stand on that. Put a plank on its back, then stand on the plank." We humans are denser than water. Surfing is waging war with physics. That is a battle we can never win. Walking on water is difficult. Even Jesus only did it the once. He didn't make it a hobby and do it every weekend. "Hey, dude! Let's cross the Sea of Galilee."

The deep is too mysterious a place for frivolity. Creatures lurk there that have deep blue voodoo. The ocean around those islands is home to whales and dolphins. Sometimes I'd see them and be comforted. The first time I saw dolphins I was away writing with Nik. Until I saw them I'd always questioned those who had dolphin tattoos or listened to dolphin albums. One day we took a fruitless boat trip that had been no fun so we headed home, glumly silent but for the raging outboard racket, when a dolphin was sighted.

At first it is exciting, like when you see a cheeky monkey. "Look, a dolphin!" someone'll say. Then ensues an age of uncertainty where every breach in the surface is pointlessly leapt upon – "There's one!" It is not one. It is a crisp packet. "What about that?" It is some polystyrene.

Then, as you begin to question whether or not the initial sighting was just attention seeking from Nik, out from the deep, a lithe and glistening exclamation mark of pure mammalian life punctuates the void with the resolute music that silently scores all wonder. "That was a fucking dolphin!" "Yeah, I saw that one!" We give chase and draw near, and soon the

distant dance becomes an omnipresent carnival. We slice in our vessel through the ocean's emissaries, they lead us and flank us, they follow and mirror. All about us these shimmering angels of the sea communicate through motion. The excitement is replaced by awe. We can hear them ripple and breathe, scorching grey, liquid flames they are, born and reborn with each emergence. I'd always questioned whether or not dolphins were actually any good or just one of those things that everyone assumes are great without really questioning it – like the Dalai Lama or blowjobs – but they are; burgeoning marble ghosts that embody grace. Among them we all became silent and transfixed, somewhere between a funeral and a firework display. These are the moments where one feels proximity to truth, where the supernatural becomes tangible. The ocean is not for humans.

A scene for which you'd assume I'd had sufficient practice over a lifetime, but in fact I could've done with some more, was the sex scene I had to do with Kristen Bell. Nick Stoller asked me if I minded if he filmed my arse, which I did, so they gave me these flesh-coloured briefs to wear. Is there a less erotic conglomeration of language than "flesh-coloured briefs"? They're the colour of a prosthetic limb. Underneath the briefs they gave me a little sack-sock thing to put my much-honoured genitals in. There was a drawstring on the top of it – like that bag put on Saddam Hussein's head when he was executed.

I felt that was out of order to ol' Saddam Hussein, because I'd come round to the opinion that we should let him off. This opinion was mainly influenced by knowledge acquired when they dug him up out of that hole in the ground. He came out a bit dirty with a long beard, looking like a Father Christmas who'd been sacked from a department store grotto for being

drunk at work. Well, they provided an inventory of what he had down his guilty foxhole with him and one of the items was a fun-sized Mars bar. It made me want to cry that he was down there with that. Not even a normal-sized Mars bar. Like the day he went down he thought, "I really like Mars bars but it's such a tiny hole." Where's the fun in that?

It was unerotic enough doing a sex scene with that Saddam sack on my genitals, but then there was the piercing glare of the bright lighting and burly trucker-type men stood around with tool belts, and Kristen Bell in her own version of nudey clothes. She seemed vulnerable in her pink plastic knickers, they looked like flat liquorice panties. Her boobs were covered with those silicone jelly things. In her jelly bra and liquorice knickers she looked like a prostitute for Willy Wonka.

The scene was hard because of unearned proximity, unearned intimacy – you're that close to someone but you haven't been through the typical rituals. Normally before you kiss someone or have it off you've gone through rituals, admittedly in my case at that time rather truncated ones.

"Ooh, are you Russell Brand?"

"Yes I am."

"Can I have my photo done with you?"

"Yes you can. Are you eighteen or above?"

"Yes I am."

"Let's go to this toilet."

But it is a ritual nonetheless.

A further sex-scene challenge concerned the practical realities of film-making in that each take began with Nick the director calling "Action!" Now if that word was followed by a breezy scene between me and Jonah, where we riffed out some sarcastic put-downs and did daft voices, that's all well and

good. But in a sex scene the word "Action!" becomes a starting pistol fired at the beginning of a sex race. It loads it with significance and pressure. BEGIN SEX NOW! Plus I'm representing Great Britain against America, I don't want them thinking we're a nation of crusty old fuddy-duddies, so I have to deliver, or as they'd say "represent motha-fucka". I think I probably over-compensated. When that camera started rolling I threw poor Kristen around the set like ballet in Guantanamo Bay – on the bed, against the wall, in the lavvy – using all my moves, the lizard whip, the flesh dagger and the now banned wet-poltergeist.

"CUT! CUT!" came the panicked cry! "He's gone over! Code red! Code red! This is not a drill. This is not a drill." The first assistant Gary took aim with his stun gun, the tranquilliser dart pierced my neck, I roared, Kristen ran to the shower as I slumped, a flaccid grizzly in flesh-coloured pants. The crew sighed. "And scene."

I'd learned a lot and made some lovely friends, but by the end I was chalking off days.

As the end of production drew near I yearned for Albion and watched the skies for signs. Meredith, my acupuncturist and secular witch, told me that Edgar Allan Poe would write about the shapes in the clouds; we all see shapes in clouds, but Edgar Allan Poe couldn't see the cloud in the shapes, it was all just a signifier in the sky to him. God's Facebook.

When you see life as a poem, then people become signs, and messengers. I needed to be again among women, to be adored. My mate Karl once said that I behaved often like a devoted lover betrothed to a woman with a thousand faces – every night we sleep together, and in the morning I wake hungry for her kiss. Today she is called Lucy, yesterday she was Emily, who

knows what her name will be tomorrow. I just hope she's there. Could there ever be a one? A unifying romance that would quell the undimming blaze? I thought not. I yearned for her in Hawaii, because one was not enough.

I got through the shoot without releasing into the convivial set my haunted lunatic shadow self. I kept him in the shack playing one-man football interrupted only by Woody Harrelson and masturbation – thank God those events didn't clash. Nick and Jason were happy with what we'd shot, there was talk from Judd and Nick about me and Jonah possibly doing a film together. That was of course exciting, but the real triumph was that I'd served my sentence and no one had known about my private madness; well, except Woody, and he can't talk.

Chapter 12
IT'S WHAT HE WOULD'VE WANTED

Do you, as I do, agree to things assuming that they'll never happen? These pledges can vary in severity – "Will you pick me up from the airport?" "Sure!" Or: "In the event of my death will you raise my daughter?" "Why not?" Of course the merry assumption is that the plane won't make it to Heathrow or that the daughter will be like flour – self-raising. In both cases by assuming the promise will remain unfulfilled you are making a fool's wager. This was the mentality I employed when I was offered the chance to make a film driving across America for three weeks in the spirit of Jack Kerouac's classic Beat novel *On the Road* to mark the fiftieth anniversary of its publication. As usual I eyed the notion of "a future" with rigid scepticism. "Fine. I'll make your poxy film in September," I belched. "Who's to say there'll even be a September?" I thought. With that idea safely stashed in the "thinky-fuck-hole" that is my brain-pot, me and my gaggle of gits got on with making my new TV series – the brilliantly named *Ponderland*.

Ponderland was a clip show in which we pulled together funny

archive and then I'd comment on the clips and use them as a "jump-off point" for stand-up. For example in the episode about crime we used footage of the notorious Santana gang boasting about their artillery to ridicule their re-appropriation of guitarist Carlos Santana's merchandise. The thugs stood there with their AKs, brazenly wearing Carlos Santana baseball caps; if they'd changed their name to "The Hello Kitty Crew" they could've brandished everything from toasters to hairnets – they'd've been the best-dressed gang of thugs in history – not including the Nazis.

The content of the show was less significant than the fact that it was the first project undertaken by Vanity Projects, me and Nik's production company, without the stewardship of a more "grown-up" operation. The production process comprised me, Matt, Nik, Jack and Gareth sat about in my office watching telly and giggling. Occasionally I imagine Jack and Gareth had to go and do boring production work, but as far as me and Matt were concerned, it was a cinch. Have a look at the show on YouTube; it's funny.

So when September arrived with its smug knowledge that I was contracted to make *Russell Brand on the Road*, I didn't want to do it. Aware that it would be real work, I tried to sabotage the production.

The documentary was for the BBC and had a highly professional production team. In a now all-too-common refrain, they assured me that the film would be made in the spirit of its subjects, in this case Kerouac and Neal Cassady, his muse, sidekick and fast-pulsing heart of the movement, the heart-Beat. Kerouac was a bit of a square actually, a scholar and a worrier. Neal Cassady was the real deal; a hard-drinking, womanising animus-storm. In the book they drive across their country listening to jazz and searching for enlightenment, some all-

encompassing moment of bliss, satori, "it".

The troubling thing about the Beats is that they are a right bunch of earnest prigs, clicking their fingers and calling each other "man" and proselytising about "negroes". This was all well and good when I (sort of) read the book at nineteen and didn't know bugger-all, but now I was thirty and had lived a bit. Of course the Beats were a great movement and begat modern counterculture and gave birth to the Sixties, but fifty years later to remain humourlessly enamoured of them would be a sure indication that you ain't no kind of comedian. And I may not be much, but I am a comedian. At least I'd read the fucking book, which is more than can be said for that layabout Matt Morgan who was accompanying me on the trip – in his first on-camera role of note. Matt, who has a brilliant mind, which he uses mostly to self-diagnose increasingly unlikely new ailments to satisfy his hypochondria, announced that he couldn't read the book because the writing was too small, or the cover was too crap, or he was worried that he'd developed a flesh-eating book allergy. So the pair of us embarked on a trip to pay homage to a legendary book which neither of us could be arsed to read. Which just about sums us up.

On the first day of shooting, which was blessedly in Blighty, we went to meet Neal Cassady's widow, Carolyn Cassady, who ridiculously lives in a caravan park in Bracknell, Berkshire. A place, it seems, for aspirational hillbillies – trailers but with window boxes, and inside carriage clocks and chintz. Now me and ol' Matt had developed a brilliant on-air chemistry for our radio show, utterly authentic, our relationship perfectly transposed to the studio. But telly is a different animal and, on it, so am I. A lone wolf, a prowling jungle-cat glaring sexual charisma and insidious seduction of my subject. I couldn't be expected to

do that with Matt sat there, piping up with the kind of enquiries you'd toss a lollipop lady on a classroom visit.

I don't know if you're aware, but as a presenter I had a terrible reputation for being difficult. A reputation for being difficult is what you have while you await the day where you have enough power to do what you want professionally. Then you are just focused and determined. Until then, though, you are difficult, and this was still my difficult phase. It manifested thusly: I like documentaries, and in fact most entertainment, to have some integrity, so if you're filming the meeting of a presenter and, say, Carolyn Cassady, I prefer to just turn on a camera and film it. Often protocol and tradition mean that you go and meet Carolyn, say hello, then turn on the camera and say hello again in a contrived and awkward way – I find it embarrassing. Plus I found presenting alongside Matt, like we were Richard and Judy (Regis and Kelly), bloody odd as it disrupted my tried and tested seduction methods. Therefore after about thirty minutes of impotently flirting with a baffled little old lady while Matt asked where she'd got her porcelain shire horses and coalscuttle I was ready to make a break. I have a self-destructive streak. A thread of divine madness that sometimes makes me really funny and wild but other times makes me a fuckin' liability. I get this gurgling discontent in my belly, a sense that everything is pointless and that nothing, nobody is worthwhile and that maybe it'd be better to slip off under a blanket or a drug and never face the light again. I think it's fear, dread, terrible knowledge. It can come at any time. It came on in Carolyn's caravan. "Fuck this," I thought. I wordlessly stood and drifted to the door. I smiled at Carolyn in a way that I hoped reminded her of Neal and slipped outside. There was a car waiting, I got in and sat and eyed the caravan park, a pre-emptive refugee camp

for a disaster that hasn't happened yet.

Inside Matt rolled his eyes and explained as he'd done a thousand times that I was a peculiar man and meant no harm. It was my childhood, the drugs, the dreams; the drug-induced dreams of childhood.

I told the driver we were off, he turned the ignition. Matt made his way outside and explained to Iain, the producer, Paul, the cameraman, and Adam, the soundman, that I was a good bloke but complicated. That I had unique and delicate methods. That I needed nurture like an orchid but that with that care I'd bloom and create something wonderful, that the key to working with me was to respect that I was fragile, brilliant and mercurial, a complex and challenging man – sensitive but ultimately rewarding. I saw them nodding in hard-won agreement as my car screeched by, Hendrix bawling, door flung open, my torso thrust through like a hard-on through a drunkard's fly – "See ya later, suckers!" I hollered like a nutter as I hammered the horn. "See? Sensitive," said Matt.

Having assured myself that skidding off in a loopy dust cloud was "what Kerouac would've wanted" and therefore less a tantrum and more a touching tribute, I rang Nik and told him I wasn't making the documentary. "Don't worry, though," I added, "I gave that man the greatest posthumous nod since Elton John fucked up the lyrics to 'Goodbye Norma Jean' for Lady Diana."

I panic before jobs begin or when I arrive in new environments. This is because I like to control my surroundings so as to avoid emotional peril or attack. We were due to leave for the three-week road trip the next day, but I was basically a bit too scared. The reason for this fear was my lack of acceptance of the conditions under which we'd be filming, and acceptance is a

vital component of recovery. In NA you have a sponsor, some-
one who's been in recovery longer than you who can give you
advice. Mine is Alfie. Alfie is a greengrocer's son turned mer-
chandise magnate and photographer, but his greatest gift is his
charm. People like to be around Alfie, testament to this fact is
his disproportionately high number of eclectic, famous friends.
Billy Bragg, Ed Norton and Lee Dixon are all chums of Alfie's.
When I was in Hawaii making *Sarah Marshall* and Ed Norton
showed up, the only thing he wanted to talk about was Alfie.
This is because he listens, gives good advice and is funny. Plus
he looks hilarious. Like George Cole playing a bloodhound
who's had his hair cut in Hoxton.

In this crisis I turned to Alfie. Alfie can always offer a new
perspective on a problem in spite of, in his own life, being afraid
of insects, viruses and kiwi fruit. When it comes to other peo-
ple's problems he's a swami. In this case he told me to stop being
self-obsessed and think of others and how they might feel about
being on the trip. Whilst thinking of others may superficially
seem like kindness it's actually a selfish technique to stop you
thinking of yourself. With this deployed I reversed my destruct-
ive decision and decided to go, forgive me, On the Road.

Me, Matt and the crew flew to Boston and drove on to
Lowell, Massachusetts, where Kerouac was from, with me
all the while robotically asking people if they were OK and
kindly offering them boiled sweets for the air pressure – even
after we'd landed.

Lowell is a small town where the only reasonable response
for a talented man like Kerouac is to clear off. We were only
there for a night, but for me a night without a woman is like
Gerry Conlon's prison sentence – long and completely unjust.
Luckily the hotel was screening that perennial classic of modern

sexploitation, *Girls Gone Wild*, which whilst being spiritually deplorable does serve as a masturbatory aid. If for some reason you're unfamiliar with the franchise allow me to puncture the sphere of your ignorance. In *Girls Gone Wild* real girls are encouraged to not so much "go wild" as to flash their boobs, bottoms and on occasion vaginas in exchange for T-shirts. A girl that had truly "gone wild" would most likely savage the off-camera antagonist who was cajoling them into nudity with the offer of cloth and smash through the window of the heavily branded tour bus before rejoining her pack. These girls aren't so much "wild" as eager for approval. Let's put aside the obvious moral problems these films present and instead celebrate how sexy they are. Normal porn is now so candid and formulaic that it can pass across the retina unaddressed like an escalator handrail, but this evil smut is sufficiently tethered to reality to trick the wank-weary mind into stiff, prickly interest. I once heard that pornography is bad not because it shows too much but because it shows too little, it demeans and reduces humans, strips us of our divinity and splays us on a slab like pork. That's probably true, but were it not for those wild girls that night in Lowell would've been continuing still.

The next day we shot some dry interviews with folks who'd known JK, then rode a vintage Dodge to the cemetery where the clicking and bongos stopped to have a look at Kerouac's grave. The grave was adorned with snacks left by well-wishers, who'd paid tribute to the dead author with Ritz crackers, Rice Krispie bars and peanut butter. It's confusing enough when people leave flowers for the dead as a generic gift to their remains, or cigarettes for Jim Morrison in Père Lachaise, but at least there is tradition and pertinence to prop up these trinkets for the dead. But Rice Krispie bars for Jack Kerouac's corpse? Why? Because

of the Snap, Crackle and Pop? "Wipe away that tear, my love, and reflect that now our Jack, dear Jack, has gone to the place that perhaps he always sought. The road is over for him, his destination reached, so weep not at his grave but leave a Rice Krispie treat." I scoffed down much of the food and stole the remainder, trotting out the already tired "It's what Jack would've wanted" defence.

In spite of my never-ending tributes to Kerouac the documentary seemed a little flat. If as was claimed we were genuinely trying to capture the essence of the book, we ought to have dispensed with the crew, got drunk and high and filmed ourselves trying to traverse America but ending up incarcerated. Cassady and Kerouac when embarking on their trips were not enslaved by schedules and BBC guidelines; my disregard of which was soon to have monumental consequences, but for now Matt was performing one of his vital functions – stopping me going berserk.

I don't think the BBC were being disingenuous, I think they truly did intend to make an *On the Road* documentary that would really capture the pioneering hippie spirit of Cassady and Kerouac. But Cassady and Kerouac didn't have runners, directors, production assistants and electric room keys when they crossed America. At no point did Neal Cassady lean across the car, tap his watch and say, "Jack, you do realise we're scheduled to smoke this joint at 3.30 – for pity's sake pull over."

The only people for me are the punctual ones, the ones who are mad to arrive on time, mad to conduct interviews, mad to be in a meticulous documentary on BBC2, desirous of everything at the same time, the ones who never yawn or say a commonplace thing, but burn, burn, burn like fabulous yellow Roman candles exploding like spiders across the stars and in the middle

you see the blue centrelight pop and everybody goes, "That was a really well-made tribute film about Jack Kerouac."

For me the rigmarole of making a TV show is antithetical to searching for satori, enlightenment, America.

Peculiarly, on this trip that was about two friends who loved each other deeply and the complexities of their relationship, me and Matt's friendship began to eat itself like a naughty gerbil devouring its babies. The dynamic had begun to shift and falter. We were no longer two gadabout, punk chancers, stealing briefcases and filming hookers for kicks; I was at last becoming a movie actor and Matt was becoming troubled by the ch-ch-changes. In these situations it's never wise to allocate blame for what went wrong so let's do that right now. Matt can be a pain in the arse but I am mad. And demanding. Matt once said of me "Give him an inch and he'll demand a moon base." I have an enormous sense of impatience and entitlement. I'm writing this in a Transcendental Meditation centre in Iowa, where the snow flirts with Humbert gravity like Lolita and deer wander up to my window and nervously peer as I toil. Earlier two men massaged my entire body with warm oil in a Vedic ritual that helps you to be relaxed and enlightened. I'm from Grays in Essex; you'd think on some level this spectacle would impress-a-me-much. It don't. I can see it's beautiful, but I think, "This ought be happening." Matt would be hobbling around nodding and wringing his cap in a contorted festival of gratitude.

I used to think we were like a band in which I was the lead singer and he was lead guitar; that the attention fell more upon me but we were in it together. But the reality is I am a performer and he is a writer and that is a less equal dynamic. So in a way the equality of our early friendship was compromised

by our success, but I tried to bring him along every step of the way – every TV show, every gig, every film, every threesome, I brought Matt along because I felt we were brothers.

Matt had to do the driving whilst I navigated, and that formed the basis of a lot of conflict, the two of us sat in a car quarrelling over crumpled maps. It was an interesting friendship, but the disparity in our beliefs – my optimism versus his pessimism – became a tangible gulf on the American freeways as I began to actualise my cock-eyed musings, pipe dreams and witterings. It must be difficult to be close to a performer who has the kind of ego that I have, with my expectations. My modus operandi is that I'll be content with anything, as long as I know that it's the best that's possible. I'll sleep in a cardboard box, under piss-drenched newspapers, if that's the finest accommodation available. But if I find out the person in the next alley has got a damp blanket, I'll want it.

This divergence in our outlook began to manifest itself in the documentary and how we reacted to the spiritual quest at the heart of Kerouac's tome. I thirsted for revolution, and the spirit of the Beats still glinted in the eyes of his old companions. I thought the Beats could rise again. Matt thought it was all cobblers.

Matt had a girlfriend at the time, I did not, or if I did I certainly wasn't honouring any half-hearted oath I may have spluttered out in an airport. I was gadding about across America, snogging girls in car parks and diddling women in discotheques and publishing houses (it was a documentary about a writer – take it where you find it is the womaniser's creed) and watching *Girls Gone Wild*, which blessedly was at every hotel we visited, providing what Championship clubs would refer to as a "parachute" for the occasions where real

women could not be found.

Accompanying the Adult Channel's consistently available, morally reprehensible hit was the Movie Channel's crème de menthe, the animated film *Ratatouille* – a hit Disney movie about a gourmet rat who makes it as a chef. Me and Matt never watched it but enjoyed riffing on the genesis of such a story. "How about a film in which a rat, of all things, makes it as a chef?" Why not? Who are we to say what species of animal we want to see making it as chefs? The very fact that rats are so commonly associated with poor hygiene and disease just makes the idea of him knocking up a lasagna all the more fun. "Could you also provide a film in which a girl makes it as a slut?" "Certainly Sir – she may need a T-shirt by way of remuneration …" "That shouldn't be a problem …"

When you, or your mate, drive across the geometrically impossible expanse that is North America you become hypnotised, as the first pioneers must've been, by its endless possibilities. I met a cowboy near Dodge City who said, "There's only so much horizon people can take," meaning I suppose that some people find opportunity daunting, that limitless sky is frightening with all its scope for change and hope.

I bought my soon-to-be-beloved rootin' tootin' cowboy boots in Denver from a woman called Roxanne. She had two staff members there; one of them, Stephanie, had a lovely bottom. Roxanne attended to me like a famous person despite not knowing who I was. We flirted and played; Quentin Crisp called charisma "the ability to influence without logic". I flirt with old men, children, anybody, but it's not sexual, it's mostly about real engagement, not the artificial prescriptive connections that we too often tolerate. Roxanne, the compassionate matriarchal stranger, sent the two shop girls off to have lunch

with us, and much more in my case. God knows I would never have relented until I received my birthright orgasm.

It was in Denver that we actually shot something which had shades of Beat philosophy. We were about to leave town when outside what must've been some tragedy-strewn trawler net for busted meat-puppets, homeless people on crutches and in wheelchairs swayed in clumsy congregation outside a shelter. "I wanna talk to them lot," I bawled. The term "Beat" don't mean percussive rhythm, it means beat up, beat down by life, beat. These people were beat. Now I don't wanna get all "Down and Out in Paris and London" but you can't spend any significant time as a junky without developing an affinity for the have-nots. In a Pavlovian way I'm still drawn to the damned, as it were them that led me to smack, it was at their feet I learned to cope with my condition, and there on the corner, choking on the symptoms of American affluence, the off-cuts of economic might shone like bleak beacons and drew me once more to their rocks.

Tentatively we pulled over and I clambered out of the pick-up like a Labrador, Matt just behind. We read *On the Road* with them, perched on their chairs, ignoring their dogs. One woman who wailed and preached teary Bible verse lingers with me. She was a rigid archetype found among the homeless, the zealous drunk. I reached into the charade and told her with good-humoured cheek that she ought put aside the game she was playing. She chuckled with acknowledgement, like she knew she was doing an impression of a vagrant. All along her soul had a home.

We were about to up and off, with at last something authentic in the can, when the most anti-social social worker I can ever recall encountering lurched his goateed bulk into our personal space.

Alerted by my lottery winner-style direct altruism – I'd been dishing out dollars on the street like they were flyers advertising dead presidents – he marched over to give me a piece of his mind, which judging from his vocabulary he could ill afford.

"I run this shelter," he growled. "This is my corner!"

"Well, you should be ashamed of yourself," I retorted. "Everyone here is destitute."

He sprayed yet more spittly rage. "Fuck off, you ponce," I said. I hate them do-gooders, telling you not to give drug addicts money for drugs. As if that is the junction where the problem can be solved. "Maybe if they don't have any money they'll just eat wind-fallen fruits and busk." No, if you are a drug addict you will find a way of getting drugs, you'll give up your house, your dignity, suck dick, rob friends and strangle pets to get your paws on a bag, a bottle or a rock. You can't just threaten to send junkies to bed with no pudding and hope they'll buck up.

Me and Matt continued to bicker our way across the States, many of which were as indiscriminate and angular as they appear on a map, like Thelma and Louise the night before their synchronised blob dropped. We were heading to San Francisco to the City Lights bookstore – a Beat Mecca – to shoot a conclusion to our trip in front of an audience. Stephanie, the Denver boot girl, had flown out to save me from myself and was in the hotel waiting for me when I arrived watching Girls steadily growing Wild.

Naturally after the performance I was so jazzed up on pomp that I ricocheted out of the store and into bars and started womanising. Know this: I want love not just physical but spiritual, I craved these women like insulin. I met an Australian girl who seemed like the solution and, through the weave of need

over my irises, she was beautiful. I smoked her out of the bar with my fumigating charm and the two of us led a merry dance through the trams and the damned, saluting street sweepers and making token gestures to hunched sentries slumped forgotten in doorways. It all seemed so right, like the moon was nodding on from the night.

"Come back to the room," I bartered, but my work was done, she was mine.

I had however in all the cloying romance and zippedee doo-da joy of it all forgotten that there was already a girl in my hotel room who'd been waiting for some time. Curses! Foiled again by my own brilliance, I thought. I'd picked up from Stephanie and my Antipodean companion a little too much Christian resolve to gamble on the obvious solution of a threesome, so I had to do some tricky admin. The hotel I was in was, as Elvis Presley almost said, "All booked up", so I had to find another inn like a randy midnight Jesus. American hotels for some pain in the arse reason won't let you check in without a passport – which I had left in my room. So I had to explain to the Australian girl that I was off back to my room to get my ID and she should wait in the lobby, after which I had to slink into my room and explain to the saintly Stephanie that I'd only popped back to get my passport for some implausible reason, then off I went, swallowed back into the night, the city night, the only place dark enough for me to hide.

What kind of a man was I? Treating women in this way? If this is what I'm telling you, can you imagine what's being left out? The hot-tub parties with one male guest, the coaches loaded up after gigs and taken back to my hotel, the backstage corridors of arenas with room after room filled with women. Appetite and opportunity clashed like a sequel to the Big Bang.

Often I'd try to mould these chance encounters into love, flying strangers around the world in an attempt to make the night last longer, but it never worked. I could never make sense of these women out of context. Like a jungle explorer enchanted by a glorious parrot, only to find that once home in the suburbs, away from the tropical glow, it just claws and shrieks and shits on your net curtains.

San Francisco was the end of the road. The end of the On the Road. Me and Matt left the exhausted crew and each other and headed home. Having journeyed so far together we had never been further apart.

Chapter 13
HEY PLUTO!

By virtue of its lure America began to baptise me. I was becoming, like the planet itself, American. If not ideologically, then practically, because that's where movies are made. My second Hollywood movie *Bedtime Stories* was to be shot in LA, which meant we'd have to find a residence, so me, Nik, Sharon and Nicola searched the Hills like prospectors or some cross between the Manson family and the Partridge family looking for somewhere to live. We found a beautiful place off Sunset Boulevard. Can there be a more grandiose word for road than boulevard? Can you be sick on a boulevard? Can there be boulevard crime? Could alley cats saunter on boulevards with grubby disdain or would the location make 'em glam?

Up there in the Hills the four of us, my beloved barmy quibbling siblings – Sharon, who once rode a horse through the streets of south London when she was meant to be at school, Nicola, who kipped beside me with a baby in her belly, and Nik, who skied with a broken ankle – searched for a home. We found a phenomenal place. A glass-walled house where Bette

Davis had once lived, where Motown mogul Berry Gordy had Rapunzelled Diana Ross when she was still supreme, and where Gabby, the cleaner and our new surrogate mother, told us that Arnold Schwarzenegger had once taken tea.

It was a romantic and perfect first Hollywood home and will stand as the Camelot of an all-too-short era where, once the lost boys came, I'd be a courtly jester-king laying waste to countless LA women. The fire always burned brightly in the hearth, and by night the city danced in tangerine light interrupted only by the ocean, the mountains and the dawn.

Bedtime Stories was a Disney movie. That is a world within a world. Disney has its own ethics, aesthetics and laws. Never fuck with the mouse, they say. Someone should tell Neil Tennant. The only reason one such as I had been able to nab the cheese without springing the trap was that Adam Sandler, the star and producer of the movie, had cast me himself. In a brilliant stroke of life-changing luck, Adam Sandler likes me, and in a way that I like to be liked. He calls me "kid" and gives me advice and looks at me like he knows what I'm up to. Like a lot of married men, he and his partner Jack Giarraputo like to listen to the postcards I send from hedonism's heart. Adam, I gather, was no slouch in the sperm distribution leagues but now has a lovely wife and two beautiful kids and would watch in wonder as I'd report my adventures, a bit like the other Fraggles watching Uncle Travelling Matt but with more orgies. Jack G, the other half of the sketch, is a big-shot movie producer. He knows Hollywood. Between the two of them billions of dollars have been accrued and dozens of hit films have been made. They've worked together since Sandler's first hit movie, *Billy Madison*, and me and Nik study them like apprentices. Not like Mickey Mouse in *Fantasia*, who is literally a wizard's apprentice, though, because that would lead

to copyright issues. Plus he went nuts with all them brooms if I remember rightly and fucked it up royally while the wizard was out shopping. I can't remember what happened, I watched that film on acid – which, if you ask me, is the only way to watch it.

An additional quirk in my unlikely participation in the children's film was that my character was called "Mickey". I was Sandler's foil and best mate, a room-service waiter to his hotel handyman. It wasn't a huge part, but all my scenes were with Adam, so it was a great opportunity for me to learn. For example, in the DNA of my pompous personal mythos is the fetishisation of the artist, the belief that art hurts to make, that it's somehow sublime and torturous. So when performing, particularly live, I go into a kind of shamanic state, meditating, chanting and asking for supernatural guidance. It's all about being in the moment. On set Sandler may or may not be in the moment, I don't know, one thing I can tell you is he's certainly in the edit. He's cutting the film while making it. His intention is in the future, that's important. There's no point losing yourself in some heightened revelry only to discover in post-production you don't have enough close-ups.

Being a kids' film, *Bedtime Stories* had kids in it. What a lot of tosh. Them film kids are a peculiar breed, there's no getting around it. Being in a film is a job, so if you're a child in a film the tendency is to become uncannily adult. It freaked me out. There were two children in it and they were, as you'd expect from a Disney film, adorable. The day you walk into a multiplex to see a Disney movie and are confronted by a malformed brat mewling and gurgling up grey bum-junk will be the day Walt puts his frozen head back on his shoulders and starts kicking some mouse-arse.

Obviously children can't work as many hours as us adults. This not being Victorian London, there are rules and regulations

to protect the diminutive divas. As a consequence the kids have doubles, so when the camera is not on their impossibly cute little faces they can use the back of some chump kid's head while the star child unwinds in their trailer with a bubble pipe and *Playboy* cartoons. If you on some level pity child stars and their inevitable descent into drug addiction, then spare a thought for those unsung future junkies, the child-star-stand-in. I overheard this piece of dialogue between one of the stand-in kids and her boss, who also on some previous less financially rewarding day had fired the brat from her vagina.

INT. DAY.
The little girl dashes towards her mother, heart full of glee, stomach craving the nourishment of maternal approval

LITTLE GIRL
Did you see me, Mummy? Did you see me ...
Mother?

MOTHER
Yes, yes, I did see you.

LITTLE GIRL
Was I good?

MOTHER
Yes, you were very good.

And here an agonising pause ...
LITTLE GIRL
Did you see my face?

MOTHER
(With brutality bordering on contempt)
No. Just the back of your head.

Welcome to Hollywood, kid. Where dreams become reality and reality becomes a nightmare.

And if you think the Mickey Mouse Mickey Mouse kids had it tough, then what remains of pity's dregs for the dwarves who stepped up to the plate when that subhuman child slime couldn't be relied upon to flash the back of their heads for money? Yep. That's right, when the real kids were all spent and their seconds were all spent, dwarves – little people – were drafted in to pick up the slack. One day, mid scene, I popped off to the lavvy having caffeinated myself into a stupor, leaving Sandler and the kids bantering while they did a re-light. When I returned to set I thought little had changed but the tension in my bladder. As I returned to my mark I made to recite my lines into the beaming faces of the fetal fat cats but found instead that I was looking into the adult faces of the dwarf doubles. It was like a lazy episode of *The Twilight Zone* – "Shy Height Zone"?

The cast was awash with interesting faces. The villain was played by the brilliant Guy Pearce, who never once, in spite of his brilliant Hollywood career, objected to me referring to him as "Mike from *Neighbours*", even going so far as to deliver the line "What's that supposed to mean, Scott?" which, he assured me, he was required to say at least once per episode when he came on the radio show which I was doing trans Atlantic with Matt. Richard Griffiths – Uncle Monty from *Withnail and I* – played the hotel manager and was a wonderful on-set presence with never-ending theatrical yarns and booming soliloquies. Although, naturally, all I wanted to hear about was *Withnail*. Then there was Lucy Lawless, whose actual name is probably as absurd as her most famous character Xena: Warrior Princess. She was a strong and spirited woman, another of those whom I eyed with wonder, pondering if ever I might have such a one to call me in from the tit-blizzard.

Of more interest, though, than the kids and the icons and ironic superheroes was the lead actress. Teresa Palmer is pretty. So pretty in fact that she could probably spend the rest of her life sat passive in a market square being pelted with money by desperate men. So beautiful that it seems like no one should be allowed to have sex with her; that her hymen should remain for alien archaeologists to peruse in the year 5000, when maybe they can quantify such beauty. Like an action figure remaining untroubled behind cellophane, too perfect to be tampered with. Not a toy. Her hair seamlessly fell in honey rivers from her golden skin, each feature a monument to its ideal, the perfect nose, the perfect mouth, the teeth too good to eat. Ah, and the eyes? The eyes! A new colour, blue like Krishna's skin, blue like the hallucinogenic sunrises of my youth. Blue. So blue that the word blue is rinsed and refreshed by their beauty. Eyes that shame my mortal eyes, that make even the miracle of light and sight secondary to their ornamental dominance. Plus she was a nice bird. Australian, down to earth – what choice do they have? They're all crooks and the price of a no-class system is no class. Christian too she was, and all bound up in moral swaddling. I watched her from the periphery as I picked off extras like Shere Khan and amused Jack and Adam with the tales.

Of course everyone's equal, I'm not picking up a gauntlet cast by Christ and Marx simply to justify worshipping women, but sometimes they're like angels, aren't they? Is this my buckled childhood that allows me only Madonnas and whores? Not to have a partner who's a friend and an equal? To strain to hear the lark within the dirge? It seemed to me that Teresa could not just be hurled into the furnace, perhaps not due to any objective quality she had but because of what she provoked in me. She made me want to get down on to my pagan knees and worship Mother Earth.

I was enjoying the extras, of course I was – I'm only human. But this Teresa situation was getting to me. We'd spoken a bit, notably on the day when I was made up as a golden robot, a kind of Rasta C-3PO – literally every bit of my body lacquered in gold paint and plastic, a gum shield of gold, golden eyelids – like Midas had tried to reach out and touch me. Actually my willy remained pink. It looked daft when I went to the lavvy, a single piece of organic matter stuck to a giant ingot. I began to charm Teresa as I best I could whilst squinting through the radiance. The day it came to a head was when we were shooting a big scene in which Adam had to impress Uncle Monty while Mike from *Neighbours* and Xena tried to scupper his plans. It was set at a Hawaiian barbecue (what is it with that place and my film career?) shot on location in a giant mansion. There were hundreds of gorgeous extras and it took place over three nights. In the scene I was wearing the exact costume Baloo wears in *The Jungle Book* when he tries to seduce "King of the Swingers" Louie into releasing Mowgli. Literally exactly. I mean I was wearing a coconut bra. Why a monkey would want to fuck a bear in a coconut bra is a mystery to me but I'll tell you what – they're fuckin' itchy. And grass skirts are no picnic either. Unless you're a cow.

I did a pretty good job of chatting up extras for a man dressed as a bear dressed as a monkey dressed as a woman, but I was starting to think I might like a shot at Teresa, and this night she was beautiful like a dagger in the mind.

In the scene there was a moment where she emerged from a swimming pool in a white bikini like fuckin' Aphrodite or a bird from Botticelli, so that in the film me and Adam would be dazzled. No. Acting. Required. I wanted to be sick out of my penis. In fact when I improvised the line "I love you" – and this made the cut – I meant it.

Which worried me, so I did what any normal person would do: I phoned celebrity hypnotist Paul McKenna and asked him to hypnotise me out of being in love.

Paul McKenna has helped me in countless situations. When I am nervous about doing gigs he hypnotises me into being more normal using his brilliant mind-bending NLP techniques. He carries still the vocal tune of an Eighties breakfast DJ, which is what he used to be; a suave nerd rumoured to be the highest paid entertainer in England.

Paul is funny. Alan Partridge funny. He's sweet and generous and brilliant, but he says some off-key stuff. When I called him to ask him if he could brainwash away my natural emotions, due to the time difference he was out socialising in London and, I think on this occasion it's safe to say, drinking. I addressed the mechanical lady who answers his phone when he's out. "Hello? Paul? It's Russell. I need your help. I've fallen in love with a girl who's on this job I'm doing. It's gonna balls up everything – I'll be thinking about her when I'm supposed to be working – or having sex with the extras. HELP!" No need to press 1 to re-record that baby.

Some time later Paul called back. I picked up and he said these exact words: "Hey, Russell, what's up? Some bitch twisting your melon?"

What a wonderful way to start a conversation, a remark first made by Steve McQueen, immortalised by the Happy Mondays and finally said to me down a phone by Paul McKenna.

"Yes, Paul," I said. "Some bitch is twisting my melon in so much as my melon has been twisted into loving her by her incandescent beauty." Paul composed himself.

"OK, no problem, Russell," he said, sensing this was an emergency. "It's just like anything else, we can hypnotise you

In Malaysia I became a rock'n'roll writer. (🔊)32

Wearing the hat I would soon dazzle Puff Daddy in, I relax with my social conscience, John Rogers, and my ball-breaking patriarch, John Noel. (🔊)33

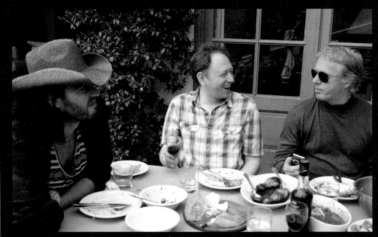

Me and Nik as Christ before and after crucifixion. (I am in make-up not post-traumatic stress.) (🔊)34

Panda-eyed Mick, Havering Hulk Danny O'Leary, me and Nik on tour.

🔊 35

My view from the back of Mick's motor. "Watch out for the bus, Mick," Danny is hopefully saying.

🔊 36

We went clay pigeon shooting and realised immediately why posh people do it. It's fucking great. I wish I wasn't a vegetarian – I'd go on a rampage.

🔊 37

We picked this photo of John Rogers because it makes him look mental. Just to be cruel. He's done nothing to deserve it. 🔊 38

This one makes Gareth look like a ponce. He does deserve it. 🔊 39

Me and Gee fighting with the lightsabers I bought him for Christmas. He literally loved them. Like a child. 🔊 40

Me and Jack – both Irons – in the Hammers dressing room. That slogan is NOT sarcastic. 🔊 41

🔊 Where you see this symbol go to www.russellbrand.tv/caption for Russell's audio commentary

My adored godson Ollie is tickled into submission in Leytonstone. 🔊42

His little brother Joey – Baby Brian Jones – hangs out in the garden. No swimming pool – thank God. 🔊43

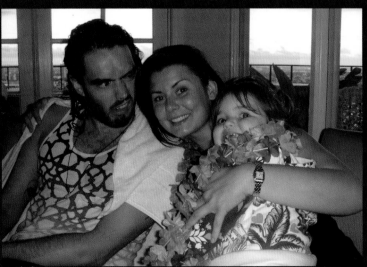

Me, Nicola and Minnie in our West Hollywood home. I ruined that photo – but, hey, they ruined my life. 🔊44

🔊 Where you see this symbol go to www.russellbrand.tv/caption for Russell's audio commentary

I fell in love with Helen Mirren during *Arthur*. I bought her this bear, which she refused to have in her house because in her words, "He has an unsavoury look in his eyes." 🔊 45

Set list on fist, in San Francisco. 🔊 46

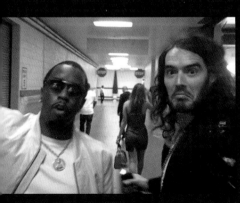

Me and Puffy on our way to Hatton vs Pacquiao, probably discussing that girl's bum. 🔊 47

On a jet with Puffy. Yep, that's my life. 🔊 48

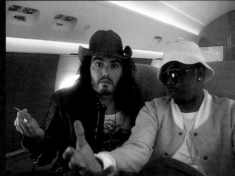

Alfie took these shots around the 09 VMAs.
Big Dan makes me feel like a natural woman.
🔊 49

Tom, Jack, Gareth and me hang out in the
room opposite a girl who would soon make
me hot, then cold, then hot again. 🔊 50

Alfie – my sponsor, photographer friend – took the photo from which the genius Shepard Fairey illustrated the amazing cover, by which you should judge this book.

Nik took this one of me and Alfie. The lid was on.

Radio City Hall, VMAs 09. Just about to get hit by the thunderbolt in the background.

And here she is.

so that you can deal with these feelings. We need to dilute this senseless love, like orange squash or strong paint, by proposing extreme alternatives to your mind. Or your melon, as we professionals call it."

He raised his voice above the hubbub of the King's Road bar I presumed him to be in. I settled into the beige sofa that all movie trailers are contracted to have.

"Now, Russell, I want you to imagine a worst-case scenario. I want you to imagine her having sex with numerous men in every single position imaginable. She is being degraded; they are doing whatever they want to her. They're using her body as a theme park for their pricks. Can you imagine that, Russell?"

I felt the bile rising in my throat at the prospect of these painful transgressions against my imagined beloved. I steeled myself and fought back the tears.

"Yes I can."

"Good," intoned Paul. "Now, tap yourself on the forehead, tap yourself on the wrist, say 'Baa, Baa, Black Sheep', look to the left, look down to the right …"

This seemingly crazy ritual disorientates the mind, disrupting all your romantic poppycock and replacing it with Paul's dark art. He continued. "Baa, Baa, Black Sheep, 1-2-3, she is having sex with all these different guys and some of 'em ain't wearing johnnies – how do you feel about that?"

"I feel queasy, Paul."

"Don't be weak – it's just your brain trying to destroy you with love. Now, relax, take a deep breath and imagine the best-case scenario." I did as I was instructed, relieved that the horror of these pornographic nursery rhymes was at an end.

"OK. The best-case scenario, Russell. Imagine she is yours …"

"What a relief!" I thought. After all that degradation finally some romance. Paul continued. "You've got her right where you want her – you're fucking her in the arse, you're fucking her in the mouth …"

"PAUL! PAUL! STOP! OW! MY MELON! Mate! That is not my vision of the best-case scenario. It's much more that I've fallen in love with her and want to, you know, give her a rose or something." But Dr Mesmer's locomotive was not to be derailed.

"You're fucking her in the arse like the whore she is."

"Paul! Stop! I want to marry her or at least go on holiday with her."

I could hear the runaway train of Paul's brilliant brain juddering into my sentimental station. He paused and reflected.

"Oh. Sorry, Russell. That's probably some of my shit getting in the way there." He recalibrated.

"OK … So you're with her, it's a sunny day. In a meadow. By the sea, or a lake – water of some kind, like in a book. Something of that ilk." His references for romance were not so quickly forthcoming.

"How do you feel now? Any better?"

"Yes, I feel a bit better I think, Paul."

"Good. And how do you feel when you think about her?"

"Erm … I still feel a bit of a twinge in my stomach when I think about her."

"Well that's not good, that sounds like it could be emotion. We'll soon get rid of that. Have you ever seen her looking ugly?"

I conjured the vision of this Venus. "No, Paul, she's never looked ugly," I sighed.

The line fell silent and for one terrible moment I thought Paul was stumped, that true love was a force too powerful even

for Paul McKenna's incredible abilities, but he had one more ace in the pack. Drum roll please ...

"OK. I want you to imagine her head on a dog's body."

The next day Lucy Lawless, Xena: Warrior Princess, was having a barbecue. These are the kind of sentences that make a mockery of actors claiming that making films is just a craft, a job – like being a carpenter and making tables. A carpenter would rarely be asked the question "Xena: Warrior Princess is having a barbecue on Saturday with Mike from *Neighbours* and Uncle Monty – are you coming?" "No, because I will be making tables." The only carpenter who would be unimpressed by that invitation is Jesus or possibly Karen.

The Warrior Princess's barbecue took place at a Beverly Hills pad, a bungalow that looked like David Hockney had painted it, spread out over acres with a Japanese ornamental pond and a giant indoor aquarium where Xena's kids kept tarantulas and lizards. I arrived with Sharon, remembering two important things: a bunch of flowers for the hostess and to imagine Teresa Palmer's head on a dog's body.

To be honest I quite like dogs, so the technique wasn't that helpful, and she looked amazing that day. Cool she looked, in the garden when me and Shaz arrived. I squeezed Sharon's hand and palmed off the bouquet. "God, look at her, Sharon, she's incredible," I said. "Even with that dog's body."

"Go and talk to her, you idiot. Use that personality you're always on about." I glared at Sharon and had we not been at a posh barbecue I would have spat at her, which was one of the main ways we communicated. After hours of watching Teresa and pretending to listen to other people I decided to employ the old "be nice to

kids to attract women" technique. Luckily the mandatory Mexican housekeeper had brought her son to work. He was about four and a likeable sort of cove. I'd been pulling faces and such like and shooting him with an imaginary gun for ages and he was lapping it up, but as yet Teresa hadn't noticed my incredible, unaffected rapport with children. I had to up the ante. So I pretended to be a sort of monster-stroke-gorilla creature and chased after the mite and swept him up into my arms with a terrifying roar. "That should do the trick," I thought. The kid was bellowing with laughter so there was no way she could ignore this move. She looked over, checkmate. But what's this? Instead of cocking her head to one side and giving me a gooey smile she looked sort of, well, horrified. Well, that wasn't on the menu. I glanced down at the pocket Pablo I was swinging about between my legs to learn that what I'd taken to be gleeful chuckling was in fact, uncontrollable crying – and not just from his eyes. The melody of his tears was being backed up by the treble of his terrified piddle. "Blast. This kid is blowing my game with his unscheduled waterworks." I tried to cheer him up with another mock shooting but the lad was inconsolable. Luckily his mum stepped in, shot me a glare and marched off with a tearful tot. I was back on track, no harm done except the wee-wee I was wiping off on to the back of one of Xena's deckchairs.

Teresa made for the bathroom. I seized the opportunity and caught up with her by the time she'd reached the tarantulas. "Kids, huh?" She looked confused.

"Kids," I repeated. "I love 'em."

"Well, you've a funny way of showing it," she said, frowning a beautiful frown.

"Yeah, I'm complicated," I muttered, staring off into the distance where the child's sobbing could still be faintly heard. Beautiful girls spend their lives getting chatted up, so to get

past their defences you need some pretty potent artillery. I gave her hair a pull. "Fancy coming for dinner?"

"What? I've heard about you, mister."

"Yeah? What have you heard? That I'm a rogue? A heartbreaker?"

I had a good speech for this kind of approach, but before I could embark she interrupted. "No. That you're a prat."

Lesser men would've been swayed but you'll get nowhere in life if you can't skip past a few superficial insults like Alan Devonshire evading a clumsy right-back. "Let's go for a walk and see if we can't get past a few of these terrible misconceptions." Blessedly there was a trampoline in the garden and Teresa and I clambered on; it was one of those ones with mesh round it like a cage-fighting ring. Like all Australians she was incredibly fit and agile so she leapt like a sexy gazelle. I nearly broke my spine trying to match her. Soon, though, the rhythmic bouncing and its obvious carnal parallel coaxed us into flirtatious union. That girl looked good on a trampoline. Her cleavage, her boobs, which I tried to ignore, were more hypnotic than anything McKenna had battered me with. Plus she was really sweet and funny and tormented me as we jumped higher and higher, and for a minute I forgot myself and it was lovely, just to be with a pretty girl, smiling, mucking about, crashing the heavens as we bounded. Other people soon turned up to pop the bubble, but by then it was too late. We'd bounced right into a romance. In the car on the way home I was drunk on it all.

"It's a shame, though," I said to Sharon, "that the film *Big* uses a trampoline to indicate the commencement of an affair when Tom Hanks takes that woman home – it undermines it."

"Russell, you idiot. This is real life. You can't go back and do the barbecue again because your trampoline scene lacked originality."

The next day was the premiere for Adam Sandler's film *You Don't Mess with the Zohan*, and this was where I'd next see her. I was in the right state of mind because I'd had a quick session with McKenna in which he'd brainwashed me into being a heartless psychopath, so I was able to cope. That night she was a Hollywood actress at a film premiere; she was just wearing a dress that was made out of ivory or whalebone or something that ought to be banned. She was cruelly beautiful.

I tracked her at the after-party at the famous Teddy's nightclub. Completely single-minded, my breath slowed as I watched her.

"Hold my coat," she said defiantly as I moved in.

"I'm not really that sort of person," I smiled.

She pushed it into my hands. "You are now."

All else faded, the chatter and light receded as I edged closer to her. She looked at me across her drink with those eyes. "Are you always going to live like you do?" she enquired. "All these girls, all the promiscuity?"

"I hope not," I replied, holding her gaze, emboldened by my sense that the moment was at hand.

"Don't you want a family? Children?" She'd obviously forgotten that little boy I'd traumatised the previous day. Good.

"I would like to one day, yes," I said, drifting closer to her mouth, imperceptibly on each syllable. She was moving closer too. These are the times that make it bearable. Perhaps this girl might bring salvation. I am tired of the unsettling whirl, perhaps I can rest here in her eyes.

"Do you think you'll ever change?" she asked me with breathtaking sincerity, and for the moment I was safe. I fell into the kiss.

"I'll change for you," I whispered. And I did. For a week.

†

Part Three

It's always funny till someone gets hurt. Then it's just hilarious.

Bill Hicks

They sicken of the calm that know the storm.

Dorothy Parker

Chapter 14
THEY NEVER FORGET

If the quest for true love, the pursuit of the ideal partner I'd craved as a lad, before I grew into a clichéd hell-raiser, remained perplexing, at least my career looked to be in good shape. *Forgetting Sarah Marshall* was doing well in the States and our decision to head for the Hills looked shrewd. As ever, though, I was impatient for more success and notoriety, so when Dan Weiner, our new Canadian PR pal, a jittery, charismatic, Jewish pogo stick of enthusiasm, floated the idea of me hosting the 2008 MTV VMA awards, Nik and I thought, "Why not?" As I observed with the NME Awards, these shows can give an entertainer an anabolic career boost, but as with steroids there are risks. Steroids give you terrible mood swings and, in a twist worthy of Goethe, shrink your prickleberry. So think carefully, bodybuilders, before making that pact. Were there a drug that shrivelled the bicep but sent your privates hurtling to the floor like a greedy flesh drill then I'm sure sexual athletes everywhere would be struggling to open jars and dragging lolloping goolies about like dead dogs.

I'd begun performing stand-up at the Roxy on Sunset Boulevard, a smoky little sex den where the Pistols, Bob Marley and the Doors had played. We got MTV execs to come and watch me play there, and they were sufficiently moved to offer me the VMA gig.

This was a big deal, as American readers will know. British readers will be thinking, "VMAs? What in Her Majesty's name is that?" Well, it's that big music award show where Michael Jackson went mad and mistook a birthday cake for a lifetime achievement award (which I suppose in a literal sense all birthday cakes are), where Madonna snogged Britney, who herself at a subsequent show writhed around with a white python in a display of phallus worship that Ron Jeremy would have rejected as vulgar. So now you know, it is an event with a certain amount of national significance; more than I'd anticipated.

One thing MTV still does well is promotion. Nik and I flew to New York to discuss the campaign that would launch the event. In a pop-cultural coup they secured the involvement of saucy snake handler Britney Spears, who'd had perhaps the most eventful year in tabloid history, having been denied access to her children, publicly shaved her head and been photographed using her baby as a pair of driving gloves. Britney and I would make a series of promotional films together. Me and Nik met with bigwigs for a powwow in a skyscraper to iron out the details.

"We want you to be edgy," said the MTV marketing guru, adjusting his specs.

"OK."

"But don't say anything rude to Britney."

"Right."

"Be rock'n'roll and dangerous but don't mention any of the year's disturbing events ... But do be edgy."

"Well, that's going to be tricky," I said. "You want me to be dangerous, rock'n'roll and edgy but not to bring up any of the things that a dangerous, rock'n'roll, edgy type of character might mention."

"That's right," said the exec. "Is that going to be a problem?"

"Well, you're asking me to walk a bit of a tightrope there."

The exec nodded. We were all quiet for a bit, and I for one had a jolly good look out the window at the Manhattan skyline and imagined playing Tetris into the gaps in the buildings. This took me approximately one hour, after which I returned to the discussion.

"I mean, chaps ..." I began, "everyone's going to be thinking about those cartoonishly scandalous events – if I don't mention anything, don't you think there might be a bit of an elephant in the room?"

Then there was some more quiet and I scanned the premises, which like all media offices was full of toys and trinkets and gimmicks; kidult claptrap.

"What if ..." began the exec – let's call him Kevin because that's his name – "there was LITERALLY an elephant in the room?"

I regarded him for signs of devilry. "What? A real elephant?"

"Sure."

"What! You know where to score an actual elephant?"

"Believe me, I can get an elephant."

"So ... I'm gonna meet an elephant?" I was naturally excited. One frequently meets pop stars in show business, but elephants? They seldom make an appearance. There was nothing more to discuss, we had our concept – an elephant.

The day of the promo, back in LA, I'd begun to consider the elephant an icon of forthcoming fortune; after all they

provide a symbol for the Republican Party, the head of Hindu deity Ganesh, and are famous for never forgetting – although this last is somewhat spurious as there is no evidence of an elephant ever remembering anything either. Britney was there, fragile and pretty. Just a girl, of course, when viewed away from the circus (although as I keep saying there was one elephant), like an ambassador visiting us from the nation of her own notoriety. "Fame, fame, fatal fame," said Morrissey. "It can play hideous tricks on your brain but still I'd rather be famous than righteous or holy, any day, any day, any day." When you meet the famous, be it Kate Moss or Jonathan Ross, Sandler or Britney, their humanity, good or bad, seeps into the encounter and you acknowledge that in fact like all objects of fetish, all icons, they are a reflection of your perception. They are used like saints or gods; here to tell stories, to give us warnings of the perils of success or to be held aloft as examples of con-temporary ideals. One figure can be used to represent either extreme, depending on the culture's mood; David Beckham or Lady Diana can be an example of domestic excellence or indi-vidual indulgence depending on the tabloid, depending on the day. But away from the page they become nothing more than people. No more remarkable than you or I.

Whenever there was a break from filming in the vast sound stage where the elephant lumbered and pissed (elephants are just people too), Britney's people would flock like iron filings to tend her. Sometimes this grooming was functional, to move an eyelash or perfect a lip, but often it was a more primal example of grooming, like the chimps we once were. "There, there," they cooed with brushes and pads. "It's going to be alright."

Britney herself was sweet, untroubled by knowledge of how edgy I was. Or indeed, who I was. She sat brittle and pretty

and played along. The highlight for me came when I asked her outright if she knew my name. "Russell Brown?" she said quizzically. The commercials, though, did make an impact and prepared, to some degree, the show's audience for the prospect of me hosting.

Hosting award shows is hard. Impossible almost, and it is a thankless task. It's one of the few things left in popular culture for which there are no plaudits. All you ever get is anxiety, criticism and abuse. So I've decided right here, right now to hold the world's inaugural "Best Award Show Host Awards". It will come as no surprise to learn that I am well represented among the winners. Here are just some of the categories in which I triumph:

Best articulation of a blindingly obvious pun:
Winner – Russell Brand, while hosting the Brit Awards 2008.
The joke: "Amy Winehouse – her surname's beginning to sound like a description of her liver."

Best use of an insect analogy whilst referring to the monarchy:
Winner – Russell Brand, again while hosting the Brit Awards 2008.
The joke: "Now for the best male category. If we were ants the best male would have to have sex with the Queen. We are not ants, but is that any reason to ignore their time-honoured traditions? And before you turn away and are sick into your own handbag, can any of you here honestly say that if I gave you an envelope and told you that inside was a photograph of the Queen's vagina, you wouldn't have a look? And here with that envelope is Joss Stone."

And finally:

Best misunderstanding of America's relationship with their head of state:
Winner – Russell Brand, at the MTV VMA Awards 2009.
The joke: "America! I urge you to elect Barack Obama! On behalf of the world! Some people, I think they're called racists, say America is not ready for a black president. But I know America to be a freethinking, forward-thinking nation; after all, you let that retarded cowboy fella be president for eight years. We all thought it was very liberal of you to let him have a go. Because in England he wouldn't be trusted with a pair of scissors."

This was the joke I opened the show with. I thought it was funny. Matt thought it was funny, the MTV executives, before it was broadcast, thought it was funny, but not everybody thought it was funny. The script for the VMAs was the last thing me and Matt wrote together, the inglorious climax of our years as collaborators.

We prepared well for the show. Nik, in fact, who is a keen student of military strategy, led the preparations like a Macedonian king. Jack and Gareth were flown over, Nicola and Sharon were drilled to groom me every few seconds even as I slept, and our Sunset View mansion was constantly awash with therapists of every description, stabbing me with pins and covering me with oil.

Our representatives at LA super-agency Endeavor were confident that hosting the awards well would launch me into a new firmament. We'd also received the incredible news that Nick Stoller, the *Sarah Marshall* director, and Judd Apatow had

met with Universal and they wanted to make a movie with me reprising my role as Aldous Snow – *Get Him to the Greek*, in which I'd star with Jonah Hill. This was a real breakthrough. It meant that my performance in the first movie had been judged a great success. Jonah is one of the hottest young comics in the world – putting the two of us together could be spectacular. We were confident. Stoller and Rodney Rothman cast an eye over the script for the VMAs that Matt and I had written; they said it was great and suggested a few more gags. One of their suggestions led to this joke, which narrowly missed out on a hosting award in the "best misunderstanding of American politics" category (fortunately, to another one I'd written). Here it is: "I am obliged by broadcasting law to show some balance in this situation, which means, uh, the Republicans might be alright. Sarah Palin for example. She's a VILF! A vice-president I'd like to … fumble, fondle, I dunno. I do feel a little bit sorry for her daughter, getting pregnant, poor kid, I wonder what she'll have? Is it a boy? Is it a girl? It's a PR stunt – come on, be honest. I feel sorry for that poor teenage father, one minute he's just a normal lad in Alaska having joyful, unprotected sex. And the next minute, he's hauled up before the Republican convention to make a point. I think that is the best safe-sex message of all time. 'Use a condom or become a Republican pin-up!' That boy will spend the rest of his life masturbating. While wearing a condom."

In exchange for their assistance with jokes such as that, Nik got MTV to allow the crew for *The Greek* to do some preliminary filming on the Paramount lot where the VMAs were being held on the day of dress rehearsals and to secure interviews with me and some of the talent that would be participating. This meant that there would be footage of fictional rock star Aldous Snow cavorting with real-life pop singers, which would be used to authenticate

the character in the movie. Nik said I had to be sure that filming these sketches wouldn't distract me from our primary purpose of doing a great show the next day, and I said he could rest assured.

The calibre of the artists that agreed to participate in the *Greek* filming was high; we shot with Christina Aguilera, Pink and Katy Perry. They were all jolly good fun, these women. Christina Aguilera was like a living sex mannequin, so well presented and scented and big-busted that you would need the mind of a maharishi to avoid thoughts of fucking her. Pink is cool. The first time I met her in London years before when interviewing her on my MTV show she was a right laugh, joining in with daft jokes and flirting, and she was brilliant that day too. We shot a scene in which paparazzi pursued us from a bar as we kissed, then I broke away from the kiss and vomited in the street. I know it sounds disgusting but it's in the film and it's funny.

I was intrigued to meet Katy Perry, as I thought the sentiments expressed in her hit song "I Kissed a Girl and I Liked It" could be well employed in my private life. I estimate that eighty per cent of women are up for threesomes if you handle the negotiation carefully. For those of you interested I'd suggest these steps:

1. Seduce one woman – you have to start somewhere, you can't get to a threesome if you can't secure a onesome.
2. Make that woman feel beautiful and empowered and give her a lovely old-fashioned orgasm.
3. Ask if she's ever kissed a girl before and, indeed, if she liked it. If the answer is no, which it seldom is, you're best to abate unless she seems curious. If it's yes, then with confidence and glee announce that you'd like to immediately commence with a sexual adventure that might very well solve the problem of all mortal fear.

4. Call a woman with whom you've already undertaken this process; unless your partner already has a girl that she'd like to involve. In the unlikely and frankly horrific event of them suggesting a man be brought into the proceedings, make a dramatic U-turn and claim to be a deeply religious chap who respects the sanctity of carnal pairing. If that doesn't work – leg it! Jump out the window if you have to because nobody wants a sweaty, grunting, vascular bloke in the room when you're at the business of sexual sorcery.

We'd already shot with Pink and Christina Aguilera before we boarded the golf buggy to take us to the pretend street on the Paramount lot where we'd be filming with Katy Perry. A few of the *Sarah Marshall* team were there, the First Assistant Director Gary Marcus, the Director Nick Stoller and the brilliantly named Dick Vane, who even with that surname insists that he never be called Richard, which makes me love him.

There she stood, Katy Perry, on a fictional street surrounded by people grooming and protecting her, as I sliced the air around her like Serengeti grass. A good-looking young woman, I observed, with mischief in her eyes that met mine, unblinking. She emerged from the huddle as Nick talked us through the scene. We were to go behind one of the façades on the street, one that resembled an Italian guesthouse, ascend to the first floor then come out on to the balcony and kiss and carouse for the benefit of the pretend paparazzi and fans below. Doubtless, I said some funny things to score our short journey across the Pseudo Street and into the bogus building. Within we climbed together the counterfeit staircase and once behind the make-believe balcony doors, I suggested we rehearse the kiss. "Right," I said, taking a breath. She really was rather pretty. "Well, we'll go out there," I indicated the

fabricated world outside. "Then I'll move towards you, like this." I moved towards her, she smiled, a lazily magical smile. "Then I suppose we'll hold each other like this." I took her waist gently. "And then ..." by now our lips are almost touching, "we'll kiss," then we kissed. And there was nothing unreal about it. This was not a fictional kiss, our mouths met and there on the Hollywood set I was lost with her in a swirl, a vacuum, the phantoms without melted away and this vast, immaculate world created for telling tales had witnessed the start to my favourite story.

We also broadcast a Radio 2 show that day, which in retrospect may not have been wise with all the filming and rehearsal for the huge event to follow. We used a Paramount studio and the building was abuzz with dancers preparing for the big ceremony the following day. All my friends were around me and there was a great vibe on the show. My mum was there, proud and beaming, and Sharon and Nicola. Jack and Gareth were producing the show, and Slash came in as a guest. We made light of the next day's proceedings. "I'm not prepared," I joked. Noel Gallagher came on the phone and gave his on-air consent for us to use "Rock and Roll Star" as my entrance music with the aforementioned killer line "Then they'll have someone they've never seen before coming on to a track they've never heard of." Me and Matt recorded what fans had called a "viddy-cast", an online visual podcast to accompany the show. In this one we recorded a dance to our mate Joby's daft song "Chugga Chugga", which was a right laugh, we fell about. "This marriage is over!" yelled Matt as we crashed into the end of the song. It was the last moment we ever performed together.

The next day, the VMA day, I awoke with that peculiar

Radio show at the VMAs 08. Joby, Matt, me mum, Nik, Iraqi Matt and ol' Russ.

dawn murmur you have on birthdays or the day after the loss of a loved one. A moment where you grope for your place in the world, aware that there's something you must do, some change, some obligation. Then it alights soft on your brow like a butterfly or lands in your belly like a kettle-bell of bad memories. "Today I must do that show."

We did another dress rehearsal, which was risible since you can't get the acts to participate because they're all too rich. Lil Wayne is not a punctual man. If he cannot be coerced into obeying firearm laws by the American government how on earth are we supposed to make him turn up on time for an award show run-through? I like him, though; he's got the peculiar crackling presence I imagine an alien might have. He touched my legs when we crossed on stage as if checking my tight black trousers were made of fabric and not paint.

The MTV crew and production team were meticulously

professional and fastidious until about five minutes before the show went live, at which point the operation toppled over like a wedding cake. Suddenly people that had before been conducting themselves like secret service agents were screaming into walkie-talkies and vertically tumbling through corridors like the Keystone Cops.

The sound-stage the show was broadcast from was a vast and unforgiving space. High ceilings, hard light. Only a thousand people in the audience in a room that could've held ten times that, and all of them industry executives and talent. The kind of people who will not sit in polite rapture while a performance takes place elsewhere on the lot, as many did that night to utilise Paramount's many impressive sets. Nor will they indulge the controversial jokes of an unknown Englishman with hair like a rookery and a mouth like a carnival at the end of the world. But I didn't know that yet. I was boothed up with Matt in the paddock made of black curtains that we always had for such events. Where we can watch events unfold on a monitor and plot pertinent responses. I can also use it as a place to wee in a bottle, which Matt obviously hates.

As I was brought on stage for the opener by the frantic and tattered floor manager, the signs did not augur well. Most of the audience were still shuffling into their seats as I began my opening link, which as you know was a comment on the American presidency. This was six months before Barack Obama was elected, but I was pretty sure that a showbiz audience would be liberal in their leanings and that this would be just the sort of thing to get them onside. What I know now, a little too late, is that American mainstream culture is powerfully homogenised, because any potent opinion has the potential to reduce sales. Why risk even a single unit by expressing disdain for

one political creed when you can instead just benignly smile? Hindsight. I delivered my opener to silence, but corporate gigs are always tough and ultimately that's what these events are, so I didn't take it too seriously. When I got out of the limelight and back to the paddock Matt didn't seem that perturbed, so I ploughed on with the material we'd written.

The next link was about the Jonas Brothers, a trinity of Christian siblings who were performing that night and who were marketed heavily on the basis of their clean-cut morality and, interestingly, their virginity. It is worth noting I think that the band are owned by Disney, for whom I was in mid-production on the Adam Sandler movie, for which he personally had cast me, since Disney at that time didn't know who I was. That was about to change. We had written some pretty obvious stuff about their purity rings, for instance that I'd take their chastity rings more seriously if they wore them on their cocks. Then over the course of the night I'd re-emerge menacingly bearing a new ring as if I'd deflowered another boy. The joke I wanted to do was drawn from the analysis of French philosopher Michel Foucault, who observed that in Victorian society the puritanical celebration of chastity was a way of bringing sex to the forefront of conscious-ness. I thought these ideas were being cynically deployed in the marketing of the boys; by constantly drawing attention to their status as virgins they are simply focusing on sex by the back-door, as it were. The Jonas Brothers are not having SEX. They don't have SEX. Imagine the SEX they don't have with their beautiful, unsullied cocks and their cute pink arses. You cannot envisage a negative; your attention is drawn to the inversion. It is difficult to convey that point on MTV in a thirty-second link, so I went with the cock-ring gag.

Even that joke, though, appeared to be a bit ripe for the

audience, so my breaks between links in the paddock with Matt became emergency summits where material was hacked from the script. After the second link we had the terrifying realisation that we'd written a show that was un-broadcastable. Which left me in the unenviable position of having to improvise an entire award show – WHICH IS FUCKING DIFFICULT! On MTV. For a mainstream audience and conservative commercial sponsors there are so many obligations both legal and moral. In my autobiography, however, things are a little more relaxed. Here are some of the jokes we cut:

> John McCain? Don't vote for him, he's a war criminal or something isn't he? [I thought this was great, because he is in fact a war hero and the lazy misunderstanding of such a significant distinction is amusing.] You shouldn't vote for him. Plus he can't put his arms over his head [this is due to injuries sustained whilst being held as a prisoner of war – this struck me as a good area of jesting]; you can't have a man who can't put his arms over his head with his finger on the button. What if the button's on the ceiling? What's he going to do, push it with a broom handle? That's no way to start a nuclear war, it's undignified.

I liked that joke, of course it's a little bad taste but I was booked to be edgy. The way the night was shaping up, though, I couldn't afford that kind of risk. And imagine if I'd delivered this crazy BAD TASTE joke while introducing the cast of the saccharine Disney hit *High School Musical*:

> In England when we hear that a load of American kids are running around in school corridors, jumping about and

screaming, we just assume there's been another massacre. Then you sent us the film *High School Musical* – suddenly the massacres don't seem so bad.

That would have raised a few eyebrows. And ended a few careers. Instead, and many would say luckily, I improvised the links for the rest of the night. By the end I was exhausted, and me and my mates made our way back to the trailer, where the MTV producers said they were thrilled, gave me a gift and said we'd have to do it again some time. I went to the after-party and despite the celebrations something didn't seem right. I left my friends partying and made my way alone back to the house. Sanctuary. Then I went upstairs to my room and, narcissistic fool that I am, picked up my laptop, typed my own name and stared into the bubbling pool that is Google.

Chapter 15

COME ON, DARLING, WE'RE LEAVING

It must've been with the best intentions that my bedroom had been filled with helium balloons of purple, silver and black on the night of the VMAs. One of my loving friends or my mother, I've never asked, in a display of myopic altruism had sought to inappropriately celebrate my triumphant return too soon after I'd left. How could they have known it would be inappropriate? I didn't even know yet, but I soon would. My ceiling was obscured and ribbons hung like stalactites in a satin world. With the deft elegance of eight finger-Nijinskis I danced my name across the keypad: R-U-S-S-E-L-L-B-R-A-N-D and the letters fell into the digital self-harming device that is Google and turned the ignition to begin the short journey from my blissful ignorance. Google was in generous form and up gurgled a toxic slick of headlines depicting the night's events:

MTV host insults George Bush – Republicans outraged

MTV host insults Jonas Brothers – Christians outraged (but will forgive him)

MTV host insults cast of Twilight – undead remain indifferent

Second by second the grisly gang of headlines grew as I sat submerged and solitary beneath the deflating balloons, slowly descending like Portuguese men o' war.

In the hours immediately after the VMA Awards the fifth-most Googled thing in the world was "Russell Brand" – people all over the planet were asking, "Who the fucking hell is Russell Brand?" "Well, I am," I glumly thought. The seventh-most Googled thing was "VMA host" as people queried furiously, "Who was that English jerk?" "Erm, it's me actually." Way down at thirty-seventh was "Russell Brown". I like to think that might have been me as well.

I felt the anonymity draining from my face and I sank into the relief that, with heroin gone, only sleep can give.

After a few twitchy hours I tentatively padded down the stairs that Diana Ross used to glide down like a swan into a terrifyingly bright new day. The omens were bad. Among my friends there was a sepulchral hush. Nik sat quietly thinking in the kitchen, Gabby solemnly polished. Nicola and Sharon surveyed the view like birds of doom, and Jack and Gareth were watching YouTube footage of my beloved friend Noel Gallagher being attacked on stage at an Oasis gig the previous night. It was horrible to see Noel, a proud and brilliant man, felled by a lunatic shove. He is a British hero, a flag-bearer for our people. In the gallows gag we cooked up to soothe us we imagined this travesty had been conducted by Americans

enraged by my performance the previous night: "Anti-British hostilities spilled over yesterday when Oasis guitarist Noel Gallagher was shoved from the stage in a reprisal for Russell Brand's scandalous attacks on American president George Bush and our cherished Jonas Brothers."

We laughed by way of medicine. Comedy served its most beautiful function of alchemically transforming leaden pain into glistening laughter. The conversation that Jack, Gareth and I had that morning formed the basis of thirty minutes of stand-up. Nik brought in some of the death threats that were being emailed in the hundreds. The confederacy of dunces were waging digital war. Our laughter formed a shield and comedy protected me from fear and death as it had my whole life. Whenever I am most alone, it comes giggling in, sensing the absurdity, the mad stupidity of our hubristic concerns when the guillotine knowingly hovers, waiting to administer the last laugh. "Who sends a death threat?" we chuckled. Death is coming, threat or no threat. If you really want someone to die all you have to do is wait. How too can you be sufficiently moved by words said during an award show on your television set to patiently type out a death threat? The same people that doze through wars, pestilence and famine leap to their feet, ready to spill blood at the chime of a dissonant joke.

"Thanks for showing me these, Nik, by the way," I said. Nik has always, ALWAYS had a strict policy of not passing on the many letters offering sex and photographs that women send of their own vaginas pleading with me to enter and offering maps and instructions, lest they should disrupt me. But for these blood-curdling vendettas he's prepared to buck the trend. We chuckled at how to write a death threat on an Apple laptop: first you'd have to turn it on, perhaps momentarily pausing

to enjoy the mellifluous cyber-jingle that accompanies the lid opening. "Ah, what a beautiful sound." Then immediately set about typing "YOU FUCKING CUNT" – and believe me they did usually write in capitals, I suppose on a computer your own excrement isn't an option, although I expect they'll soon have an app for that. These death threats formed the basis of my next stand-up tour, *Scandalous*, but for that fledgeling show to fly we'd need further controversy. Tick tock, tick tock. For now though we had enough to be getting on with.

I called Noel to see if he was OK after his altercation, and his reaction to the incident was a further affirmation of the manner of man he is. Far from responding with bawdy, macho posturing, he spoke of the hurt and confusion engendered by the attack with tenderness and intelligence. He is, lest we forget, which we could because he often revels in braying like a twerp, one of the great artists of our time and one of the best popular musicians in history.

I was glad Noel had taken it so well because I was traumatised by my experience. Yes, me and my mates were joking about it, but my head was not a nice place to be when the laughter stopped.

This is a selection of some of my favourite death threats received in the immediate aftermath of the VMAs. I should also add that there were some life threats, "Continue to live," they'd say. "Take your vitamins" – but they're less fun than the death threats – see for yourself. The first indication that you're dealing with an imbalanced character often comes in the form of their name. This is from "Yankee".

> **From:** Yankee
> **To:** Russell Brand
>
> *YOU PIECE OF SHIT!!!!!! WHO THE FUCK DO YOU THINK YOU ARE?*

Presumably the question is rhetorical, though he could be asking me to confirm his assertion that I am a "piece of shit". That's the thing with Yankee, you can never be sure.

> Who do you think you are? Telling US who to vote for? You ignorant piece of shit!

Here Yankee addresses the matter at the problem's core. He doesn't like being told who to vote for, particularly, as he emphatically states, by a "piece of shit". In this next stanza, though, Yankee delves into metaphysics, and this is where his thesis becomes confused.

> Why don't you drop dead and die?

Well, the reason is that the question is tautologous. You cannot "drop dead" and then "die". The dropping dead prohibits the subsequent dying. Unless what Yankee is requesting is a Hindu-based double-death in which I drop dead, get reincarnated as a mouse, then die again, but this seems needlessly complicated and if that is what he wants he should make it clearer in his death threat.

> "I'll NEVER vote for Obama, EVER!!"

This is my favourite sentence as I like the capitalisation of NEVER and EVER as it provides rhythm, plus it implies that between Yankee writing NEVER and EVER, someone tried to persuade him to vote for Obama again.

> "I'll NEVER vote for Obama ..."

Erm, Yankee, it says here he won't raise taxes ...

> "EVER!!!!"

Yankee lets himself down with a rather humdrum ending.

> "You better hope I never see you, if I do, I'll kill you."

Well there's a chance encounter I'd like to avoid. What concerns me most is that the death threat has no expiry date. I wonder if it still stands. I wonder if the raging fire still blazes in Yankee's angry heart? It's a good death threat but personally I prefer this one from Patrik, AKA Bully Defender. Very kind of him to include an alias, I think.

"Erm, if you don't know me as Patrik – perhaps you'll be aware of my work as ... Bully Defender?"

"Wow! You're THE Bully Defender? Sir, it is an honour. How oft I have rehearsed this moment in my dreams ..."

He commences ...

| From: Patrik – AKA: Bully Defender |
To: Russell Brand
"SCREW YOU RUSSELL!!"

It's an engaging opening gambit; succinct – good use of capitals, as if he's screaming it into his baffled laptop, plus it's personal – he thinks to address me as "Russell" not just "Piece of shit" like Yankee. That's what makes Patrik AKA Bully Defender a far superior death threatener. He errs somewhat in his next demand by assuming that all people are of the same mindset as him and that I can be goaded through literary means that he himself finds provocative.

"Stick to figuring out your own pathetic government!"

Patrik AKA Bully Defender somehow arrived at the conclusion that I would be fiercely protective of the British government and that his accusation that they are "pathetic" would rile me. Well, Patrik AKA Bully Defender, I've never voted in my life and have no allegiance to any government of any nation. I am an anarcho-Marxist-spiritualist revolutionary, so you'll have to insult me on the basis of that creed, but before you can do that you'll have to work out what it means, which is more than I've ever been able to do. Back to the death threat:

"Stick to figuring out your own pathetic government and your precious Queen!"

Right. You've crossed a line there. Sir, you can say what you will of me, and attack my government if you must. BUT WHEN YOU BESMIRCH THE NAME OF ELIZABETH REGINA, YOU MAKE A POWERFUL ENEMY, Bully Defender! If that's your real name – which I doubt! What a twit. I don't care about the Queen either. She's just a little old lady in a shiny hat – that we bought her.

My favourite death threat, however, comes from the charmingly named "White Boy", not just because of the racism implicit in his name but also because he was almost alone among the death threateners in that he included a subject heading in his emailed death threat. Plus his use of capitals for EMPHASIS was second to none.

From: White Boy
To: Russell Brand

Subject: FUCK RUSSELL BRAND YOU NEED TO GET THE FUCK OUT OF MY COUNTRY, YOURE A FUCKING ASS-HOLE A FUCKING PIECE OF SHIT, I'M GOING TO KILL YOU, GO HOME BITCH BOY!!!!!!

The thrust of the sentiment that follows in the main body of the text has actually been addressed in the subject heading: 1. He doesn't like me. 2. He'd like me to go home. 3. He'd like to kill me. 4. He considers me to be a "bitch boy".

He needn't have written another word, he'd done all he

needed to in the "haiku of hate" that is this thorough and artic-
ulate headline. But he did and here it is:

> YOU LITTLE UGLY FUCKING CUNT.

That is so rude it's almost erotic. The artist Francis Bacon's dad
used to whip him as a boy in the stables where he grew up – this
led Francis to have a lifelong homoerotic attachment to being
beaten by burly men. If I'd heard White Boy's vehement swear-
ing when a child I wouldn't be able to cum now without it.

> YOU NEED TO STAY THE FUCK OUT OF MY COUNTRY!!!

Well that's becoming clear. It was clearly addressed in the sub-
ject heading; in a way the demand for extradition is repetitive.
Also I note, he's sticking with capitals. This whole letter is being
bawled into a screen.

> PUNK RUSSELL FAG BRAND YOU NEED TO WORRY ABOUT
> YOUR GOVERNMENT INSTEAD OF MINE.

I quite like the nickname "Punk-Russell-fag-Brand" and am
thinking of employing it as a *nom de plume*. I am more troubled
by the idea that as an Englishman I'm not entitled to address
any non-domestic political matters. I only said George Bush
was a retard – thank God I didn't go with the "John McCain is
a war criminal" routine.

YOU MORE THAN LIKELY SUPPORT MUSLIMS THAT
DESTROY THE WORLD

This is my favourite line from the whole death threat. The sentence appears to have been constructed from a multiple-choice quiz in a lifestyle magazine:

Q Does Russell Brand support Muslims that destroy the world?
 A No
 B Unlikely
 C Likely
 D More than likely
 E Definitely

I like that he went for "D. More than likely" as opposed to "E. Definitely", as this indicates that White Boy doesn't like to make knee-jerk assumptions about people where there is room for doubt.

"'Why don't you go for 'E. Definitely'"?

"No! I don't like to be too judgemental."

Also implicit within this statement is the idea that White Boy has no problem with Muslims who don't want to destroy the world, and I'm viewing that as hugely positive. Although I'm still not entirely clear about which particular Jonas Brothers joke he regarded as tacitly supportive of the 9/11 attacks.

SO I'M GONNA FUCKING KILL YOU FUCKING FAG BRAND
COS YOU'RE SO FUCKIN UGLY REALLY NO SHIT YOU'RE
FUGLY

He's freestyling now. He's really found his voice. Over the course of the death threat he's really grown as a writer. That's what makes him first among all those who threatened to kill me that day. His energy, style, commitment and passion. In fact, I was so moved by White Boy's death threat that I did something I seldom do. I decided to reply.

> **From:** Russell Brand
> **To:** White Boy
>
> ---
>
> Dear White Boy,
>
> Initially, I assumed your letter was a covert homoerotic advance. If it is, be assured, sweet one, that I'd gladly accept. As long as I've got a lap, you'll never need a place to sit down, you big, beautiful, white brute.
>
> Yours with everlasting affection (and, dammit, erection)
>
> Bitch Boy

In spite of the laughs and the camaraderie those first few days after the VMAs were terrifying. The American press and paparazzi lurked at the gate like jackals sensing there'd soon be a corpse to snack on.

Nik subtly and with as little fuss as possible organised LAPD police protection as some of the death threats seemed as though they might be acted upon. (Although my secret dream of meeting White Boy has still yet to be realised.) Through this challenging time Nik and I adopted the demeanour of outlaws who knew the final bullet could be in the chamber. We were like Butch and Sundance awaiting the final showdown. The fear was never addressed or expressed, but there was a looming dread, a sense

that all our hard work could've been squandered in a few mis-judged moments. Adam Venit, my agent and the most powerful person in our circle, came round and from his advice we gleaned that my previously unstoppable trajectory might have encoun-tered its first obstacle. "Well, Russell, now everyone in America knows who you are. And not all of them like you."

Failure is destructive to relationships, like death. Some of the friendships in the group suffered. Me and Matt quarrelled our-selves into silence and our working relationship became unten-able. This was a concern as we still had a weekly radio show to consider. Sharon and I became incestuously jagged around each other and decided we needed space. Nik and I never spoke of our fear that the gamble might not have paid off, that we might have to return to England chastised, back to the comfort of John Noel's patriarchy, and admit that we were wrong; that we couldn't handle it alone. I had a new perspective on America. My naive excitement at the land of the free was tarnished; the coastal Utopia had closed like a lobster claw, squeezing me into the barren heartlands where all they had for me was death. No more pretty girls and applause – here is the prejudice, aggres-sion and damnation of which you read, the other America. I yearned for England as only an Englishman can. I wanted to be home in London, East London, Upton Park on a Wednesday night in the rain watching West Ham lose 2–1 with ten min-utes to go, having pissed away a 1–0 lead. I wanted the grim, grey normal things. To get the District Line home to my nan's in Dagenham and fuck a bird called Stacey or Tracy or Kasey, or all three, stinking of chips with glittery lips and glottal stops at bus stops, but the bus don't stop, it never arrives.

This is where you are defined. Here in the machine. Not with success and its transitory glow but when the cogs grind.

When your enemies are about you grinning, with blood on their teeth. The British press gloated and chugged. "Brand commits career suicide," they yawped, passing the blade and enticing me to consider the real thing.

Man, I hate failing. Failing to chat up a girl, or a joke twisting in mid-air like a struck gull and falling before the laughter lands. I don't have a wife. I don't have children. This is my wife, my life, my children. I need them to laugh. Sometimes on stage I tell them I love them, and I hope they know it's true. They must know it's true, they must feel it. Somewhere inside them they feel the yearning of a man who has nothing else, nowhere else to go. The only home I've ever known, up there in front of them; skewered in the spotlight is where I live, the only place I've ever lived. If I can't do that any more, if the laughter stops, I've got no other option. There is no plan B, no safety net, no exit strategy. The way back is obscured by the smoke from all the burnt bridges.

"Let's go home to England," said Nik. We could just keep things simple, rethink, regroup, lie low for a while, just do some small gigs and the radio show. Stay out of trouble. Me and Matt weren't talking, so I asked Jonathan Ross if he'd do it with me. So it wasn't all bad, he's the best broadcaster in the country. What could possibly go wrong?

Chapter 16
OPPORTUNITY SUCKS

When you first become famous, you see how other famous people, your new famous friends, handle paparazzi – abruptly and aggressively – and you think, "I'll never be like that. I shall fashion myself in some new fame strain where with perpetual gratitude I accept the intrusion of the press and paps as an inadvertent consequence of success." And for a while you stick to it. You joke with them and pull daft faces, you're polite and tell them of approaching kerbs and obstacles as they backward gambol, cheeking and snapping. Then one day you grow tired, the novelty fades like a once lurid transfer on a kid's elbow. "Fuck off and give me some space," you think. You then realise that what you'd assumed to be your "oh so different, oh so Gandhi" novel take on handling the press was just the naive first step on the journey to behaving like everybody else. They too probably initially felt grateful and hubristically joshed and preened, but for them as for you, as for me, the day came where you want your privacy back. As Jonathan Ross told me at Mount Fame's corpse-strewn foothills, the privacy was gone and, like Captain Oates, it "may be gone some time …"

The advantages of fame are many and obvious – the girls, the incessant, piping hot whistle of the self-e-steem-kettle, the restaurant table in the corner at the back – but if you're pursuing fame as an end itself I urge you not to bother. Look within, find God, or Buddha, a flickering Yogic light, because – and yes, it is easy for me to say – fame ain't all it's cracked up to be. If you're an artist and you simply must sing or dance or weave baskets then carry on, but make sure the focus is the singing or the dancing or the baskets. Otherwise when you get here you're in for a terrible shock; your problems that you were trying to bludgeon with a shimmering neon rod will be here waiting stronger than ever.

The bright side is, if you have your art, that will never leave you. If you respect it. And you might get to be friends with some of your childhood heroes. Like Jonathan Ross or, if you're really lucky, Morrissey.

You must have noticed that throughout this book, glinting at you through the sludge, the scandal and muck, are lyrics and lines from the mouth and mind of Steven Patrick Morrissey. This is because those words served for me as sermons, buoying me through murky adolescence and anguished early adulthood. For me as for many, Morrissey was a prophet who showed me there was a light at the end of the tunnel of self-banishment, and, as he said himself, that light "never goes out".

I interviewed him first on one of my flung-together TV dog's dinners and meeting him was like meeting, ahem, the Queen. I had ground-floor vertigo when I met him in his dressing-room at the BBC in Shepherd's Bush. Waiting at the door like I was about to freefall from the aeroplane of fandom into the sky-blue plunge of friendship with an icon.

Never meet your heroes, they say; well they're wrong, do.

They're usually great. Maybe I just selected good heroes. Tony Cottee, Paolo Di Canio, Jonathan, David Baddiel and Morrissey have all been completely fulfilling. But the first four on that list I always secretly knew were human, with Morrissey one has doubts.

"What's he like?" people ask me. Well, he's EXACTLY LIKE HIS SONGS! EXACTLY. Like the living embodiment of every rhyming quip, pun, poem and wail. He says things that transport you magically back to "The Queen Is Dead" or "Vauxhall and I", in mid conversation.

Like his work he is tender, humorous, adolescent, unspoiled, melodramatic, English, insightful, self-absorbed and utterly fucking brilliant.

After the interview in which I sycophantically grilled him, we exchanged email addresses and began a correspondence. Morrissey, obviously, does not have a phone. The first time he came to see me do stand-up was in LA in a titchy fleapit theatre on Hollywood Boulevard called the Paul Gleason, which I thought must be named after a dead legend. It turns out it's named after Paul Gleason, the bloke who owns it. "I'd like to pay a tribute to Paul Gleason," thought Paul Gleason, "something to honour him, and all he stands for. What would be a fitting tribute to him? I'll just go and ask me what I think." It seats about fifty people and the toilet is conveniently placed between the front row and the stage, which is very helpful during performance and smells great. When performing to a room of fifty, one of whom is Morrissey, it is difficult to maintain focus. It's like doing a gig on the tip of Michael Jackson's shoe.

Somehow I held it together that night and did a good show, ignoring his iconic silhouette, his famous quiff looming above the other forty-nine spectators like Mickey Mouse's ears or the Taj Mahal. Afterwards he came to see me backstage.

Meeting the Queen

If I'm left alone with a computer I will just end up wanking

Different attitudes to wanking

Seagulling

Sex Talk

Deep Throat Blow Jobs

bumming / different voices

- reciprocal altruism
- mentally ill man
- noam chomsky

- paris hilton / crips — barbed comments
- reciprocal altruism
- consumerism — boots... Death/Life
- Mormons / Hillbillies...
- Hawaii — mac / woody... Horse/Surf
- Dogs up bum / 'Still me' — Childhood... Bedtime.
- Serena Williams...
- Queen
- Seagulling — Elections — Hitler Bad eggs...

Set list for my first US gig, which Moz attended. A lot of favourites
– seagulling, death/life (finally explained) and, of course, Hitler.

The backstage area of the O₂ arena is crap, so imagine if you can the backstage area of the Paul Gleason. If you were dragged there to be whacked by mobsters you'd turn your nose up at it. "Can't you just kill me in the car park?" you'd ask.

Desperate for approval and notes I stared at the concrete floor with me mum, Sharon, Nicola, Nik, Jack and Gareth when Her Majesty swept in with her ladies-in-waiting. I tried to stand up but was already standing so just stretched like a deer feeding off frosty leaves just beyond reach. Even though it was my gig and I ought to have been in charge of hospitality, it was Moz who gestured to the two plastic garden chairs with a regal sweep of his arm. The two of us sat opposite each other, like Letterman shot on location in *The Book of Eli*.

"Introduce yourself," he instructed me, nodding to his entourage, who like mine remained well back on the periphery watching the pair of us like anxious spaniel breeders.

"How are you?" I politely enquired. This talk was too small for Morrissey.

"Well done," he said with sincerity. Then, with genuine wonder, "How do you do it?"

"What? That?" I spluttered. "It was nothing." I had to stop myself telling him that he was the inspiration behind every joke. He wouldn't have needed informing of the influence of his performance, I swish the mic cable during every significant laugh in an act of self-aggrandisement that even Paul Gleason would consider ostentatious. We talked for a while about a documentary about him we planned to make together. Morrissey at the time was a resident in a Los Angeles hotel. "It's difficult to schedule, Morrissey," I said, "with you having nowhere to live."

"Nor nothing to live for," he immediately responded. "Wow!!! Morrissey!! It's Morrissey!!"

Our email exchanges follow a similar pattern – regard:

From: Morrissey
Sent: 09 July 2008 15:58:34
To: Russell
Subject: Empty TV

Rustle:

I'm delighted for you with your MTV hosting thing;
as you say, it will be good for America - so please
don't hold back - educate them, drag them
forwards. Naturally, I've never been mentioned at
the MTV Awards, or Awarded, or whatever it is they
do, so I don't know what
It's like, but assume it's awful. This is where you
change things. You
Can, you will, you must. Off you go, Fatso.

> Everly,
> Misery.

What a thing to discover that in your inbox after growing up
so entirely enamoured of him. And what helpful advice – after
preventing me from killing myself as a teen he was actively
encouraging me as an adult. Luckily I didn't overdo the "gush-
ing" in my response ...

From: Russell
Sent: 10 July 2008 02:57:35
To: Morrissey
Subject: MmmmMMMmmmmTV

eMissary,

I shall dedicate the evening to you and your cause/causes - I'll harangue anyone flogging hot dogs and stinking up the world with fleshy aroma, I'll make it clear that I regard with disdain all inhabitants of the legal establishment but my most coruscating venom I'll reserve for that unforgivable wretch; a soul so rancid I scarce dare write her name, I refer of course to that foul blemish on the face of humanity "Cancer's poster girl" *********** mbe.

Then I'll get that baby off the cover of "years of refusal" and arrange for him to ascend into a tunnel of light while "Yes I am blind" is played by Jean Michel Jarre.

You were wonderful at Hyde Park with many nominating it as their favourite live ("as oppose to dead") performance of yours. I enjoyed What she said and, yes, all of the new stuff. Naturally I expect you to have devised a new set by the next time I see you, perhaps incorporating those Israeli fellas who were at the after gig garden party - they seemed game.

Why don't you come to one of the records for my TV shows? There's one Monday, come. Also I know an acupuncturist who would dearly love to prick you, this is not a euphemism - let me know if you're interested. Finally, be sure to watch me on Richard and Judy this Friday.

Scandalous love

razzle.

It was all I could do not to send him one of my earlobes. Morrissey however remained untroubled by the flattery and amusing.

From: Morrissey
Sent: 10 July 2008 11:40:03
To: Russell
Subject: RE: MmmmMMMmmmmTV

Rustle:

Oh, the pain, the pain. Richard Mad said of me (last year): "he is
Insufferable and poofed-up" - so he's bound to say the same about
You. I replied: "this is a bit much coming from a man who married
His own mother," and the quote was printed in the Daily Mirror!
of course I'll come on your telly show. Only if I can dress up.
I sat by the pool yesterday (I'm in Switzerland) listening to a CD of
Alan Carr (your ONLY competition in the hee-haw stakes), and I had
3 vodkas and belly-laughed for about an hour. Am I still ill?
A very sexy French woman came up to me and said "how much are
YOU?" and Well, I'll complete this story on your telly show.

Lashings of luv
Monotony.

That's how people throw up.

That's my favourite one. I think it's safe to include the Madeley line as he himself has already said it publicly. Plus he seems still to revel in rabble-rousing. Consider this one after I'd given him a pair of underpants as a birthday gift.

From: Morrissey
Sent: 26 May 2008 00:02:57
To: Russell
Subject: Rustle

Thank you for your y-fronts. It was only a matter of time.

Thanks to Sharon Stone for the candle - tell her to ask for Jeff Turner
when she's next back at the Peacock gym.

I hope you can drum up at least one new joke for tonite's show - do
your best, anyway.

Bucket's full of luv to you

MOZZERREY.

The Sharon Stone to whom he refers is of course my beloved Sharon, whom once at dinner in LA he sat listening to spellbound as she forensically discussed her routine attendance of a south London boxing club, a topic I'd brilliantly raised knowing it would pique Moz's interest. He sat rapt as she fine-tooth-combed her way through the details. "You know in Peckham Rye, up Asylum Road?" Morrissey nodded. "Well, Peacock's Gym is up Hangman's Lane ... you heard of it?" Morrissey smiled with acknowledgement. "If you go a bit past

the bus depot" ... he continued to smile ... "there's a lovely pie and mash shop – do you know it?" Morrissey sighed, "Well, I don't know about a pie and mash shop; I lead a very busy life." He just changed the rules of the conversation in an instant. Before detail had been all, but now, spying a wry giggle, the game changed. MORRISSEY!!!!

My response ...

From: Russell
Sent: 26 May 2008 12:15:44
To: Morrissey
Subject: Moz def

The show was a triumph. The new joke knocked em bandy.

I think I may've made a mistake with the y-fronts, my mojo might've been contained in there; I feel their absence like an amputated limb. I'm like a eunuch who's still got his unmentionables but doesn't know where to put em - they're ornamental now. But what fine trinkets.

Your new record is fantastic; it feels like the summit of a trilogy or the centre of a triptych, whichever suits, regardless it is a marvellous evolution of its two predecessors.

Oh well... what'll I give you next year? The mind boggles.xxx

Branded for life

This next – regarding our plans for the documentary – is a beautiful example of his sense of humour and puts the kibosh

once and for all upon those who would dub him a misery guts.

From: Morrissey
Sent: 03 November 2007 21:42:07
To: Russell
Subject: Branded for life

Russell dingle:

my idea (which is piles better than yours) was
Russell Dingle &
The Morrissey Band adrift on a small boat off the coast of Central America with just one cameraperson and a week's supply of Mini-wheats. there would be many nail-biting questions for telly-viewers throughout Nuneaton:

1. who will throw russell overboard first?
 2. what will russell wear?
 3. who IS russell, anyway?
 4. why do we in Nuneaton deny our love for Morrissey?

and so on.

Sensationally, M.

ps / I am now in South Carolina. *You'd* have a bit of trouble here, I fancy.

I love that one. He called me "Russell Dingle" as he is a fan of the rural teatime British soap *Emmerdale*. I once asked him why this was, and he said, "Because it's brief."

If Morrissey asks you a favour it's like Suge Knight offering

you a cigar — you're concerned about the possible outcome but what choice do you have?

Morrissey asked me for a favour. He wanted me to interview him as an "extra" on his album at the time, *Years of Refusal*. I said yes. Then he asked if we could use the Sunset View house as a location, and again I said yes. Don't let your house be used as a film location under any circumstances except perhaps if your childhood hero is behind the request. Film crews will treat your house as a set, move stuff, smoke and fart and do as they see fit. You only have to observe the way location crews behave on city streets, blocking the roads to film, holding up traffic, not letting people carry on with their daily lives — shushing them. When I see one I make a point of barging past the shot. "I live in this fucking city!" I shout, or think (depending on the size of the crew). "Your pretend film is not as important as my real life!"

Imagine that in your house. Only Morrissey could make it worthwhile. He entered after his horde; only the make-up lady was welcome other than himself on account of arriving with some massive boobs. Morrissey perused the house. I perused his make-up lady's boobs; that is the miracle of big boobs, they remain interesting above all else. I have stared over the shoulder of enlightenment to get a butcher's at a cleavage. I would eschew a drink from the Holy Grail to see some knockers wobble. Morrissey spied the portrait of him above the fireplace. "Is that weird?" I asked, but he didn't seem to think so, he is acclimatised to devotion. We strolled upstairs and there was a girl in my bed. Morrissey was polite, she was probably a bit too young to be impressed (by Morrissey I mean, I'd already put on a dazzling display of sex-robatics). That is one of the problems of the widening gulf between me and my quarry, the reference disparity. I once took a gorgeous floosie for a wander

round Abbey Road where Oasis were recording a tribute to *Sgt. Pepper*. I was with David Arnold, the great composer and oddball who was arranging my soon-to-be ridiculed cover of "When I'm Sixty-Four" (which me and David maintain is brilliant in spite of Noel's relentless abuse). David gave me the direction that I ought sing it as if I were a contemporary Paul McCartney looking out of his window, all frail. I thought it was haunting. FUCK NOEL!!! David by way of politeness began to tell the young lady of Abbey Road's history. "This is where the Beatles used to record, you know the Beatles of course?" She looked at him like a cat watching a tennis match. "I've heard of them," she said vaguely. The way I've heard of GG Allin or Plushies, esoteric oddities at the outskirts of my interest. She made up for it though later when knowledge of pop music plummeted down the charts and orgasm rocketed in translucent shards to the top of the hit parade.

I interviewed Morrissey in the only non-leather chairs in the house in front of the fireplace, having removed the portrait of him in case it looked too staged. For a man who'd requested the interview Morrissey was incredibly uncooperative. Interviewing him is like a blustery old colonel trying to cajole his pretty young wife into fellatio. He may not have seemed incredibly grateful at the time (grateful is hardly a word one associates with Morrissey), but the next day he sent me a beautiful basket of fruit. The grapes formed a glorious centrepiece in an orgy I was involved with that day, inspiring the unforgettable line "I can't believe I've had a Morrissey grape in my ass!" I informed him of this titbit via email. "That's not the first time I've heard that," he responded.

Friendship with Morrissey, though, hasn't been all fan worship and arse fruit. There have been challenging times due to

his fastidiousness and ability to control me. Obviously this chapter had to be sent to Moz for approval as I would never dare offend him. What follows is his emailed response to our mutual friend Jen Ivory.

From: Morrissey
Sent: 03 June 2010 13:58
To: Jen
Subject: Rustle -vs- Lord M, Supreme Court Division

jivory:

I don't like my emails being reprinted. I'd feel as if I'd been
interfered with by the Romford Kiddie-fiddler.

I don't like being referred to as "The Queen", especially by a man who
wears make-up, has ringlettjes and wears eye-gouging
rings on each of
his 12 fingers. I don't mind "Monarchy".

I don't like being referred to as "Her Majesty"; I'd accept His Misery.

I didn't refer to Rustle's assistant as "Sharon Stone" - I called her
"Sharon Stoned", which is much funnier. Trust Rustle to pear-down my
sharpness in order to make his own Bargain Hunt jokes sparkle.

The Peacock Gym is in East London, NOT South London.
Sharon Stoned was referring to Peckham and

 Asylum Road as directions to
her OWN house, NOT to the Peacock gym. Rustle is
OBVIOUSLY back on the
Bulmer's, or else his memory is a shaky as his legs.

"Then he asked if we could use the Sunset View
house as a location."
What! I was TOLD that this is where the filming
would be. I don't go
around asking people if I can film in their houses.
What is this -
Cash In The Attic?

"If you know anything of Morrissey you'll know it is
not unusual for
him to ... disappear during a gig," ...
oh really? such as ... when? and how exactly do I
"disappear"?
Through icy fog?

Finally, Rustle KNOWS I'd walk over hot coals to
read at his funeral
... I mean, to do ANYTHING he requires, but let
decorum and dignity be
today's watchwords, otherwise I'll set the pugs
loose. Please
give him these notes, and my undying love.

thanks
M

This eloquent evisceration demonstrates the price of my
devotion almost as clearly as one disastrous night in London,
to which he refers.

I went to see him perform at the Roundhouse in Camden,
a cool venue that I'd played not long before and the only
place in England the Doors ever played – plus the Ramones

did it too. Surprisingly Morrissey's shows have a dispropor-
tionately high yob fraternity in attendance. I think a certain
kind of working-class male have Moz as their only emo-
tional outlet, along perhaps with football. That night I was
there with a pretty young woman who'd never heard of the
Smiths, causing the revaluation of my life to become a more
pressing priority, but not yet, for now the hedonism was suf-
ficient distraction still. In attendance along with the yobs
and the wistful were an impressive selection of British celeb-
rities. I was sat quite near *Little Britain* star and long-time
friend David Walliams (who, in spite of incessantly ribbing,
I adore on account of his beautiful heart which he keeps in
his oafish chest), David Baddiel (who was one of my favou-
rite comics as a teenager and who is now one quarter of my
idealised domestic template), and further along the row I
saw dear Jonathan Ross.

If you know anything of Morrissey you'll know it is not
unusual for him to cancel gigs or disappear during them. We
his fans accept this as part of his genius and a price worth
paying. On this evening, three songs in, with all looking well
and the mic cable swooshing like a good 'un, M's voice began to
falter, crack and finally toppled like Saddam's Baghdad statue.
So off he went, a bit like Saddam. Also like Saddam it would
be bloody difficult to persuade him to return. The yobs grew
restless. Boz Boorer, lead guitar, and the rest of Morrissey's
band shuffled about like a football team trying to compensate
for the sending off of a star player, but if Rooney's been sent off
you can't plug the hole by getting Boz Boorer to drift upfield
and play with his back to goal; he doesn't have the pace. The
band looked at each other and wondered what to do, the yob
rumble grew louder. Walliams leaned over. "You know what,"

he whispered, "you should go up there and do stand-up."

"Fuck off!" I said, in spite being the kind of attention-seeking missile who'd love to explode into that war zone.

Jen Ivory, Moz's mate and safety net, was sat behind us and overheard. "You know what, that's not a bad idea." It was a bad idea. "I'll go up if you come," I said to Walliams.

"Alright. Let's ask Jonathan."

David B wisely swerved it but Jonathan said, "Yeah alright, it should be a laugh," an attitude he was employing a bit too freely.

So we agreed, the three of us would go up and make the announcement. I saw a flicker of relief betrayed on Jen's face as the four of us (David B came to gawk from the wings) made our way from the seats and to the backstage area. I felt we were like vainglorious musketeers marching to a well-choreographed battle. What we actually were was dickheads.

I shall never forget if I live to be a hundred the awful dread that rose in my guts as the three of us walked on to that stage into a storm of boos and bottles. Never has the phrase "don't shoot the messenger" ever seemed so poignant. They slaughtered us, as if they sensed the motivating vanity behind the altruistic veneer. It'd been a long time since I'd been jeered on stage, even the VMA audience had the courtesy to be silent, but these derisive cries took me back to the terrible time when the sound that now drowned me was as familiar as the sound of my own heartbeat. Jonathan made a quick announcement but the crowd wanted only two things: either Morrissey or blood, and Morrissey wasn't coming back. I tried to lighten things up with a few jokes, using my experience with dealing with hostile crowds – they were not buying. In the back of my mind I remembered the beautiful girl I was there with and

burned with a further circle of shame. Walliams was struck with a bottle top and went down like JFK – that was probably the only good thing that came from the whole god-awful experience.

Morrissey later thanked me and offered the words, "You may be a whiz on *Opportunity Knocks** but that doesn't mean you can play any audience."

I learned a painful lesson that night. Don't go on to a stage if your name isn't on the bill. Also that the crowd can turn as fast and as fierce as the tide. Beware the wrath of the masses, beware the rage of the mob.

†

* A popular Seventies talent show – a beige *X Factor*.

Chapter 17
HE'S FROM BARCELONA

It was the biggest media event since Princess Diana died. An event that received as much news coverage as the mysterious death of the most famous woman in the world. When it happened it was blown up like 9/11. It was on the front page of every newspaper, every day, for almost a month. Every television news broadcast opened with the story. Twenty-four-hour rolling news channels rolled with the news for twenty-four hours. It was analysed, debated and contested by an entire nation. Even the country's leader, the Prime Minister, was involved when it was discussed in the Houses of Parliament. What was it? A prank phone call. And who done it? I did.

Meredith, the acupuncturist in London who I visit in her electronic hermitude, would in less enlightened times have been burned as a witch. Once she told me that within me I have a supernova black hole of destructive energy. She said that the magnetism within was so powerful that people and things around me would need to be powerfully centred or they'd be sucked in and destroyed. I took that to be a metaphysical

endorsement of my charisma, I didn't realise it could have such material and far-reaching consequences.

Back in England, bruised from the VMAs, all I wanted was simple familiarity. The radio show had become one of the constants in my life, a pleasant routine that had abided for several years where me and my mates would together produce and perform a show. Made by Vanity Projects, it was ours, which gave us control. Plus Lesley Douglas, the all-powerful controller of the station, loved me so I was indulged like the world's naughtiest little boy. The show had a loyal audience of around a million people, some listening live, many more listening to the podcasts on iTunes, which was rare on Radio 2, whose listeners are traditionally older. In fact Radio 2, within the BBC, a proud and traditional organisation, is perhaps the most respectable and professional outlet.

Our show was a shameless, late-night boys' club. Cool and stupid. Yet sometimes esoteric and tender. I knew it would be difficult for me to do the show without Matt, and I didn't know how to resolve the situation after the VMAs, or when we'd start doing the show together again. It turned out that would not be relevant.

Matt and I were funny together. Looking back at some of the shows I am astonished when I recall that they were thrown together without preparation or concern. They were a giddy waltz through me and Matt's tumultuous friendship, though other people got on board, notably Noel Gallagher. Have a look at some of these beautiful moments:

STUDIO. DAY.

MATT
What about your up-to-date thing you did
the other day? "What if Crippen didn't do it?"

You said it like it's in the news at the moment!
You're such a Victorian weirdo.
> RUSSELL
> I very nearly dropped my monocle when I
> realised Dr Crippen may be innocent!
> MATT
> What if Jack the Ripper is two people? With
> similar techniques!?
> RUSSELL
> Now, Matthew, I've been working on a cure for
> rickets.

What a delightful improvised exchange. The listeners enjoyed it because it was live and warm as well as being a little dangerous. The next exchange about Paddington Bear wouldn't trouble the censors, though.

STUDIO. DAY.
> RUSSELL
> Why was Paddington Bear at Paddington
> station if he's going from Chile to Peru?
> Paddington station isn't en route!
> MATT
> He wasn't. He was from Peru.
> RUSSELL
> Right, where's he going then?
> MATT
> To visit his uncle.
> RUSSELL
> Well, where does his uncle live?

MATT

In London.

RUSSELL

He's not got an uncle in London! A bear living
in London? It'd be all over the papers! He'd be
tearing people up! What about Gentle Ben?
He went off the tracks for half an hour and
they cancelled the show! You can't have a bear
in London, Matt! Bad planning!

Also Matt called me on my madness. If I had done something
churlish or embarrassing during the week, Matt wouldn't hesi-
tate to bring it up on air. Like when he brought up this tantrum
I'd had in Montreal because a hotel room wasn't nice enough,
causing me to sink into a peculiar depression.

STUDIO. DAY.

MATT

So why did you pull your hat down over your
face? Was it about hotels?

RUSSELL

There was no natural light in my room, Matt!

MATT

What? Why do you need natural light? You're
not a jeweller!

RUSSELL

How am I meant to judge these rubies with no
natural light??

MATT

You fool. Besides, if it was about natural light
how would pulling your hat over your face help?

RUSSELL

Well that was part of my protest! If I can't have
any natural light I'll deny myself all light!!

MATT

Pulling your hat down over your face? That's
not the worst thing you can do if you're
depressed, Russell. "Oh yeah, I got so depressed
I pulled my hat right down over my face, no
one could see me then."

RUSSELL

One time I was so depressed I put my left shoe
on my right foot and vice versa.

The above wittering is a typical representation of the dynamic
between me and Matt. Noel was able to seamlessly fit in with
the recurring themes of revolution and provocation. He too is
a man who likes if not to court controversy, certainly enjoys
giving controversy's arse an occasional squeeze.

STUDIO. DAY.

RUSSELL

I would like to take this opportunity to say I
am better than Jesus himself! A nicer man, an
all-round good egg. And you name a religion
and its key icon, I'd like to say I dress nicer,
sexier and have a better message ...

NOEL G

Scientology!

RUSSELL

Not that one! That's a good one!

He won that round! Never tangle with the Scientologists, even
I know that. But the monarchy? What are they gonna do?

STUDIO. DAY.

RUSSELL

When I met the Queen it was comparable to the
meeting of Walter Raleigh and Queen Elizabeth
I or the Earl of Essex and Queen Elizabeth I.
I'm a great member of the court of this country,
I'll rise up, I'll probably have a knighthood soon.

NOEL

What did she smell like?

RUSSELL

Lovely, like autumn and pears. I held her hand
in my hand for a moment and the two of us
dreamed of what might have been.

NOEL

What did she say?

RUSSELL

"You know what young man, I wish I had
fifteen minutes with you, I'd give you such a
reach-round," she said.

NOEL

(doing Queen voice)

"Do you have any gear?"

RUSSELL

Because I'll tell you what, I'm clucking like mad.

My relentless pontificating on revolution and a new social
order came in for a lot of deserved abuse. Insanely I still believe
in this stuff.

STUDIO. DAY.

MATT

Have you been thinking about your religion/
new order?

RUSSELL

Yes, I have actually, Matt, and I've got a few more
theories for it to make it absolutely watertight.
We'll all be living on a nice island, vegetarians,
doing yoga and that. We'll get rid of ideas such
as the nuclear family and like in African tribes
the word "mother" will mean all female members
of the tribe and the word "father" will mean
all male members. There will be a lot of [wolf
whistles] ... and also we're not going to have
no more currency, stuff like that, no brain-
bending or mind-washing and we'll all be free to
explore ourselves, although there will be an age
of consent and it'll be the same as usual so as
people don't go, "Oh no ...".

MATT

Pretty watertight, isn't it?

RUSSELL

Pretty watertight so far, Matt, I'd like to see
a political theorist drive a bus through that.
If so where did he get his licence? As we're
in charge of issuing bus licences and they're
not issued to possible dissenters, who are
immediately killed on Traitor's Cove – one
of the nicest parts of our island, decorated
with all lovely corpses.

MATT

No one's holding their breath for your
revolution ...

RUSSELL

Well good!!! ... cos that's not part of the plan ...
I don't want a load of wheezing asthmatics ...

But mainly I just loved the rapport between me and Matt and
the velocity of the spontaneity.

We spent a lot of time gently bating authority and teasing
the media, leaving stupid, unplanned answerphone messages for
forgetful guests and unsuspecting newspaper editors when we
couldn't get through and interrupting the channel's own news
broadcasts with childish interludes. Soon though we'd take over
the news entirely. When Matt and I weren't speaking I brought
in well-known entertainers to take his place, well, to do the show
with me – no one could ever take his place. Top notch they were.

Noel Gallagher was obviously part of the show's furniture
– and not a nice piece of furniture, a rickety old grandfather
clock who doesn't know what time it is, farts on the hour and
lives in the past. Some of the best comedians in the country
came and joined in: Alan Carr, a camp variety stand-up but
sharp as a tack (and beloved of Morrissey, you may recall); Noel
Fielding, a sexy young Python (Monty, I mean, not a boa con-
strictor); David Walliams, who came in and unsettled me with
his David Niven charm and Kenneth Williams sneer; Simon
Amstell, the puppy-dog-eyed assassin, killing you with acer-
bity and kindness; David Baddiel, one of my comedy heroes
and now an intellectual elder statesman of the craft; bizarrely
the Hollywood auteur and cinematic genius Oliver Stone, with
whom I'm making a documentary; and, best of all, Jonathan

Ross, who for twenty years has straddled British television and ridden it like a horse-prostitute.

I'm very proud of my friendship with Jonathan as I indicated earlier. He brought me into his family, gave me great advice and used his shows to launch my career. Which is why what happened next is so extraordinary.

Jonathan is a roaring alpha male. When in his company socially, it is plain to see why such a man would become the nation's host every Friday night. He is strong, witty, garrulous and sensitive to others. When he's compering an award show he's in complete control, and on his own BBC1 Friday night chat show he expertly steers the biggest stars in the world. I suppose he must've seen coming on my show as a punk busman's holiday, doing a job he's good at but with the shackles of responsibility he's long worn due to his position loosened. The Radio 2 shows were broadcast from BBC2 HQ in Western House on Great Portland Street. The building has all the facilities of modern media as its organs, but from the outside it is a staunch and imposing edifice, a talisman of the world's most respected broadcasting organisation.

Jonathan arrived like Mr Toad in a fun convertible and driving gloves, I arrived simultaneously with a beautiful, six-foot dancer I was seeing. We were both in character. The show was to be pre-recorded, not broadcast live, to accommodate our busy schedules. Waiting patiently upstairs as usual were Mr Gee and Nic Philps, the vicar's son and BBC's representative producer who we all adored and ridiculed, telling him his involvement in our operation was an affront to his father and yes, the Holy Father, God himself. Gareth was there to produce, with a specific portfolio regarding comedic content. Do you remember Gareth from earlier chapters? His blunders? His ability to say the wrong thing? Him? He

was there. Also in attendance were a few engineers and a journalist who'd been following me for a *Nylon* magazine cover story.

Like every week, there was a cursory run-through of the show's itinerary to which, like every week, I didn't listen. But now of course I recall with Alaskan clarity the contents of that show, as well as the usual items: "Gay!" (where we'd solve a gay problem – always the same one, "I'm gay, I fancy my mate," as was the solution, "Fuck him then"), callers, a competition (without prizes, as the Beeb were forever being pilloried by the country's privately owned print media for trivial indiscretions like the value of competition prizes), and a few guests. This week it was Mexican actor and heartthrob Gael Garcia Bernal, respected, elderly comic writer Denis Norden, and the actor who played Manuel in the sublime sitcom masterpiece *Fawlty Towers*, Andrew Sachs. Andrew Sachs was to guest on the phone – a "phoner" they call it in the trade. There were several reasons for him being on the show: 1. His performance as the iconic, bumbling Spanish waiter had captured the hearts of the nation when the show was first broadcast in the mid Seventies and had never let go. 2. He was promoting a TV programme or a product, that's why most people go on shows. And 3. Because of a story that I'd told on air the previous week. David Baddiel had been co-hosting with me that week. David, as well as being extremely funny himself, is a great comic foil – he identifies areas, imperceptibly and intuitively where his comedic partner can be funny. This is why he's been half of two phenomenally successful double-acts: firstly with the beautiful comedian Rob Newman in the early Nineties at the birth of the British "Comedy Rock'n'Roll" movement (in which Noel Fielding and I were currently being richly rewarded) – which was the first time comics played arenas; and then with Frank Skinner in the mid Nineties as part of the

"New Lad" movement which also comprised Oasis, Euro 96 (an international football competition held in England) and Chris Evans. Not to mention a hugely successful partnership with his supremely talented and undeserved partner, the comedian Morwenna Banks, with whom he has two chokingly beautiful children. The funniest bit of the previous week's show came when David recounted a tale about me which had excited him. He spoke of an occasion when he visited me in Hampstead, London (we're neighbours) one Saturday and was surprised upon discovering that among the guests in my swish town house that morning had been a female burlesque dance troupe I'd been dating called the "Satanic Sluts" and my mother, called Babs. David was understandably confused to find such opposing entities present at the same breakfast. The Satanic Sluts and Barbara Brand. One a lovable mum, the other, of course, a group of satanic sluts. That's not to say they won't become lovable mothers themselves one day or that my mum won't become a satanic slut, but for now they occupied two very distinct territories – and just one kitchen table. Actually the Satanic Sluts and my mum had got along just fine. It was like a mismatched buddy comedy: "She's a loving mum, they're a striptease act that worship the devil – forced to drive across America to find the Holy Grail; yet maybe they're not so different after all!" My mum can get on with anyone, she's a very warm, loving woman and highly non-judgemental. She's had to be, she raised a lunatic – if she'd been too judgemental I'd've been for the noose. My mum, the Satanic Sluts and I had already taken our morning stroll through genteel Hampstead, twenty-five miles and a world away from Grays where I'd grown up. Hampstead is liberal, intellectual and bourgeois; Grays isn't. Along the way we'd picked up an umbrella for me mum to protect her from the autumnal London drizzle and I'd brilliantly

dubbed it the M-umbrella, because it was my mum's; I know, I know – it's what I do. Back from our jaunty walk beneath my mum's mum-brella, "brella, brella, brella, brella, hey, hey, hey" the Satanic Sluts and I had retired upstairs for some recreation, or re-creation, depending on my attitude to contraception that morning, whilst my mum made tea. That's when ol' Dave turned up. Fascinated by my peculiar life he began to quiz the Sluts. Not far into David's prurient interrogation, Georgina, very much the leader of the Sluts (like Mike Nesmith in the Monkees), revealed that her grandfather was national treasure and comedy star of yester-decade Andrew Sachs. What a delicious piece of trivia, thought Dave. I was already privy to this tickly titbit as, during a prior conjugal encounter with the Sluts, *Fawlty Towers* had come on my television and Georgina said, "Oh look, there's my grand-dad." I tried not to let this potentially disruptive information put me off my stroke. "WHERE?!" I shouted, pulling the sheets up over me 'arris, thinking he might be under the bed having a Werther's Original or a fit, but Georgina clarified that she meant on the telly. Well, me and the other Sluts were relieved I can tell you, and I for one, a massive fan of the show and Manuel in particular, began to ask what he was like. "Does he really speak in that voice?" I enquired. Now it was Georgina's turn to be put off her game and a few of the other Sluts didn't like the granddad chatter, so the topic was shelved until a more obvious break in the proceedings could be identified. When that break arrived, ages later, seriously, AGES and AGES (that's the trouble with dating a dance troupe, there's loads of 'em and there has to be equal opportunity like in the Cuban Gobstopper Testing Society, so I had a terrible jaw ache. Also like in the Cuban Gobstopper Testing Society), I asked her more about her granddad and she told me what a lovely fella he was. Of course.

Well, this story went down brilliantly on the wireless, and we all had a bloody good laugh. I laughed, David laughed, the BBC laughed – before the broadcast. The next week, for the show with Jonathan, I was thrilled to learn that Andrew Sachs had agreed to come on the show as a guest. "That will be well funny!" I thought.

Me and Jonathan knew we had a couple of hours, so we didn't fly out at the first bell, we took our time, danced around, just jabbed each other a little. You've got to give the old warhorse his due, he's been in the game a long time and he can handle an upstart like me. We read a few emails, made a few cracks, kept the people present giggling, knowing that little was at risk, what with the show being a pre-record. Gael Garcia Bernal came on and I conducted a psychopathically shoddy interview, ending every question with the banal enquiry "Is it nice?" For example, "You are from Mexico; is it nice? You were in *Y tu mamá también*; was it nice? You played Cuban revolutionary hero Ernesto 'Che' Guevara in the movie *The Motorcycle Diaries*; was it nice?" I went on with that for ages. When Denis Norden came on we were appropriately respectful to him as an older gent and politely learned of the craft of comedy writing; I resisted the urge to ask "Was it nice?" for the vast majority of the interview. Gareth came in about half-way through, and told us Andrew Sachs wasn't answering his phone, and we said, "No problem." This continued throughout the show until someone suggested leaving a message on his answerphone. Now, I don't want to point the finger, given the tremendous repercussions, but it was probably Gareth's idea.

From behind the glass plate that separates the engineers and producers from the talent, the men from the boys, the signal came that Andrew Sachs's phone was ringing. They patched us through, so listeners would hear the outgoing message to authenticate the call.

"This is Andrew, please leave your message after the tone ..."

And so began perhaps the most significant minute of broadcasting in the BBC's history. I started, while Jonathan smiled encouragingly and drank some water.

"Hello, Mr Sachs," I said respectfully. "This is Russell Brand from Radio 2. We're all very much looking forward to hearing from you and I'd like to say that I'm a great admirer of your work and your descendants ..." I thought it would be funny for listeners and Jonathan to hear me being sweet, with the amusing undercurrent of the shared knowledge that I'd been involved with a member of his family. I continued: "I respect you, Mr Sachs, and your progeny and would love one day to meet you and if there's anything I can do to help you or any of those you begat ..."

"HE FUCKED YOUR GRANDDAUGHTER!" said Jonathan quite loudly.

Which is obviously both funny and shocking. Funny because it is the extreme and explicit statement of previously concealed information and because it is such an unusual and rude combination of words in such a crazy context that it explodes as it hits your brain. Shocking mostly for the same reasons, but with one additional element: Andrew Sachs is a real person. Because in my mind, as Matt later pointed out, while this was all happening I just saw the character of Manuel in 1975 in a white waiter's service jacket, holding a silver tray.

"Jonathan!" I exclaimed. "Sorry about that, Mr Sachs, it isn't true; anyway, I wore a condom."

This in retrospect did not make the situation any better. It made it a bit worse, if anything. I apologised and hung up the phone. We carried on with the show, frequently referring back to the call and in a joke inspired by the movie *Swingers* kept calling the answerphone AGAIN and AGAIN leaving further

messages; apologies that would always descend into inappropri-
ate attempts to justify what we'd said, making the matter worse.

In one, I improvised a barbershop a cappella apology. Now
I know what we did was wrong, but for a moment can you look
past that and see what a brilliant improvised song this is? Look
at some of the rhymes! This is it. It's sort of a bit like the tune
to "Mr Sandman, bring me a dream":

I'd like to apologise for these terrible attacks
Andrew Sachs
(*Jonathan in background*)
Ba-ba-ba-bo
I'd like to show contrition to the max
Andrew Sachs
Ba-ba-ba-bo
I'd like to create world peace
Between the yellows, whites and blacks
Andrew Sachs, Andrew Sachs
I said some things, I didn't have oughta'
Like I had sex with your granddaughter
But it was consensual
And she wasn't menstrual
It was lovely consensual sex
It was full of respect
Ba-bo
I sent her text
Ba-bo
I've asked her to marry me
Andrew Sachs, if you deign it
This nuptial pact could be …

At this point the harmonies Jonathan was doing became disruptive and the whole thing fell apart a bit.

We wrapped up the show, which was to be broadcast that night, and said goodbye. We did, Jonathan, the crew and myself, have a discussion about whether to include the phone calls in the completed show. Jonathan said maybe they should be cut out, a few of the crew thought they should be removed. I said I thought they were funny so we decided to leave them in.

Gareth Roy's producer notes from the Sachsgate radio show. He has marked the bits to put in the "highlights podcast". Note the second one down.

On the way home Jonathan called again to say the phone calls should probably be taken out, but I reassured him, "Nah, I think they're pretty solid." The show went out that night and there were two complaints, both about me teasing Jonathan for his soft Rs, a delightfully convenient comic speech impediment he sometimes has.

There was no mention of the phone calls anywhere. Our listeners knew the show was anarchic and silly and sometimes crossed the line, but as I always say, "There is no line, people draw that line in afterwards to fuck you up."

There was an awareness among the BBC's administrative hierarchy that something a bit dodgy had happened, and for the next week's show which I was doing with Oliver Stone they asked us not to refer to the incident, which I didn't. Well, I did a bit. I replayed the improvised song. I just thought it deserved more credit. Also I'd heard that the *Daily Mail*, the hated right-wing agitation rag, planned to run with something condemning the show the next day, so I bated them a little. The *Daily Mail* famously endorsed Nazi leader Adolf Hitler in the 1930s, so I made a remark along the lines of "It is bad to swear on a stranger's answerphone, and I apologise, but will leave it up to you, our listeners, to decide what's worse: childish telephone calls or supporting a regime that murdered eight million human beings."

I had intended to goad the *Daily "Sieg Heil"* with this pertinent reminder of their bloody past and I clearly succeeded. The story about me and Jonathan's broadcast was moved to the front page.

The next day I think the Hammers had been playing at home so I was at Upton Park when Nik called to say there had been a lot of calls regarding the show from the BBC. As always it was Nik who was first to notice that my perspective

with regards to comedy and what's acceptable is often slightly askew. "You've forgotten how to judge things, mate," he's fond of saying. "You've become desensitised to shock." He's right. I like shocking jokes because they stir something in me. All of us make off-key jokes amongst ourselves, don't we? In the office, those emails that make the rounds after a disaster, the dubious texts about matters which some say are not fit for humour. I agree with Woody Allen, who said the only criterion by which comedy ought be judged is: is it funny? The more difficult, taboo or sickening a topic, the more I think jokes ought be made about it, to lessen its impact, to give us authority over the terrifying grip of our conditioning and our fear of death. In this instance the problem was that at the core of the matter was an inappropriate remark left on an old man's, not a Spanish waiter's, answerphone. That was wrong. But what ensued was far more interesting.

Jonathan sent a letter of apology to Andrew Sachs and said I should too. I did, and Andrew Sachs graciously accepted that apology. We foolishly, FOOLISHLY thought that would be the end of it.

The *Daily Mail* is a powerful newspaper. If you ever read it, and I don't suggest you do, you will notice that its editorial perspective on most subjects relies on the evocation of fear: "BE AFRAID!" it screams in lurid inky horror. In fact, as a game, try stealing the *Daily Mail* (for God's sake don't pay for it, if its readership continues to drop at its current rate we'll soon all be spared) and, in your mind, before reading each headline insert the prefix "BE AFRAID BECAUSE …" Then continue with their text, and it will always make sense:

BE AFRAID BECAUSE ... "Illegal immigrants are taking your jobs"

BE AFRAID BECAUSE ... "Paedophiles are hunting your children"

BE AFRAID BECAUSE ... "It is going to snow and not just normal English heterosexual snow, immigrant snow, immigrant paedophile snow. For God's sake don't build a snowman; it'll come alive, sneak in your house while you sleep and fuck your children"

They want us to be afraid. Afraid of difference, afraid of change, afraid of each other. But the only things we actually need to be afraid of is them and the fear they generate.

BE AFRAID BECAUSE ... "Ross and Brand make sick call to pensioner"

There were many reasons why this story escalated beyond the usual tittle-tattle and into a national scandal, and here they are:

1. Newspapers are dying, as are their traditional readers. The generation that listen to my radio show don't buy newspapers, they get their news from TV and, more significantly, the internet. This means that newspapers have to find a function beyond relaying news to justify purchase. The most successful of these new means is campaigning. So they began a campaign to have Jonathan and me sacked.

2. The privately owned media detest the BBC, because it is publicly funded, it carries no commercials and it is huge and

powerful and loved, so the privately owned media cannot compete. Also there is a profound philosophical distinction at the matter's heart: the commercial versus the social. Privately funded media are capitalist, publicly funded media are socialist.

3. The *Daily Mail* doesn't like me or Jonathan. Jonathan is the most highly paid broadcaster in the country yet came from a working-class background; his demeanour and attitude could be described as anti-establishment, he is cheeky, smart and fearless. In the eyes of the *Daily Mail* I am a heroin addict fornicator with no respect for the system. The *Daily Mail* wants junkies dead, not cavorting around on the telly making money and living it up with thousands of beautiful women. It is antithetical to their joyless, puritanical doctrine.

4. This was a bad time for the country, a bad time for the world; an economic depression meant that all there was to write about and read about were job losses, interest rates and poverty. The press needed a distraction.

5. As a story it had exciting elements: the constantly under-attack BBC and its highest earner, a sex-mad junky, a beloved TV icon from more innocent times and an erotic dance troupe called the Satanic Sluts – tabloid gold!!!

Oscar Wilde said, "The English are a people who have no interest in a work of art until they are told it's immoral." It went mental. All the other newspapers picked up on it and ran with it on the front pages, then TV news, even the BBC itself made the incident its main story. The guilt-ridden Beeb fell to the floor in a baffling display of self-flagellation and capitulation and the country, bored of hearing how poor they were, discussed the matter in offices, pubs and common rooms. Amidst this chaos

I was calmly intrigued, it felt like the maelstrom within me, that supernova black hole of destructive energy, was pulling the planet in. Quietly I watched as my name and face began every TV news broadcast, and far from it seeming odd, the narcissistic tendency that spends all its time restlessly jostling for more focus slept contented. Like Morrissey, my cat, who napped on my knees as I gazed at my reflection on the screen.

Jonathan took on the role of older brother and elder statesman, as each day we talked on the phone, sheltering from the blitz. "It'll blow over," he said. But it didn't and it wouldn't, each day the momentum grew like a dinosaur rumbling back to life, shaking off the somnolent earth as it rose and rumbled with heavy haunches into the present. The BBC didn't contact me, but for Lesley, who told me not to worry and that we'd be alright. Strangely, though I knew as the monster roared and grew, that I would be. Each morning brought new madness – they're discussing it in parliament, the Prime Minister just made a statement – and outside the paparazzi stuck to my window like dead bugs.

Jonathan called to say he'd been suspended without pay. I felt worried for him and about how it would affect his home life, but he was proud and cool about it and positive throughout. The event, we both agreed, the moment of leaving the message, was regrettable, and amends had rightly been made, but this tumult, this tempest that had been darkly conjured by the axis around the *Mail*, this was insanity. The incident itself was now irrelevant. The objective truth had been removed, dissected and conveniently reassembled by the Frankenstein press to suit their narrative. Now the story was that Jonathan and I had grinned and snarled and, with malice aforethought, howled into the elderly man's face, "I FUCKED YOUR LITTLE,

BABY GRANDCHILD," then returned to our grinning.

Nik came round one morning whilst I lay in bed. The house purred with our team, our war cabinet. Outside you could hear the cackle-jackals, who now numbered fifty, smoking and burping.

"This is getting heavy now, mate," said Nik.

The cat slept on.

"Yeah, it does seem to be getting out of hand," I replied, raising my voice to compete with the helicopter hovering above. "What shall we do?" I asked him. Nik is much more sensible than me, he understands media and diplomacy and hasn't yet become desensitised to what's right and what's wrong.

"You've been suspended."

"So what?" They used to do that at school; sometimes to punish you for non-attendance, which always struck me as poetic.

"Without pay."

I didn't care; I didn't do the show for money. None of our lot are in it for money. We're in it for the kicks and the glory.

"We're under a lot of pressure here, mate, they want us to do an apology."

"I've apologised to Andrew Sachs."

"They want us to apologise publicly."

"What's the fuckin' point in that? We've apologised to him for the incident, all this bullshit that's happened since ain't our fault."

"I know, mate, but that's not how people look at it."

"Well, what do they want me to do? I'm not going to resign."

We looked at each other. Resign. We realised in that moment that the only power we had was to walk away, to seize the initiative. We only did the show for fun and it was no fun anymore. To be honest, it had stopped being fun when Matt left.

Nik was aware of the impeding severity and rippling irritation far more than I could be; I was locked into the battle. He knew how my actions looked to people who read about it in the papers and saw it on TV. He knew that I looked arrogant, self-satisfied, unrepentant.

In my life I have encountered a lot of conflict and committed many wrongs. As a breadline junky, morals were ballast to be dispensed with as they interfered with survival. Now the skills and attitudes evolved to cope in an unforgiving environment peopled by ne'er-do-wells, dealers and chancers were themselves a hindrance.

I suppose it's easy for others to forget, as it is for me, when they see me all perfumed and flouncing, that I crawled out from between a rock and a hard place. When then strife occurs I know only to stiffen and to fight. To prepare for the insults and the onslaught, but sometimes that's the last thing you should do.

It was a mistake to leave those messages and upset Andrew Sachs. Even though he has since joked that he's done quite well out of the affair, it must have hurt him. I know what it's like to have complicated familial relationships and to have those fragile feelings jangled for a gag is wounding.

Now, more than I did at the time, I see how wrong it was to use such private matters to fuel humour and I hope he and his family know of my regret; it was certainly apparent in the apology I sent him and I hope clear in these words I now write.

At the time I was so incensed by the media reaction, which I still consider to be hugely disproportionate, that I too quickly disregarded my own transgression. In spite of what I've been through I have never sought to make capital or jokes at the expense of vulnerable people, my mother did not raise me that way.

Resign. Nik and me knew what we had to do.

I called Jonathan. He was sad, but accepted it was the right thing for me to do. Nik called Lesley. She was worried. "Don't do it, darlin,'" she said, all Geordie. But we'd made up our minds.

We went to the John Noel offices in grimy Kentish Town. John was in and he loves a ruck. We went into his office. Jack and Gareth, John Rogers and Gee were all there. Jack picked up a camera and aimed it like a rifle. I made a heartfelt speech. I said I regretted that I'd damaged the BBC, a great and beautiful institution. I hoped that by resigning and accepting culpability the storm might acquiesce, that Jonathan, who I regard to be less to blame than myself, and Lesley, who was entirely guilt-less, might be spared further recriminations.

We exhaled and a courier came. Within twenty minutes it was on every single channel. It was like letting off a visual bomb – a moment that had only just happened was there on every screen in the office bouncing back at us. When we recorded it, someone noticed that on John's wall at the back of the shot was a framed picture of Stalin with a red clown's nose on. Nik said we should move it and took it off the wall. "No, leave it, mate," I said. Later I saw experts discussing the semiotics of that image and what it meant, whether it was a comment on media tyranny and dictatorship. But in essence that summed the show up: the picture of Stalin in a red nose just happened to be there; no one planned it, but when we spontaneously noticed it we had the intuitive foresight to know that it was funny and pertinent. It wasn't planned, it was just funny.

The storm continued to grow. There would be an official inquiry by a board of governors. Jonathan was suspended for three months and his shows were taken off air. Dear, beau-tiful, brilliant Lesley Douglas resigned. A great professional, who loved her job, who loved and understood radio, who had

reinvigorated a dusty old fuddy-duddy station and made it the most listened to in the world, was forced to leave. That's the saddest thing about it. For her, for me, but mostly for radio and the BBC.

The sky was black with scandal still and the rain lashed down hard on us. The waves crashed against the shores, the furore would not relent. Nik and I packed our bags; I had got a part in a film with Helen Mirren directed by Julie Taymor. An adaptation of a Shakespeare play, scheduled perhaps by the only poet greater then he, God himself. Nik and I set off for America, leaving the storm behind, to be in *The Tempest*.

Part Four

I've learned from my mistakes and I'm sure I can repeat them exactly.

Peter Cook

The one measure of true love is: you can insult the other.

Slavoj Zizek

Chapter 18
MUMMY HELEN

Helen Mirren's presence blazes through all my best social defences and everyday façades, right to the writhing uterus of my throbbing Oedipus complex.

A man of my age wouldn't rightly regard her as a partner; she is a generation older, but in spite of this she has traded none of her sexual allure. Which is confusing. Nonetheless, intrepid thinker that I am, I've managed to distil my requirements of her into this conveniently perverse package: I'd like her to give me a bath, a bath which begins as functional, merely the business of cleaning my body, but then, a few minutes into the bath, it all gets a bit confusing. The boundaries become blurred. I imagine the catalyst could be the necessary soaping of my unmentionables. Dame Helen would be vigorously setting about my prize-winning privates (Shagger of the Year, three years running) with a bar of Pears when we'd make eye contact, then, and I'm aroused even as I write, then, we tumble into a bubbly wonderland, all squeals and half-hearted admonishments, till thighs part and eyes roll. I'd still be into it if she

was wearing her Queen costume, and I've got a whole other scenario that centres on her Oscar.

I suppose it's haphazard delusions such as these that will ensure that I am never ennobled as Helen has been, and that led to the embarrassing episode I shall here impart, when the Dame and I first worked together.

The Tempest was an ambitious project. It was to be directed by Julie Taymor, a lunatic visionary who only ever seems to have one eye on the real world, and the cast was incredible. Joining Mirren were Alfred Molina, who can surely be described as "a damn fine actor" and a convivial gent; Ben Whishaw, a gentle pixie Jimmy Dean effortlessly enchanting all with downcast eyes and mumbles; Djimon Hounsou, intense, magnetic and in a state of constant regret, having agreed to play the part of Caliban in make-up that covered his entire body and took four hours to apply and three to remove; and me.

As with all films, the majority of filming took place in Hawaii. This time though there was far less money, which equals more pressure for everybody and peaked with me and Fred Molina sharing a trailer about the size of this book. A caravan is what it was and not even a nice one; if you saw it in Margate you'd kick it down the beach while bellowing the eponymous Chas & Dave song. The stuff for which they required a studio took place, unusually, in New York City, where they matched the exteriors shot in Hawaii with sets they'd built on a sound stage, common practice.

The final day of filming was very busy and comprised a complicated scene where Alfred, Djimon and myself had to be pursued down a frankly bloody dangerous fifty-foot open staircase by angry Rottweilers. Whenever there are animals on a filmset they are accompanied by their handlers, invariably

characters somewhere between Mowgli and inhabitants of a
news item in which a loner is evicted from their home for living
with sixty cats. From within her fleece that shimmered with
dog hair the trainer gave the three of us the rundown on how
to behave around her canine Kray twins, one of whom stood
menacingly at her hip. Djimon is quite butch and wandered off
indifferently; Alfred is professional, so listened patiently; I was
scared, so stared intensely. This was the worst thing I could
have done, as the dog-lady went on to recite a list of decrees
that if you were told them before meeting the President you'd
say were a bit over the top. One of the main things you mustn't
do with these dogs, it turns out, is stare at them, they don't
like it apparently. I confess to being somewhat irked that I, a
movie star, was being given protocols on how I had to comport
myself around a mutt. In the good old days I would've put a hat
on it and tickled its balls, this bugger I was expected to treat
like J.Lo. "Don't stare at Franco," she said, "or go behind him." I
silently nodded at these commandments. "Nor shalt thou covet
his oxen," she may've added, but by then I was lost in a fantasy
in which I'd saddled Franco up and rode him into Bethlehem.

Once shooting began the dogs behaved like a right couple of
arseholes, snapping at us and terrorising us for mere kicks. Fred
and I were dressed in women's clothes, as the script required it
and Djimon was nude but for a loincloth and a ton of make-up.
Sometimes in films a stunt or effect is achieved not by trickery
but simply by forcing some poor sap to undergo the horror that
the story demands. In this instance to get the effect of three men
being savaged by devil dogs they simply acquired those ingredi-
ents, released the dogs and filmed the inevitable carnage.

When the ordeal concluded, Tom, my adored assistant,
hurried me from the set and to the dressing-room upstairs as

we were due to catch a flight back to London. There was no time to lose, so I hastily stripped off my costume and leapt into my civvies, first removing the bright yellow underpants I'd been wearing as the day had involved much running and considerable dread. I had no time to pack them, though, so I fled the dressing-room with them clutched in my fist. I was scarpering plane-ward down the corridor to freedom when from a doorway in a voice that conveyed regal authority and mischievous sexuality I heard, "Aren't you going to say goodbye, Russell?" Dame. Helen. Mirren.

I stopped and politely curtsied.

"Goodbye Ma'am," I said, struggling to subdue the image of her filling a tub with Matey.

"I've enjoyed working with you, Russell, you naughty boy!"

Uh oh, that's not helping.

"And I you, Your Highness."

"Well, I hope that we shall work together again soon, you cheeky monkey."

In my mind the bubbles part and the loofah is submerged.

"Yes. That'd be nice." My voice cracked. Did she notice? I bowed.

"Well, I best be off ..." I was ready to depart and had made it through the entire conversation, in fact the entire shoot, without doing anything peculiar – a triumph.

"Goodbye." Then I noticed her eyes momentarily flick over to my hand, which still contained the yellow underpants. For some reason I was holding them with my arm straight out at shoulder height. They were bound to be conspicuous. I felt awkward at her having noticed the ol' pants, so I thought I'd give control of the situation to the insanity that forever lurks at the back of my consciousness waiting for moments such as this,

when I'm vulnerable and inclined to do bloody stupid things.

Luckily the insanity is never short of an answer. In any situation, he'll come up with a solution. The problem is of course that these solutions often cause greater problems than the one they were enlisted to alleviate.

"Dame Helen …" began my madness, "I could not help but notice you were admiring my underpants …" She remained silent, the lunatic did not. "Please accept them as a token of my erection, I mean, affection." He then thrust them under her proud nose. Dame Helen Mirren considered the dirty yellow pants for a moment and then with a gracious smile … SHE TOOK THEM.

SHE TOOK THEM RIGHT OUT OF THE MADMAN'S HAND! SHE HAS THEM STILL! I hope to God she hasn't looked inside them.

Also whilst in New York me and the barmy gang were working under the name of our production company, Vanity Projects, and if you think the name is stupid just look at the bloody logo!

Matt drew that. It's a man examining his own bottom whilst masturbating. Matt assures me the man is called Jason, though I don't see how that makes his behaviour any more forgivable.

Matt and I were, I suppose, estranged at this time, although he'd hate the use of that term as it implies marriage and that was something he would always strenuously reject – even on our honeymoon. I missed him, of course, but sometimes close friendships have a tidal beat that pulls you towards different shores though the ocean that connects you remains.

On this New York trip we made my first American stand-up special for the Comedy Central network, which was surprisingly commissioned even after I, during the meeting to discuss it, forlornly stared at the floor of the terrace upon which we were dining and fed the sparrows at my feet pieces of bread from the table. "What's the point?" I said to the concerned executives. "I mean, why should we give you this programme?" Luckily, Nik had told them that I was a lovable eccentric and they assumed this was part of my charm. The special went ahead and was jolly funny, mostly because, freed from the context of other English people, I became such a preposterous caricature of Englishness I'm surprised the gods didn't punish me by turning me into a bulldog.

Once more on Albion's shores we sought to turn the catastrophe of Sachsgate into a palatable piece of entertainment. The guiding star of my anguished adulthood has been the knowledge, absent in my childhood, that shame, embarrassment and failure are funny. These torturous, in-turned Furies are a resource, a deep asphyxiating mine from which gems can be plucked. With each humiliation I now encounter, and they still rain down in tropical streaks, I remind myself of their value as I stand there hot and drenched.

The mêlée around the BBC farrago had indeed been fruit-
ful – effigies had been burned, death threats issued and politi-
cised debates held. Best of all, the entire episode was on camera,
documented. The stand-up show that ensued was a unique
comment on an absurd situation, and arenas all over Britain
and Ireland quickly sold out. I even did gigs in Australia and
the States. Throughout this adventure the surrogate family that
surrounded me grew. In addition to Nik, Matt, Gee, Nicola, John
Rogers, Sharon, Tom, Gareth and Jack there was the implausi-
bly comedic pairing of Danny and Mick. Ostensibly security and
driver respectively, these men have clumsily dragged such humour
into my life that I feel duty bound to here pay them homage.

Danny O'Leary is a big man. So big that he has to get suits
made. Big Danny he is known as round the clubs and pubs of
Essex where he has been "doing doors" since he was fourteen.
He comes from Romford, a few miles away from Grays where
I'm from. Now, through our friendship, a sturdy and occasion-
ally violent bridge back to my past has been built. Although
I might have been in his presence before in the white-cider
blitz of adolescence, the first time I properly clocked him was
when I saw him working with Courtney Love, like a cupboard
in a beige suite, lantern jawed, smiling infectiously and with a
demeanour and hair that hark back to post-war Britain. He
looks like a spiv's henchman. I immediately liked him and felt
a connection, perhaps due to his accent and the familiarity and
nostalgia it evoked. Perhaps too I sensed that in him I'd discov-
ered at last a burly protector upon whom I could depend, like
having the hardest kid in your school as a mate.

The next time we met was on the promotional tour that
accompanied the publication of the first instalment of this

book, *My Booky Wook*. Danny and five or six of his crew were doing the security for a nationwide book chain. That tour was mayhem. It came during a period where my carnal appetites raged like a bush fire or an awesome CIA-manufactured plague. The words "book tour" hardly summon the spirit of Dionysus. Alan Bennett does book tours and I bet he's no trouble. I imagine he signs the fans' books then gets on his way. Well, this was a carnival of destruction, we marauded up and down the country causing mayhem, doing gigs in the evenings before thousands and signing books in jam-packed precincts by day. Proper fame, with screams and bras and codewords to select. In Danny O'Leary I found the perfect accomplice, someone who gleefully facilitated my gluttony. Jack said we reminded him of Fred and Rose West as we exchanged glances after gigs and gave nods and winks and directed women to the area ordained for these matters to reach their conclusion. Once more, I am not proud of the morality employed during this indulgent time but one has to marvel at the efficiency. This operation travelled all over the world and effortlessly assimilated into any culture it encountered, New York, Sydney, Hull – it was all the same: wristbands issued, rooms filled with women in their dozens, day after day. A relentless machine with no off switch, like an untethered lawnmower chewing its way through the Amazon jungle. Journalists often ask me to estimate a number, but I never do because I know they'll isolate it and make me look like Bluebeard, but between me and you it was a one-man, multi-woman sex epidemic. And some of it was fun. Brilliant, exactly what you'd expect. I felt like I was repaying a debt to the fifteen-year-old boy I'd been who watched life from the sidelines, blustering and shy. "And what's wrong with that?" many people will say – all the girls

were willing and up for it, sometimes they DRESSED up for it. It was astonishing, like being able to walk through walls or dance like Michael Jackson. Naturally though, as is always the case with such things, there was a price to pay – in loneliness. What an unexpected and disappointing clause. I should have read the small print but I was distracted by the boobs. If you live cyclically and obsessively something within you withers as you gorge. But enough of that morose honesty – let's get back to the rollercoaster.

Danny and I had been working together for a while, we'd connected and laughed and swapped stories. We'd formed a bond. One of the most notable stops on our hectic book tour was at Lakeside shopping centre, Essex. It was fantastic to see the crowds numbering thousands waiting for Booky Wooks, because as a kid I'd bunked school and shoplifted in that very mall. I always gave Danny and his lads problems at these signings by breaking away from the agreed parameters – which means signing books and smiling – and instead merrily romped through the crowds and out of the shop to cause a bit of bother. As you know, I like chaos. Seeking refuge from the hysteria I'd stirred up, me and the lads and my mum were hiding in the storeroom of the bookshop when my mum, on learning where Danny was from, asked if he knew Mark Stone. Mark Stone was one of my best friends at school, a benevolent, funny fella, tall and handsome and sweet, who after we left school worked at the Ford plant in Aveley and of an evening worked doors in pubs and clubs around Essex. Sadly at the age of just twenty-nine Mark had been killed in a motorbike crash, and though by then I'd been swallowed up by London and drugs, it still broke my heart. Not for him an early death, Mark who was so fit and happy. Untroubled

and straight in word and thought, Mark Stone would surely make old bones. It had never occurred to me to ask Danny about Mark, but my mum, who'd loved him too, was keen to know if they were acquainted. At the mention of Mark's name Danny's eyes filled. "I knew him," he said quietly. It transpired that the two men had laughed and fought side by side and that had I been more psychologically present in my early twenties I'd have heard Mark talk of "Big Dan". What's more, if I'd had the presence of mind and a little more sense of duty I'd have been at his funeral and seen my school friend, this sweet and affable man, generous and fun, carried to his grave by Big Danny and his lads.

We stood among the boxes of books in a moment of silence for Mark. Then, when we were once more composed, I took a copy of *My Booky Wook* from a storeroom shelf, and opened it to the acknowledgements page at the back and showed Danny the tribute I gave Mark in lieu of attending his funeral. He welled up as he read on the short list of names "Mark Stone RIP".

Me and Mark, when a little worse for wear, had often conjectured through the fumes that one day, when I was famous, he and I would work together. "I'll be your bodyguard mate," he'd say. So now me and Dan had an unbreakable alliance; the tragic bond of our friend's death.

Next to Danny, in silhouette from the back seat of his Mercedes sits Mick. The two of them natter, squabble and laugh. On tour I watch them like TV as they crash and stagger through the issue of the day – women, crime, politics, mostly women – and chuckle cosily. "Lights are green, Mick," says Dan as Mick invariably fails to notice that they've changed. Mick is Cypriot and will never lose his Eighties taint. For him regardless of the date or his impeccable attire it will always

RUSSELL BRAND

Nicola Schuller
Malcolm Hay
Tony Arthur Hay
Ben Miller
Dr Abood
Dr Gormley
Sam Crooks
Moira Bellas
Barbara Charone
Mark Stone RIP
The Macleans
Dennis Noonan
Ian Coburn
Alfie Hitchcock
Brian Cox
All my secret fellows
Kevin Lygo
Meredith Church
David Marshall
Christopher Fettes
Yat Malgren RIP
Reuven Adiv RIP
Mark Lucey
Iain Coyle
Andrew Newman
Andrew Antonio
Lindsey Hughes
Heidi LaPaine

402

The tenth one down. Stoney.

be 1984 – Wham! and espadrilles, gold hooped earrings and Thatcher and, more pertinently, Hoddle and Waddle; or just Hoddle after he's eaten Waddle. Mick is a Tottenham fan, the mighty Spurs he calls them. He loves them only marginally less, I imagine, than his two kids Yiodi and Christy. He has a giant heart and a panda face, eyes permanently and prominently ringed, even on his ludicrously tanned face. Mick has a grace that all drivers, hairdressers and masseurs ought be endowed with: the ability to know when someone wants to chat and when they want to be quiet. He speaks with gurgling, faltering joy, somehow slow but energetic, each word formed and sent out as if brought down from Mount Sinai. Which is why it's surprising that he comes out with such a lot of rubbish.

One Christmas Eve we all went to Nicola's – me, my mum, Gee, and a few of the others. We sat in festive comfort in their tinsel-Katrina front room. What a Yuletide scene it was too, Nicola on the carpet with her two-year-old daughter Minnie and her little niece Elsie, her mum Debbie, a one-woman chain gang of snacks, her dad Albert, at the computer playing patience, and beloved Nanny Pat, peering at it all through her glasses thick as pub ashtrays, sighing sentimentally. Mick and Albert got on well, they chatted about Spurs and Arsenal, who Albert supports, and the Christmas telly, which they agreed was crap. My mum and Debbie kept up the grub and Nanny Pat chirped contentedly. The two girls were happy with their "one Christmas Eve gift". In short, it was perfect. I watched with awe as this exchange unfolded.

INT. DAY.

> MICK
>
> What's that film, Albert?

> ALBERT
>
> I dunno. Tom Hanks. Poland Express or summink.

> MICK
>
> Any good?

> ALBERT
>
> It's fuckin' shit.

> NICOLA
>
> DAD!!!! Mind yer language!

Pause here. Albert embarrassed, Mick steps up.

> MICK
>
> It's alright, Nicola, I don't mind.

Mick sincerely thought that Nicola was trying to protect *him* from the "eff" word; not the two little girls or the pensioner in the corner or even the mums, but him, Mick, great big burly Spurs fan Mick. Not to mention that the film is actually *Polar Express*, not Poland Express.

This kind of exchange is invaluable to me. Banter from the people who treat you just the same, who take the piss and call you out. You need them around you when the cacophony of sycophancy is so loud it drowns out the voice in your head that says, "None of this is real, you know, it's all an illusion, all of it will pass."

✝

Chapter 19
THE LAST AUTOGRAPH

The severance that success brings was further exacerbated when my mum moved from Grays. After that I had no umbilical link to the place where I'm from – I need never go back there again. I went to visit "one last time" on the day that she was leaving while Morrissey scored, as usual: "As you walk without ease, on these streets where you were raised …" Me and John Rogers walked past the flowerbed that I'd stomped on because the man who lived there had asked me nicely not to. We went to the garages at the end of the street, where once as a boy I'd hijacked a vacant unit and kept pet mice in it. Also I'd wee'd in it. And so did the mice. It stank beneath the corrugated iron roof, behind the battered door. "I am moving house, a half life disappears today, with every hand waves me on secretly wishing me gone, well I will be soon …"

There too were the allotments, fabled to the kids of the street, for the unused lots, wild with brown grass, an arsonist's dream, all in the shadow of the fire station tower where they practise being firemen, that once I'd climbed in moonlit dread

and on top seen all the world roll out beyond the sirens and the tarmac. "Goodbye house forever! I never stole a happy hour around here …"

At the garages I examined the courtyard floor and could recall, almost affectionately, individual potholes and cracks. Later, as me and John strolled past the ambulance station at the top of our road (ambulances and fire engines, my childhood must have been incessantly rinsed with distressed chimes and blue light), I instinctively jumped up on the short boundary wall and continued on with one arm outstretched upward to my mother who was no longer there but still in 1979, when we'd have last walked there together.

John said it was as if the memories were not neurological but physical. They lay there, amongst the gutters and cracks, awaiting collection on our return, like a once-prized rag doll, tarnished and forgotten.

In my bedroom where I'd spent years in devoted solipsism and self-absorption I signed an autograph for a removal man's daughter and finally bleached away the last remaining corner of my anonymity. Fame seeped through the walls and delivered its dubious cure to the forlorn youngster who'd sat and craved away summers seeking its gilded kiss.

The *Scandalous* tour, the show for which the *Daily Mail* almost deserve a credit as co-writers, romped into the country's biggest stand-up venue, the O$_2$ arena. Eighteen thousand people would see me joke my way through the media furore that months before had threatened to derail the whole kerazy Brand-Wagon. But here we were. We few, we happy few. Danny and Mick, by now at the apex of this Caligulan excess, openly competed to see who could bring me the most post-gig girls; they were delivered in giggling gaggles. After a night

at the Brixton Academy I took home five girls and we kissed, canoodled and shrieked till the early morning in my notorious, "never gonna be clean enough" hot tub. And through their white wine kisses and perfect skin I tasted something poisonous. The end was approaching, the fun had faded, the lights flickered on the Ferris wheel and the carriage uneasily creaked – but still it turned. As I lay on my bed watching them above me it felt like an alien autopsy; they prodded, not caressed, they fed, they did not kiss. Their fingers were like scalpels dissecting my compulsion. Still the beast lumbered on. I tried to quell the impotent liquor of this lust by doubling the dose. You would not believe, because I cannot believe, the ferocity, the velocity, the pounding, racing, thrusting curse of my commitment. Women met for the first time in my bed and tumbled into the abyss of my serpentine kiss. Chains and trains of strangers, some as young as eighteen, some as old as forty-five, were flung together in a metropolis of flesh. Four in the bed, two in the kitchen, three in the hot tub and still the doorbell rings. Night after night, I don't know how I could be a conduit for so much passion. As I gaze across the collages left behind, there were compelling, diverting giddy times. Five girls in Bournemouth closing in on me like sweet murder. Four in Sydney, coffee brown to lily white, a mother and daughter on the coast, and, perfectly, given its reputation for incest, sisters in Devon. Protocols and taboos dissolved at my touch, momentarily some power visited me and, by this alchemy, transformed the "World's ugliest boy" into this creature with flashing eyes and darting tongue and the desperate wail of my adolescence was at last silenced by the climactic screams of a thousand strangers.

Them sisters were bloody amazing actually. We were staying in some castle in Devon, we were crewed up, loads of us

were there. I was exhausted, but after the gig we brought back maybe twenty girls and they were scattered around the grand drawing-room bar of the castle. By 3am it looked like the cover of an album the Stones never got round to recording called "Crumpet Banquet" or "Floosie Soup", they were propped up against the mantle or dumped on chairs like plane crash survivors. They'd chat to lads for a while, but then I'd swoop down from the turrets and claim 'em.

I don't know why I wouldn't just go to sleep. I'd take a couple upstairs, Jagger through the motions then Bowie back down to the bar, all knackered.

This castle was the scene of some vintage Mick conduct. Each morning at 10am, as breakfast was served the hotel would put on a display of falconry on their glorious grounds for the guests. A Tawny Owl would at the behest of its handler circle overhead and take meat from the gloved hand. What a treat. On rainy days like this one, however – a rain sent no doubt to wash away the transgressions of the previous night – the display, more excitingly, took place in the corridor visible from the sumptuous restaurant.

We sat, munching toast and slurping cornflakes, awaiting the hour when the display would start. Mick stumbled down late complaining that some of the girls I'd consorted with in his room, because mine was occupied with sleeping sisters, had nicked his lighter. "I liked that lighter," said Mick, glumly looking off into the distance where in his mind the lighter was still at hand. "It was over a hundred pounds." "Sit down, Mick," commanded Danny. "That lighter was pony. And they're gonna be doing the owl display in that corridor at ten, that's in five minutes."

Mick's panda eyes dilated with wonder. He looked down at his watch. "Really?" he said, unable to contain his enthusiasm,

then, cynically, as if this might be one of Danny's pranks, "Wait a minute. How does the owl know what time it is?"

The word "entourage" simultaneously aggrandises and undermines the peculiar troupe that accrued around Nik and I. A family, a band, a gang. The value and charm of which, like so much, cannot be truly appreciated until it is irrevocably altered by something beyond human control, like a hurricane or love. Each individual, in their way flawed and hopeless, but unified perfect in their chaos. The success we were enjoying was a culmination of the efforts of these ratbags; and in terms of live stand-up we were approaching the pinnacle.

The O$_2$ was the climax of an incredible tour. Tens of thousands saw me, the show got great reviews. On the night, Universal sent a crew and some of the Apatow people to shoot a piece at the end of the gig of me as Aldous Snow performing songs, so there would be footage to use in *Get Him to the Greek*, which I would shortly be starting. This concert footage, like the stuff we'd shot with popstars at the previous year's MTV VMA awards, would be cleverly used to authenticate the "world of the film", to make it look legit. Loads of my mates and family came, it was a real buzz, and famous friends turned up: David Baddiel, Matt Lucas and Dave Walliams and, gratifyingly, Jonathan and Jane Ross – who loved it. Incredibly, to provide entertainment while I was off stage after finishing my set and making the "earth-shattering transformation" into Aldous Snow (which Matt maintains involves simply "wetting down" my hair), my mate from *Sarah Marshall*, Jason Segel, came on stage and performed with Jack Black. It was a remarkable night. It signified a triumphant return after the scandal, it was the biggest stand-up gig of my career – the biggest gig you can do in Britain – when three years earlier me and Gee

were performing in front of thirty people above pubs. It even led into my first leading movie role by virtue of the songs. After in the green room my mum and John Noel were dead proud, and all my mates were buzzing, but I had the feeling of emptiness and fear which, I understand, is common in comedians after shows. Gee said he remembers the two of us being sat in the dressing-room together after and me quietly saying, "What now, mate? What now?" That night, after all the hoop-la and glory, I went back to the house and felt like I did as a teenager before any of this happened. The cat was out. Adrenalised and wide awake I sat on my bed alone.

Chapter 20
BONER FIDO

To be sung to the tune of Lionel Bart's "Food, Glorious Food"

Sean "Puff Daddy" Combs,
He is in our movie.
When he's in the mood,
He can be quite groovy.
But which name should you use?
When you have to address him,
What if you balls it right up?
Then you'll fuckin' upset him!
He's Sean "Puff Daddy" Combs,
"Puff Daddy" Combs, "Puff Daddy" Combs.

That's the song I kept singing throughout the filming and rehearsal of *Get Him to the Greek*, in which I starred alongside Jonah Hill and, notably, Sean "Puff Daddy" Combs. Obviously I never sang it in front of him in case it annoyed him; I would just wait for moments where, for my own amusement, I could

sing this jaunty, humorous ditty. Of course now that I've printed the lyrics in a book I've exposed myself to reprisals and made the quietly clandestine months utterly pointless. No matter, I'm sure, if he reads it, he'll appreciate it. That's a gamble I'm willing to take. He is a fascinating character, who I think, alongside Madonna, has understood and exploited the modern notion of celebrity better than anybody else. He is a producer, a rapper and a brand. In my time working with him he was mostly introspective and quiet, focusing on the movie and the umpteen other projects, records, vodkas and clothing labels that make up his empire. There were two notable occasions when he unleashed the magnetism and colossal will that has got him to the top, and here they are.

Judd put on a dinner for all the cast and prominent crew members in an LA restaurant so that we could get to know each other better. I was about an hour late and everyone was there already, except Puffy, who eventually arrived about three hours late, which for a dinner is really late as most dinners don't last that long. I don't think this one would have, but we had to elongate it to wait for Puffy. When he arrived it was like he was the Silver-Surfer riding the tide of his own charisma, his lateness was completely irrelevant as he went round the table charming everyone with a phosphorescent gleam. Judd chuckled, Jonah Hill guffawed and Nick Stoller, the director, bumped fists in the whitest way imaginable and demonstrated his Black Power salute, which he bravely, insanely and deliberately made resemble a man operating a glove-puppet. Puffy loved it, it was well funny. When it came to my turn to be dazzled he went all out, inviting me on a trip to Vegas. I hate Vegas. The desert, like the ocean floor, is not for man. It belongs to nature, life does not flourish or belong in that barren, neon citadel of all that

is unholy. "What happens in Vegas, stays in Vegas!" I fucking wish it would. I wish the whole damn place could be evacuated and used by the French for illegal nuclear missile tests.

"Wanna come to Vegas?"

"Yes. I'd love to. I'd love to come to Vegas. Coming to Vegas is what I'd love."

So there it is, I was going.

"Thanks, Sean ... Diddy ... Puffy ... Puff."

I was never quite sure what to call him and it seemed uncool to ask. As time went on I worked out a "name hierarchy". Calling him Sean, I believe to be, like suicide, the coward's way out. Mr Combs isn't on, obviously. I like Puffy but I think I read that he changed it from Puffy to Diddy, which incidentally is the hardest one to pull off. In time I noticed, however, that a lot of his mates called him "Puffy" or "Puff", so once the ol' confidence was up, I started calling him that. Not at this dinner though.

Puffy, with incredibly poetic specificity, demanded that I show up late for the private jet he would organise to take us to Vegas. "I want you to show two hours late. No! Three hours late. In an eight-foot-long silk scarf." He paused then cried out, "FUCHSIA! The motherfucking scarf should be fuchsia! And I wanna see it trailing across the runway behind you!" What an insane request. Where would I get a fuchsia scarf at this late notice?

In the event I got a gold cowboy hat and hoped for the best. Ricky Hatton was fighting that weekend in Vegas against Manny Pacquiao, and I, IDIOT THAT I AM, said that I'd sort us out tickets.

"That's cool," said Puffy. "You score the tickets, I'll grind out the jet." That's by no means verbatim but it is the gist and style of what he said.

"Sean, you can rest assured that it will be no problem getting those tickets," I lied.

"Make sure they're ringside. I can't be sitting in no punk-ass bullshit seats." Similarly, that may not be verbatim but it was certainly the gist and vaguely the style.

"Sean," I said. "Sean, Sean, Sean, Sean, Shawny Sean. You don't know me well yet, mate, but I am connected *all over* Vegas, a place I LOVE, incidentally, so you needn't worry one iota about these tickets —we're going to that bout, and what's more, we shall have the time of our lives." That is what I said — verbatim.

And so began the frantic quest to get tickets to a highly sought-after boxing match taking place in less than forty-eight hours. I know Ricky Hatton "a bit", but Noel Gallagher's good mates with him, so I started nagging him about it. He said he'd try, he got me Ricky's number, but, guess what? It turns out that Ricky was a bit preoccupied on the days building up to the biggest fight of his career and wasn't answering his phone. Shit. Puffy calls.

"Yo, how's it going with them tickets?"

"The tickets? How's it going? It's going well. Very well. Very, very well. Very, very, very, ver-y …"

He interrupts, "You got 'em?"

"Not as such, no. BUT, I am a hair's breadth away from getting them, so worry not."

Eventually, after enlisting everyone I've ever met to pursue an objective that I don't actually, in my heart of hearts, want to achieve, through Dan Weiner, hornet of enthusiasm who pursues PR like a vocation, we got some tickets. But they weren't good enough. Fourth row.

Puff explained that if you're seen on TV sat too far back you look a bit of a prat. So he sorted the tickets himself, which

made me feel a bit embarrassed. When the day arrived me and Nik, my plus one, headed to Burbank to catch the private jet to Vegas with Puff Daddy – which is not a sentence I envisaged myself writing when I was a crack-head. To be honest I didn't envisage myself writing any sentences, I could barely hold a pen. We'd arranged to meet Big Danny O'Leary out there so that I'd have a bit of an entourage, although secretly we were all mates.

The plane journey was pretty good, Puffy is a remarkable host and knows how to create a vibe, although I regretted wearing the cowboy hat as it made me look like a thin Chippendale, and I didn't have the courage to be three hours late. I think we were actually a bit early.

On private jets they do your passport on the plane and you can use your phone at all times. Plus there's no customs or security and you can have music on, not that crap they play usually. The safety announcement is essentially a gesture and the feeling that you could have it off with the stewardess is heightened even further than usual. In Woody Allen's film *Zelig* the protagonist laments that his father's words to him on his deathbed was the advice "Always try and fuck waitresses." I would extend this creed to include stewardesses, masseuses and bystanders. Puffy's entourage, or "mates", depending on how you look at it, were a nice bunch. A couple of big blokes were his security, he had about four assistants and a couple of people who were not working. One of them, Tracey, has become a proper friend of mine as a result of a spiritual chat we had in the dawn aftermath.

Fame and money and glamour aren't the answer. You can't find spiritual solutions in the material world. I've learned this empirically but the knowledge is useless in front of the glare.

The chat I had with Tracey in fact was spun around the idea that life is like a game or *The Matrix*, which is a dangerous analogy to use around me because when I first saw that movie it capsized everything from my philosophy to my dress sense, but the analogy, thankfully, didn't call for me to don a black coat and stare into the mirror fretting about whether or not I was "the one", it was actually about the nature of compulsive behaviour and illusions.

Me and Tracey conjectured, the morning after, framed by Puff's crumpled entourage in the obnoxious Vegas suite (that's not a judgement on them, I had the same one a floor down), that the universe, in my extraterrestrial worshipping language or God in his, sets challenges for you, and until you overcome them you remain ensnared on that "level". For me, for the longest time I was trapped on a narcotic plateau, and until I addressed the problem I could not progress spiritually. Now, clearly, the problem was women. The night before had been testimony to that. Me, Danny and Nik, having become separated from Puff and Jay-Z's conga up and down the Strip, had wound up at our hotel with some girls.

The fight was not good, Ricky was knocked out in the second round at Caesar's Palace in front of a largely British crowd. I was stood next to Puffy, behind Jay-Z and was struggling with my new context. It transpires that I'm not really into boxing, and when I saw Ricky being expertly pummelled by the sublime Pacquiao I felt sad and guilty. I wanted to climb into the ring and help him. What assistance I'd be capable of offering under those circumstances is questionable, I think the two men would have whisked me into a smoothie of blood and hair before I could even whip out a Gandhi quote. The feeling of alienation was not helped by Puffy, who seemed to have a soft

spot for Pacquiao and was now standing on his seat cheering and whooping. He does create a buzz, ol' Puff. To be in a fancy Vegas restaurant or entering a club with him and Jay-Z is like living in a hip-hop adaptation of *The Great Gatsby*. Sometimes though he creates a party atmosphere in a situation which, in my view, could've gotten along without one. We were in the hotel lift with an old lady gambler and her dog and Puffy and his razzamatazz turned it into a claustrophobic version of *Girls Gone Wild*. Except it wasn't Girls, it was Puffy and a Yorkshire terrier pulling up its dog jacket and barking "Spring Break".

I overdosed on oestrogen again back in the suite, squirrelling all four girls into my room like a right little greedy guts. It wasn't even that good. I imagine that's why the next day I was talking about the excesses around women feeling like a trap.

When it came to the first week of filming on the *Greek* we were slung with cruel poetry right back on to the Vegas strip and indeed the very same hotel and room as before. My suite, I observed, had a lot of boys' toys-type trinkets like a pool table and fußball (I hate that word), but also a wipe-clean couch. In fact all the surfaces were wipe-clean. I'm not sure that it is a talisman of success to be staying in a room designed to be covered in sperm. In the front room there was a glass cylindrical shower, like a teleportation device, with lights on the ceiling and floor. At the centre there was a pole for the inevitable pole dancer that you would be bringing back to your suite. This is the ergonomic ideology employed at the hotel. No trouser press or little kettle, no shortbread or mini shampoos, no, a private pole dancing shower. I used it once to shower in, alone. It was the most depressing shower of my life, it was like doing your taxes in Disneyland. The closer I got to the summit of this mountain of indulgence, the more the climb seemed pointless.

The film itself brought more opportunity. By the time this book is out it will have been released and we'll know if it was a commercial success or not; either way I've seen it and it makes me laugh. It looks cool, Jonah is brilliant and adorable, Puffy is a revelation as the self-parodying music magnate Sergio, and Elisabeth Moss and Rose Byrne as me and Jonah's girlfriends are both hilarious. I loved working with the Irish actor Colm Meaney, who like Alfred Molina in *The Tempest* exudes qualities that one longs to emulate: diligence, warmth and class.

Making movies is not like watching them. As I've explained before, and I don't wish to sound ungrateful, it's like a long, boring caravan holiday, and I'd had enough of them as a kid. The performing and the collaborating with talented people are the upside but, for young aspirants out there, if you want to succeed in film-making, don't study *On the Waterfront* or *Goodfellas* while reading Stanislavski, book yourself into a caravan park in Ramsgate for three months and say the same thing twenty times every morning while caked in make-up – if you enjoy that, then Welcome to Show Business.

Nik sometimes says that I shouldn't make films as I clearly don't enjoy it. That's not entirely true, you get to work with amazing people, and when you see the end product all the pain and hard work seem worthwhile, like giving birth, right girls? Yep, that's what I'm saying, it's like childbirth. Only a lot more important obviously.

I suppose what I should do is practise yoga and meditate all day, then in the evening present a chat show, to get the exhibitionism out of my system – I should be a swami-entertainer, a monk-Leno. What is it, this thing that we're all questing after? Love? Acceptance? Blowjobs? Some disgusting combination of all three?

I met a lot of girls making the *Greek*, but this tale I think illustrates rather well that my womanising was approaching its nadir.

I plodded on with the production line of daily seduction and by gum, thank heavens, there were some romantic encounters, I am not a marauding dog-man, grinding out jizz on any unguarded leg, I see the beauty in people, I want to connect with it and hold on to it. Meredith, the witch-acupuncturist who I would forever trouble with my musings and enquiries, especially the craving I felt for love and companionship, would say, "Don't worry, Russell, you won't choose a girl, a girl will choose you. One day a woman will come along and scare off all the others with a big gun." I hope the last bit was metaphorical or it seems I am destined to wind up with Ma Baker or Lara Croft. She'd be alright actually. Unless she wanted me to go Tomb-raiding with her, which I wouldn't be into unless "tomb-raiding" is a metaphor for bumming.

The day after Michael Jackson died we were on the vast expensive set built to match the Vegas suite from the first weeks' filming. The loss of this genius lay like a sombre mist around the lot. As Jim Morrison said, "Death makes angels of us all," and Michael was returned to his rightful status as an icon to be worshipped. We were working loooOOOOOoooong days, seventeen, eighteen hours sometimes. The gaudy, opulent set was hallucinogenically bright, as were the extras that populated it. Usually between takes Puffy did deals on his Bluetooth earpiece, so I was surprised to see him chatting to an extra. I saw this as a chance to interview him on his views about women. Also the girl he was talking to was not the prettiest there and so I was curious as to why he'd elected to chat to her. He explained that he was in a relationship that meant seducing

women was off the menu and that he'd merely noticed that the girl had an interesting energy. I enquired further, hoping to glean specifics from a man who clearly understands human nature. He remarked that the woman, in his view, would be exciting to be around. Given that he'd already said that it was an avenue he was unable to explore, I asked if he thought it was something that I ought pursue. He said I ought.

The girl was Hollywood pretty, blonde and shapely. I sharked over and got her number. When we wrapped I gave her a call. "Fancy coming over?" I asked. She said it would not be possible as she was looking after her sister's dog. Blast. Incapable of countenancing a night alone I called another young lady, dusky, mysterious, saucy and accommodating and asked if she'd like to come over. She would.

So we head home, Nicola, Tom and I, back to our glamorous West Hollywood home we'd rented with its boundless view of the twinkling orange grid that LA becomes at night. I'm in fine spirits as I'm anticipating the arrival of the dusky girl, a girl with whom I've had liaisons in the past and who has proven to be quite diverting and adventurous. Then my phone rings. It is the curious extra.

"I can come over," she says. Well, this is interesting.

"Would you still like me to?" I would. But what about the other girl, you may wonder, she is already en route to the house. That could be viewed as a problem, but I like to approach these matters optimistically. Sure, if the two girls arrive simultaneously and one of them has some cumbersome moral code to contend with it could be a minefield, but fortune favours the brave.

"Oh, I've got Nobu with me, is that a problem?" Nobu is the English bulldog she is looking after for her sister. His presence is not ideal but I've already handed over complete control of

the situation to my madness, who in this is abetted by the part of me that puts anecdotes before reason. Anyway, I tell myself, even though I'm not really listening, I've been in billions of situations like this and I calculate that the most likely outcome is a threesome. Content with my speculation, I move on with the plan. Now both girls are coming over. Luckily I arrive home first and I'm pretty confident that "dusky" will be up for anything, given her previous behaviour, and "curious extra" I can play by ear. As I've said, the only problem would be if they arrive simultaneously, then I have no time to separate them and tailor a deal that is amenable to all parties, or possibly, if luck goes my way, a merger.

DING DONG. That's the door. I don't have a doorbell but "KNOCK KNOCK" doesn't have the farcical connotations that the anecdote demands. Hopefully it's just one of them, preferably Dusky, I think as I approach the door but, of course, it is both of them, stood on the step looking at each other at 3am, baffled. Only Nobu is untroubled. These are the scenarios where you earn your spurs.

"Come in, girls," I say like a jocular butler.

"What's going on?" enquires Curious.

"Nothing. You're tired, come this way and try not to think. Is this Nobu? He looks thirsty."

I guide Dusky to the TV room, pouring wine for her and Curious and placing a bowl of water on the floor for Nobu as I go, gliding through the moment like a kinky ninja.

"I'm not having a threesome," announces Curious.

"Of course you're not. What an absurd suggestion. Whatever gave you that idea?" I imagine it was Dusky's somewhat forthright mode of dress. Hot pants, crop top, dark tumbling hair, Hispanic accent and dark, suggestive eyes.

"We've all had a long day, this is no time for pondering ethics. Why don't you and Nobu come upstairs? Diana Ross used to live here."

Me, Curious and Nobu ascend the stairs, leaving Dusky to flirt with her wine. Once in my room I light the fire, in every way, and spend the next few minutes bolting up and down the stairs between the two girls like Mrs Doubtfire. As I'd assumed, ol' Dusky is up for anything, so my attention must now be focused on Curious. Nobu asthmathically snuffles and grunts his way through his water, so I turn up the music and light the candles to compensate. Puffy's verdict is proven to be accurate, and once assured that Dusky is safely downstairs the two of us get in bed and have a proper cuddle. I enjoy it of course, but the perfectionist in me is troubled by how to turn this twosome into a threesome. As long as I can create a land of sexual wonder for Curious I'm pretty sure her reservations will fade. The inhibitions around sex are mostly about conditioning. Some women just don't like girls, and that's fine, but normally if you can unpick the social stitching with some beautifully put universal truths a good time can be had by all. I am about to embark on a Byronesque soliloquy designed to facilitate this bliss when, blessedly, for once fate takes the matter in hand and things move on for the better without my input. For whilst Curious and I cuddle face to face, in enjoyable, vanilla conjugation, I feel that cheeky rascal Dusky round the back taking care of the region oft neglected in heterosexual men, but in my view a tunnel to endless pleasure and amusement. I continue to kiss ol' Curious, more passionately than before because the mischief of Dusky's unannounced appearance, not to mention the expertise of her tongue, elevates the encounter to a whole new realm.

"God, I'm good," I muse as I occupy these two beautiful women.

"People will write books about me – and if they don't, I will."

Curious seems a little reticent suddenly, but Dusky is going crazy at the backdoor and I'm struggling to maintain control.

"Hold off, Russell," I think, we've got to take care of Dusky too, especially after this incredible surprise performance she's put in round back – she's certainly very thorough, I've never been so well tended to in that department. I smile and continue to kiss Curious. But she gasps and pulls away, doubtless to accommodate the screams that will accompany the massive orgasm she's about to have. Her lips part and her mouth widens ...

"NOBU! GET DOWN!"

No.

Yes.

No!

Actually, yes. That's right, folks, I turned my head to see that my bottom was being licked by a bulldog. There's no nice way of saying it; it was bestiality but I was the victim. A lesser man would've been tempted to let Nobu finish what he started but I, ever the gentleman, politely insisted that the hound remove his snout and return to his water. Was I able to unite Dusky and Curious? I'll leave that to your imagination. What I will tell you categorically is that an episode of that nature makes you question your lifestyle.

"Is this really what I want?" I thought as I eyed the bulldog at my rear. "Is this really part of my life-plan?"

"So, Russell, where do you see yourself in five years?"

"Well, ideally I see myself getting rimmed by a bulldog." Hey, you've gotta dream big, right?

I told Puffy that story the next day and he exploded with joy. I've never known such happiness. Well, maybe five seconds before I looked over my shoulder to see a symbol of the British Empire disgracing us both, the flag and Her Majesty.

The movie shot in LA, New York, Vegas and London. It was a big deal. I loved shooting in London, especially as my mate Karl Theobald turned up and did a cameo, as did Gee and Jamie Sives, all characters from *Booky Wook 1*, and also, less importantly, real life.

The movie wrapped and I felt as often I do at times designated for celebration, peculiarly cold. My first lead role had been a success, Judd and Nick and the studio loved it. Everybody was very excited about its potential, but as usual I had no partner to share it with. And Nobu wasn't returning my calls.

Chapter 21
BOTTLE ROCKET

After the death threats and hysteria that followed the first MTV VMA awards Nik and I swore that, no matter what, we would never, EVER host another award show. It's too much aggro for not enough reward. But somehow, when MTV offered us the gig again I accepted. Mostly through pride and wanting to slay a few demons, I suppose. I didn't like the way the previous year had been reported in the UK as a catastrophe, so I saw this as another chance, a way to redemption, a way to rewrite my personal history.

MTV said the awards would be huge, live from New York with performances from Jay-Z, Beyoncé and Lady Gaga and appearances from Madonna, Janet Jackson and Katy Perry. The MTV execs, Van Toffler, Dave Sirulnick and Jesse Ignjatovic, said they would go all out with the promo and my entrance if I agreed to host.

Previously I'd just strolled out into a silent and unseated room, this year the audience would be amped up and I would enter on a concealed hydraulic podium which would rise from

beneath the stage with me ascending like a deity on a wedding cake while an as yet unconfirmed pop star introduced me with the Queen song "We Will Rock You". The show would be coming from the legendary Radio City Hall, a five-thousand capacity venue, but cool and art deco, tiered and raked, a great performance space, certainly better than the mirthless aircraft hangar they held it in the previous year.

Nik and I considered if we could make this work, and we're both a bit gung-ho and up for glory, so we said yes. From the moment we consented I was immersed once more in terror. What if it goes wrong? What if I say something crazy? I can't take any more death threats; surely, eventually one of these lunatics is gonna have the integrity to carry out this flimsy vendetta against humour.

The VMAs took place during a busy time in our schedule. We'd finished the *Greek* but were now into a documentary about happiness and the current generation's fixation with seeking satisfaction through self-indulgence and the fulfilment of desire. Who better to make this documentary than me? I'd also been offered the lead in a remake of the Dudley Moore movie *Arthur* which was being scripted by Peter Baynham, who wrote on *Brass Eye*, *Alan Partridge* and *Borat*, making him, in my view, one of the most influential comics of the last twenty years. So aside from barmy hubris there was no reason at all to get involved with the VMAs again. We were all there in New York, Nik, Nicola, Jack, Danny, Tom and Gareth plus lil' Dan Weiner, a lovely twerp-squad of Brits and nits. Their presence was vital for me to navigate the meteor-scattered starscape of this most unrewarding award show.

We were staying at the swish Soho Grand, yet another of the hotels I stay at that are more interested in being cool than

bringing you an egg sandwich, but they're certainly more fastidious than the openly hostile Chelsea. The penthouse suite I occupied, paid for by MTV, was one of two on that floor, and whilst it wasn't palatial it certainly made me question my role in achieving social equality. When you get famous, nameless ghosts bleed you of your principles like a pig. But it nags and bugs at the back of your mind, especially if it's not where you're from. You can't drown out the echoes of your past by chinking glasses and slapping arses. Luckily I was much too consumed with selfish fear to worry about the galling inequality of the supposedly democratic Western world. Alfie had come along too, to take photographs and keep me relaxed, his sage-like advice, as ever, conflicting wildly with his ridiculous conduct.

We sat about the suite locked into the incredible amount of prep such events demand: a promotional film, in this case a parody of *West Side Story*, interviews, rehearsals, writing the script and junkets. Additionally the Vanity Projects team working on the documentary were prepping for our trip to Louisiana State Penitentiary to meet death row inmates and our spell in Fairfield, Iowa, where I would learn Transcendental Meditation. Into the hive came the hotel manager.

"Mr Brand," he began, "the suite opposite has been booked by Miss Katy Perry, would it trouble you if she were to occupy that room?"

Obviously not. That would place her right within the sphere of my influence. Geography is destiny, said Napoleon, if she's in the room opposite I'll be able to destiny her brains out. She's like a lamb to the slaughter! "Bring her in, Jeeves!" I hollered at the manager, who had by now departed. Nik had overheard the enquiry and my arrogant response.

"Hey, be careful, mate. They've got her down to do your intro, the last thing we need is you ballsin' it up by givin' her one the night before the show."

"Sir," I countered, "my sperm is an elixir, if I give her one the night before the show she will give the performance of her life!"

"Come on, mate. She's living in the next room. What if you upset her? You'll have it off with her and then she'll see you doing the maid or some groupie or her assistant or make-up person or the bell-boy."

"Alright, alright!" I conceded. "You have my word as an Englishman, I shall not seduce Miss Perry till after the show." I was secretly thrilled that Nik thought I'd so easily enchant her, as I'd maintained a flickering curiosity since our kiss the previous year.

The next day at rehearsals in Radio City it was confirmed that Katy Perry would indeed be doing the "We Will Rock You" intro and the entire MTV top brass were frantic with worry that I'd jeopardise the show's opening with my philandering. "Please, Russell," they begged, "do not unleash your fierce charisma," as if it were the Kraken. Rather enjoying the attention I surveyed my nails.

"Gentleman, I promise nothing, for the force that dwells within me is not of this Earth and will not do my bidding."

By now we were in the auditorium, which the day before the show was a crackling inferno of activity with lights and sets being rigged and crews bustling and the entourages of the many stars, present to rehearse, fretting. Mine laughed at my dopey boasting.

"The thing about me is ..." I announced to the assembly, "is I'm a sorcerer with the birds, an alchemist, you put a dame in front of me and I will hypnotise her with my sheer magne ..."

I was planning to say magnetism, in fact I had a whole brilliant speech to give on the subject of my supernatural ability with women but I had to stop to observe the bottle that was arcing towards my head at some pace from the other side of the room. Thud. Ouch.

The bottle hit me right on the head and although it was plastic, it was half full, or half empty, depending on your perspective, and it hurt. Everyone laughed. What had I done to deserve such insubordination? I surveyed the missile's trajectory for clues to reveal the culprit – and there she stood. Beaming and pleased with herself, hidden by sunglasses, a beanie and a yellow sweater the sleeve of which was a giraffe glove-puppet concealing her right hand, Katy Perry stormed into the laughter she had created.

"Hey, Brand!" she cockily cawed.

I was aware of my mates and the MTV people watching this exchange – here was the woman they'd been beseeching me not to seduce. I needed to look cool. "Come on brain, let's go," I thought, but my brain wasn't working properly, I think perhaps because of the bottle. Plus my stomach felt odd. Sort of sick.

"Got you on the head there, huh?" she said. "Kind of an easy target, it's big and you've got that ridiculous hair ..."

The lads, MY LADS, laughed. As did the MTV folk, plus a few of the crew stopped working to watch.

"Come on," I appealed silently to myself in a split-second prayer. Wit, don't fail me now. The audience looked on.

"Yes, your aim was impressive. Particularly as, judging from the fact that you're wearing sunglasses indoors, you must be blind ..."

A laugh! Yes! Now move in. "Which would go some way to explaining your decision to wear that ridiculous sweater."

Double laugh, I'm winning, that's 2–1! Unbelievably someone even shouts that out, literally keeping score. At this point the expanding audience make that sort of "Whoooooo …" noise that often follows a jibe in Jerry Springer, you know, where they say things like "You go, girlfriend!" or "Kick him to the curb!"

Katy, though, doesn't miss a beat.

"You know it's hard to take fashion advice from a man who looks like a lazy transvestite."

Which I thought was a bit weak, but the crowd loves it. "2–2," someone says. Bloody hell! This is like *8 Mile*.

"Yes, I suppose I do look feminine …" I parry neatly, "… compared to you." 3–2! Surely that's enough to win this confounded match. I was doing well, especially given my head injury and the strange feeling in my stomach. I march up to her and command that she remove her glasses.

"I'm not removing anything I'm wearing around you, I could get herpes."

The crowd loves it, of course they do, it's a VD reference, the philistines.

Sensing this slanging match may not be going my way, I expertly sequester her away from the gawping crowd which now numbers about thirty and see if I can dazzle her better without an audience. She takes off her sunglasses, which I thought would give me an advantage, but it just made me feel more queasy. She has very beautiful eyes. Big and questioning, playful and tender. Away from the crowd my wit will surely return to full strength.

"Your bracelet," I announce, "… is nice." Thank God no one is keeping score now.

"You think so. Thanks."

It is an Alexander McQueen bangle, a simple hoop with two skulls facing each other at the ends.

Wordlessly she smiles, removes it and places it on my wrist, gently handcuffing me.

The floor manager bellows that we are needed on stage to rehearse the intro.

We separate, and by now I'm feeling really weird like when you do acid and resist its mercurial pull – when you don't, as Jim would say, "ride the snake".

On stage I assume my position on the submerged hydraulic lift. You will get no clearer demonstration of the absurd juxtaposition between the appearance of fame and its actuality than the scenario I shall here outline. When cued by Katy's introduction, both in rehearsal and "on the day", as showbiz people coolly say, the lift will rise up through the stage to about thirty feet in height, at Radio City, whilst my name lights up in Gothic font on the huge backdrop and fireworks go off, I then turn wearing a gorgeous suit and top hat and descend the stairs passing Katy and Joe Perry from Aerosmith, who is doing a guitar solo, and begin my monologue.

Wow! How glamorous! The reality is that to be in position for the lift to carry me up I have to hunch in a tiny dark space on a platform under the stage for ages. My posture is further impaired by the top hat I'm wearing, so I have to crouch right down, which in turn means my trousers come half-way down my arse, so Nicola has to stand there hoisting them up and holding them in position whilst I clamp my top hat to my head like a chimney sweep politely doffing to a lady only to discover that it's actually Medusa and is thus turned to stone in that ridiculous position. Then when I emerge I have to pull myself together in a split second and look all cool, instead of like a

man who's been crumpled up in terror with his pants down. It's like being launched from a cell in Abu Ghraib straight into the Oscars and having to make your orange boiler suit look snazzy and pretend the dog wee is a fancy new cologne.

Crammed in my glamour pen like a reluctant Houdini I listen as Katy half-heartedly sings, the way they do when they rehearse, like they can't be bothered, every syllable subtextually screaming, "I'll do it better on the day."

"We will, we will, rock you …"

I am shot through the stage, Nicola lets go of my trousers and I release my hat and act like my spine hasn't been folded up like an ironing board.

"We will, we will, rock you …"

I look at my big daft name on the back wall and nervously come down the stairs. I look at her and it makes the vertigo worse.

"Ladies and gentlemen," she says, "please welcome the biggest queen I've ever met, Russell Brand!"

"4–3" I hear someone shout from the dark auditorium. I'm pretty sure it was Gareth.

I smile as I walk past her and sort of want to pull her hair. When I reach the end of the runway from where I will deliver the monologue, the stage that Katy is standing on is being lowered to make room for the next performance set-up. Slowly she descends, the ground swallowing her. My wit returns, like I always knew it would.

"Thank you for that introduction," I began, then gesturing behind me, "And, before your very eyes, in a chilling foreshadow of the next twelve months, Katy Perry disappears without trace." Just as her head passed from view.

I win. Or at least draw. But hey, who's keeping score?

Afterwards I dash over to my mates to check how funny my last comment was, plus we're in a hurry to get off because England have a World Cup qualifier against Ukraine. Katy and some of her friends are hanging around by the mixer.

I feel the bracelet on my wrist. I really don't want to give it back but consider it would be ungentlemanly to stroll off with it.

"Erm. I'm going now, so ..."

"OK," she says and smiles.

"Well. We should stay in touch," I mumble like a twit even though I'm going to see her the next day at the award show we've just rehearsed.

"Oh. Yes?" she replies. "And how are we going to do that? Smoke signals?"

She's flirting. I think this is flirting. All my instincts are being affected by the head wound and stomach disruption. Plus now I'm getting short of breath and hot.

"I could give you my phone number?" I say. She takes it.

"Right. Bye then." I go to leave, the football's starting plus it is very hot in here.

"Oh, I forgot to give this back," I say, flimsily attempting to remove the bracelet, but she interrupts.

"It's OK. Keep it. To remind you of me."

And I begin to understand what all these symptoms are. I look at her and it makes me feel still. Then looking into her eyes, quietly I say, "I don't need anything to remind me of you."

That is how I fell in love.

The next day we did the show, I was so nervous I tried to convince Nik to call the theatre claiming to be a terrorist and say he'd planted a bomb there.

"I'm not doing that, mate."

The show went great. Kanye West took a bullet for me, his reverse stage dive on Taylor Swift meant we overran and I cut gags that would've seen me lynched.

Throughout I carried the bracelet in my pocket. Even though she was there.

The next night we went on our first date and she was so funny and pretty but more importantly she emits some gentle power that makes me want to be good. You'll think it frivolous of me to say I knew I'd marry her on that first date, but the truth is I fell in love with her when she hit me with that bottle. Like Cupid in a riot.

From the first date I changed. No more women. Well, actually, thousands of women. I wake up to a different one each day, but they're all her.

She's sleeping next to me now, tranquil and silently beguiling, it's impossible to ally her with the incandescent girl that blazes through the day. Her hand rests on her shoulder and I can see the ring I gave her when I asked her to marry me, at midnight on New Year's Eve in India, under a full moon, a blue moon. Once in a blue moon. She said yes. She chose me, bottled me and cuffed me. And now this is my life, my girl, this beautiful woman.

Just her and the revolution.

ACKNOWLEDGEMENTS

Nik Linnen

John Noel

Matt Morgan

Nicola Schuller

Nanny Pat

Mr Gee

Trevor Lock

Alfie Hitchcock

Danny O'Leary

Tom Chadwick

Sharon Smith

Hannah Linnen

Mick Panayiotou

Giovanni

Jose Gutierrez

Barbara Brand

Ron Brand

Adam Venit

Sean Elliott

Jessica Kovacevic

Dan Weiner

Moira Bellas

Barbara Charone

Kevin McLaughlin

Matt Labov

Jack Giarraputo

PJ Shapiro

Brian Wolf

Bobby Roth

Paul McKenna

Jack Bayles

Gareth Roy

Nic Philps

Lisa Mitchell

John Smith

Suzi Aplin

Craig Young

Gillian Blake

Lynne Penrose

Gabriela Banuelos

Lesley Douglas

Meredith Churchill

Focus12

Chip Somers

Jonathan Ross

Noel Gallagher

Sara MacDonald

Anna Valentine

Carole Tonkinson

Shepard and Amanda Fairey

Jenny May Finn

Sara Newkirk

Heidi Lapaine

Mark Lucey

Ian Coyle
Danny Smith
Kevin Lygo
Andrew Antonio
Ian Coburn
Phil McIntyre
Paul Roberts
Geof Wills
Ian Scollay
Judd Apatow
Nicholas Stoller
Jonah Hill
Adam Sandler
Phil Eisen
Leesa Evans
Jesse DeYoung
Erik Hansen
Roberta Gianotti
James Butkevich
Eddie Stern
Ross Cascio
Jose
Peter Baynham
Jason Segel
Julie Taymor
Helen Mirren
Jason Winer
Kevin McCormick
Larry Brezner
Chris Bender
Mike Tadross

Ray Quinlan
Van Toffler
Jesse Ignjatovic
Wendy Plaut
Dave Sirulnick
Al Ashford
Rosemary Chadwick
Keith Hudson
Mary Hudson
David Hudson
Angela Hudson
Tamra Natisin
Bradford Cobb
Ade Adepitan
Tracy Mills
Dr Norm Rosenthal

And finally to John Rogers for
your remarkable work on this
book and our friendship; that
but for this 'umble line would
have remained thankless.

PERMISSIONS